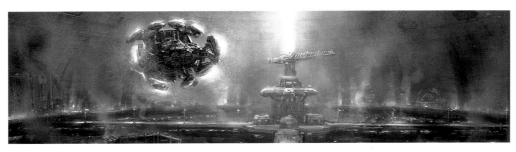

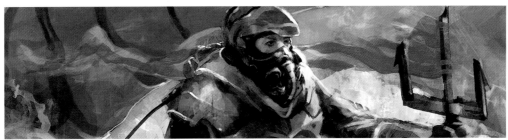

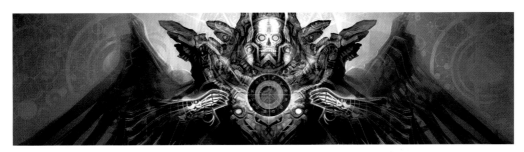

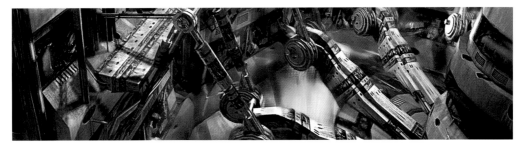

CONCEPT ART

d'artiste™
DIGITAL ARTISTS MASTER CLASS

d'artiste ™

Published
by

Ballistic Publishing

Publishers of digital works for the digital world.

134 Gilbert St
Adelaide, SA 5000
Australia

www.BallisticPublishing.com

Correspondence:
info@BallisticPublishing.com

**Third Edition published in Australia 2008
by Ballistic Publishing**

Softcover/Slipcase Edition ISBN 978-1-921002-33-5
Limited Collector's Edition ISBN 978-1-921002-32-8

Editor
Daniel Wade

Assistant Editor
Paul Hellard

Art Director
Mark Snoswell

Design & Image Processing
Lauren Stevens

d'artiste Concept Art Master Artists
George Hull, Andrew Jones,
Nicolas "Sparth" Bouvier, Viktor Antonov

Printing and binding
Everbest Printing (China)
www.everbest.com

Partners
The CG Society (Computer Graphics Society)
www.CGSociety.org

Also available from Ballistic Publishing

Visit www.BallisticPublishing.com
for our complete range of titles.

Cover credits

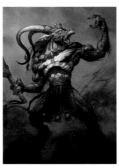

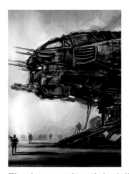

Mad Minotaur
Photoshop
Eric Ryan, USA
*[Front cover: d'artiste
Concept Art Softcover edition],
148*

Zion hovercraft and dock lighting
Concept art from 'Matrix Revolutions'
courtesy of Anarchos Productions Inc.
George Hull, USA
*[Back cover: d'artiste Concept Art
Softcover edition], 18-19*

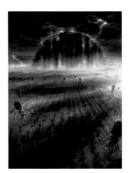

The Power Plant and Fetus Fields
Concept art from 'Matrix Revolutions'
courtesy of Anarchos Productions Inc.
George Hull, USA
*[Cover: d'artiste Concept Art
Limited Edition cover], 7*

/ B A L L I S T I C /

Daniel Wade
Managing Editor

Paul Hellard
Assistant Editor

Welcome to the fourth book in our Digital Artist Master Class series. **d'artiste: Concept Art** showcases the work and creative prowess of acclaimed concept artists: George Hull, Andrew Jones, Nicolas "Sparth" Bouvier, and Viktor Antonov. These four Master Artists have worked on a remarkable number of high-profile movie and game projects including: 'Matrix Reloaded'; 'Matrix Revolutions'; 'V for Vendetta'; 'Finding Nemo'; 'Mission: Impossible'; 'Constantine'; 'Jurassic Park: The Lost World'; the special editions of 'Star Wars', 'The Empire Strikes Back', and 'Return of the Jedi'; 'Star Trek Generations'; 'Twister'; 'Forrest Gump'; 'Metroid Prime 2'; 'Metroid Prime 3'; 'Metroid Prime Hunter'; 'Half-Life 2'; 'Half-Life 2: Lost Coast'; 'Renaissance'; 'Alone in the Dark 4'; and 'Prince of Persia: Warrior Within'.

In **d'artiste: Concept Art**, each Master Artist presents his conceptual art techniques through a series of tutorials which start with the idea and step through the process of bringing the idea to fruition. The book is broken into four sections based around each Master Artist. Artists' sections include a personal gallery, the artist's work and thoughts in their own words, a large tutorial section, and an invited artist gallery featuring paintings from some of the most talented concept artists in the world.

The d'artiste imprint (pronounced dah-tee-st) means both 'of the artist' and 'digital artist'. Each d'artiste title features techniques and approaches of a small group of Master Artists. The focus of d'artiste series is not limited to just techniques and technical tricks. We also showcase galleries of the artist's personal work and a gallery of artwork created by invited artists. Along with artist interviews this gives the reader a comprehensive and personal insight into the Master Artists—their approaches, their techniques, their influences and their works.

Ballistic Publishing continues to expand the d'artiste series to encompass all aspects of digital content creation. The d'artiste series already includes: Digital Painting; Character Modeling; and Matte Painting. Look for new d'artiste title announcements on the Ballistic Publishing web site: www.BallisticPublishing.com

The Editors
Daniel Wade and Paul Hellard

GEORGE
HULL

ANDREW
JONES

NICOLAS
BOUVIER

VIKTOR
ANTONOV

d'artiste ™
DIGITAL ARTISTS MASTER CLASS

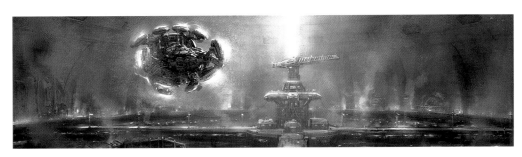

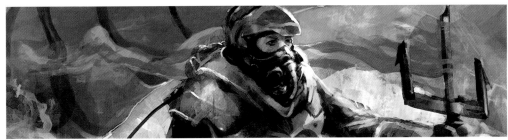

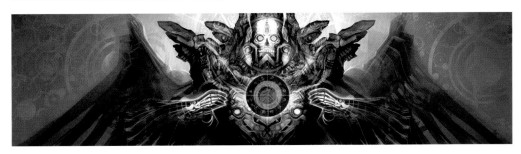

CONCEPT ART

GEORGE HULL

George Hull is a film designer who worked on 'Matrix Reloaded' and 'Matrix Revolutions' as a conceptual illustrator and then Senior Visual Effects Art Director. George holds a BSA Degree in Industrial Design and started as a conceptual vehicle designer for Chrysler and Ford Motors before joining Lucasfilm's ILM creative team in 1994 to become a Visual Effects Art Director. George's work spans more than 16 films including: 'V for Vendetta', 'Finding Nemo', 'Mission: Impossible', 'Constantine', 'Jurassic Park: The Lost World', the special editions of 'Star Wars', 'The Empire Strikes Back', and 'Return of the Jedi', 'Twister', 'Star Trek Generations' and the Oscar-winning 'Forest Gump'.

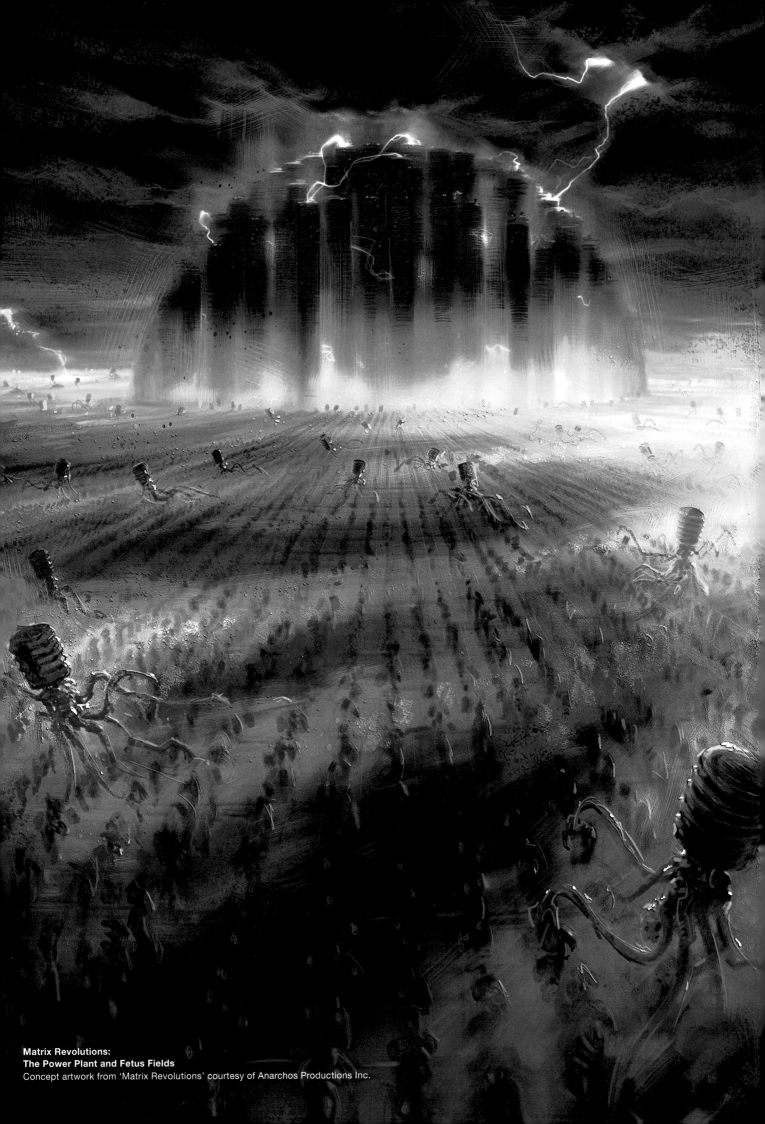

Matrix Revolutions:
The Power Plant and Fetus Fields
Concept artwork from 'Matrix Revolutions' courtesy of Anarchos Productions Inc.

CONTENTS

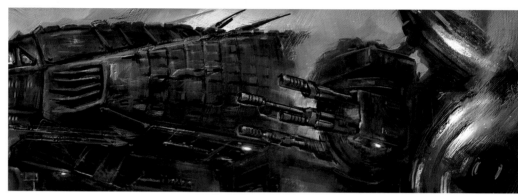

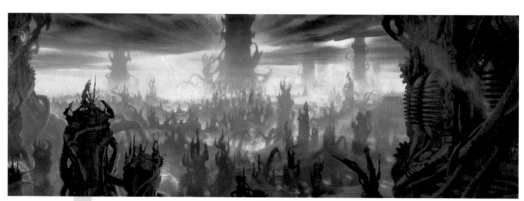

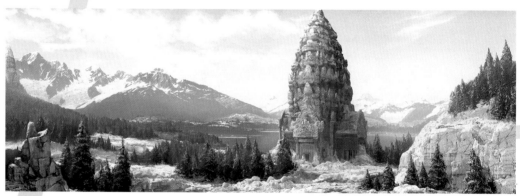

Background

As a kid I always loved to draw, but I certainly didn't think I could make a career out of it. Even though my family always encouraged me, I just thought of my art skills as an adolescent hobby. I loved growing up with 'Blade Runner', 'Indiana Jones', and 'Star Wars'. They were such captivating films and challenged my imagination. I would entertain myself by trying to draw bits and pieces from inspiring films. I was also lucky enough to live near the Cleveland Art Museum which has an amazing collection of art. I remember the first time I saw a Fredrick Church landscape. It blew me away. It was essentially the first matte painting I saw in my life and it transported me to another world, just like the movies. The film and fine art experiences have stayed with me throughout my life. They were all things I enjoyed but I never imagined myself working towards as a career. In my high school art classes I tried a little bit of everything. From really bad abstract design to an oil painting of the Taj Mahal. The only "realistic" jobs I knew of were architecture or commercial illustration. Neither of those felt quite right. Then one day I was flipping through a car magazine and saw my first conceptual design for future vehicles. I found out that you could study Industrial Design and make a career out of creative thinking, engaging your imagination, and drawing! My mother bought me a basic magic marker illustration book and I started my first concept sketch of a next generation car. I cherished my film experiences, but working as a film designer never occurred to me as a realistic pursuit.

Education

I studied Industrial Design at the University of Cincinnati, which was a five-year program of art and academics. The program required 18 months of internships over the last few years. This was invaluable for me because I got to see early on what my job would be later in life as a product/car designer. After talking to many working professionals, I found out that very few get to do "conceptual" work. Most of the jobs involved real-world manufacturing details of the same product, versus a lot of imaginative drawing and thinking. I was about to spend my senior year on my design thesis. The project should be "the grand portfolio piece which would sell your skills as the career you want to have after graduation". Well, the job I really wanted to have was in film design, but in Ohio that felt like saying you wanted to be Indiana Jones for a living. I had spent my entire education learning all the details of product design. If I switched gears, I could be shooting myself in the foot. If my thesis didn't get me into the film world, and the ID companies could not relate to it, I could be dusting off that Bob's Big Boy restaurant uniform again!

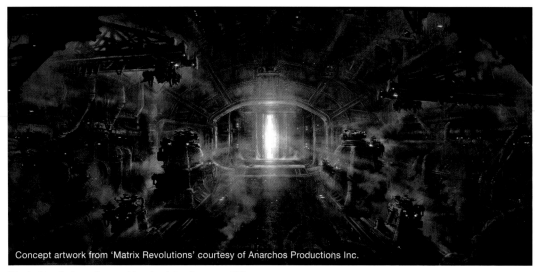

Concept artwork from 'Matrix Revolutions' courtesy of Anarchos Productions Inc.

Matrix Revolutions: Approaching the defensive gate of Zion

After much soul-searching, I decided to do my thesis on film design and stay true to my instincts. My school had no film design insight and even discouraged the idea as wasteful. I was a man with a mission and made up my own agenda. I used my "art-of" film books to determine what to aim for. I set out to do something imaginative but still purposeful in the real world. My thesis was a human-operated robot (designed for hazardous emergencies or disasters like Chernobyl and Three Mile Island). It won best in show and got me into the ILM internship. I was so happy I followed my gut and my family supported me taking the risk.

Getting a foot in the door
As soon as I entered the ILM art department in 1993, I knew film design was what I wanted to do for the rest of my life. I was amazed by all the great artwork on the walls and range of subject matter you could work on as a film designer. I lived in Ohio and had no exposure to the film industry. The internship allowed me three months to have access to art directors, model makers and visual effects artists. I decided to make every second count. I knew it was a small network and very hard to get inside. I plunged into my second "mission" in life and decided I was going to do everything in my power to get a design job. Every night and weekend, I practiced my drawing and

rendering skills. I was completely obsessed. Even after the internship was over, I continued training myself. Because I didn't have any professional film experience, I made up my own. I gave myself an imaginary film assignment based on an existing science fiction book. After my day job I worked on storyboards, concept art and character designs to fill my portfolio. Four months later my luck and hard work paid off, and I was hired as a staff Conceptual Artist at ILM.

Technique
Ever since I was a kid, I've had a bulletin board on my wall with photocopies of an assortment of work from my favorite artists. Every so often I'll swap out images with new ones that inspire me. This wall of images inspires me, and the featured artists have become my silent teachers over the years. By comparing my work to the leaders in the industry as well as my favorite painters in art history, I've had a constant reminder that there is always more to learn. It is impossible to become complacent with my work. I could struggle all weekend on an illustration, think it was pretty good, but then put it up on my wall for critique. It would be lacking in comparison, but as long as I advanced in some aspect, I felt like it was time well spent. If I thought I painted a sky pretty well, I'd just put it next to a Frederick Church painting and

laugh. I just keep plugging away at the whole artistic process and patiently watch my skills evolve.

Starting out
My first film job was drawing VFX storyboards and concept design for 'Forrest Gump'. I remember this was before Photoshop because I'd have to trace the background plates from a Movie-O-La (a film light table) and painstakingly draw out everything before adding the visual effect. I was absorbing all the mechanics of visual effects production and where a concept artist fits in. I then started working as a VFX Art Director, on films like 'Mission: Impossible', and 'Jurassic Park: Lost World'. I immersed myself in the world of computer graphics and managing people. After six years I found myself with a lot of VFX experience, but very little experience with designing a film from early on—the more creative side. That was the work that intrigued me from the beginning and I wanted to get back on that track. I found that almost all of the really creative work was done in pre-production versus visual effects production. I decided in 1999 to change my career path again and left ILM in pursuit of working in pre-production. I searched for an imaginative and design-heavy film that would entertain my interests in science fiction and industrial design. In 2000, my wish was granted and I was hired to help design the 'Matrix Reloaded' and 'Matrix Revolutions'.

The Matrix
After seeing the first 'Matrix' film, I was intrigued by the possibility of working on the sequels. Ridley Scott's 'Blade Runner' and 'Alien' films inspired me at an early age, and I wanted to work on an intelligent adult science fiction film. I sent my portfolio to the Wachowski Brothers and was elated when they asked me to join their team. They were still writing the scripts in Chicago when I was commissioned to start helping the visual development process from my home in San Francisco. I later moved to Los Angeles to join the director's core creative staff, including production designer Owen Patterson, Geof Darrow and other talented artists that created the look of the first film. Over the course of the next four years, my role as conceptual designer evolved into Senior Visual Effects Art Director. As a fan of adult science fiction, working on the futuristic mythology of the Matrix was a dream project. My favorite films are ones that offer new ideas and challenge the imagination. With such high concepts and unique mythology, I was honored to help the directors illustrate their scripts into drawings and paintings. Without a doubt, working on 'Matrix Reloaded' and 'Matrix Revolutions' has been the most satisfying experience of my career. You might think that is because of the hype of the films and such. But it was actually the personality of the directors, artists, and crew that made working on these films more than a job. I got the opportunity to collaborate closely with the core creative team, building the movies from script to stages and visual effects. This stage of preproduction was the most incredible artistic experience of my life. The creative talent and energy within this core group was absolutely thrilling. The directors were very accessible, quite humble, and treated the artists with great respect. For me, that is the greatest motivation, and it drove me to do my best conceptual work. Every director has a different style and creative process. Some have a clear vision in their heads and can communicate in words how a scene or idea should look. I then ask questions, maybe

brainstorm ideas, and then create drawings to help pre-visualize the setting, scene, visual effect, etc. Sometimes a director is searching for a look and simply points to the script (if there is one) and asks for ideas. This can be frustrating or rewarding as I can participate in the creative process more. At the end of the day, a director hires an artist as they would an actor. The artist should be cast because their artistic style already matches the look the director envisions for the film. He can give a brief description and the artist should know where to take it. Just like an actor who knows the script, knows the genre, and has done his or her homework.

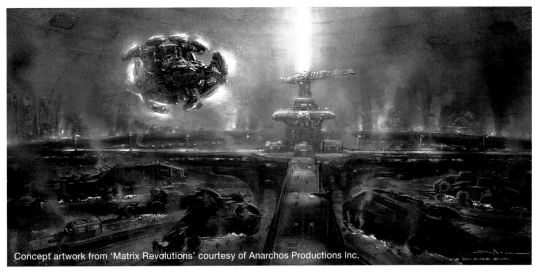

Concept artwork from 'Matrix Revolutions' courtesy of Anarchos Productions Inc.

Matrix Revolutions: The Nebuchadnezzar hovercraft returns to Zion

Development

I learned how to do conceptual illustration with markers, inks, gouache, and pastels. Just as I was feeling pretty confident at it, the industry changed to more digital art. I was always better at drawing than painting and I spent most of my time trying to improve my drawing/design abilities. For this, I think the computer offers little or no advantage. But, when it comes to rendering a design realistically, markers and inks can only go so far. No one ever used paints extensively to render because the work has to be done very fast. I first started trying digital painting in 1999, and it was not pretty. I decided to take a step back and take some time off to practice traditional painting. I did many color sketches to ease me into things. I finally ventured back into Photoshop for my work on 'Finding Nemo'. I found that it was very handy for film concept work—fast and easy to revise. While I worked on the 'Matrix', I tried to do as much as possible in traditional media. I always drew in blue pencil, inked my line work, and sometimes did a preliminary marker rendering. As I became more digital savvy I skipped the marker rendering step and went straight into the digital painting. After a year of that, I began to feel comfortable painting from scratch, working digitally from the very beginning.

Concept art for movies

Before movie design, my only experience was from my internships at industrial design companies. I could draw cars, consumer electronics and other products. The first thing I learned when diving into the film world was a film designer must be able to draw everything. Because there are so many genres of movies, a designer can't survive by just doing a few things. I needed the skills to draw complex perspectives, churches, canyons, machines of every kind, as well as dinosaurs, people, fashion, animals, etc. Although this was daunting, it was the exact reason I chose film over any other type of design. The variety of subject matter means you will almost never get bored, and you are always learning about new things. I love to study new subjects through the drawing process.

The process

Whenever I start an illustration, I think about the focal point and value composition first. I like images that can be bold enough to make the point in a few seconds, yet subtle enough to have depth and emotion. I go through a process when providing art direction which helps people clearly decipher the qualities of strong imagery. It revolves around three basic ideas: (1) knowing the essential controlling idea of a shot; (2) deciding on the focal point which will express that idea easily; and (3) designing everything in the color, lighting and value composition to support that idea. With complex imagery, this can be much harder than it seems.

However, attention paid to these steps can be the difference between dramatic, captivating imagery, and a muddy composite of great detail but poor design. Computer graphics are inherently noisy with detail; so this is crucial in visual effects.

Breaking into concept art

At the end of the day, your artistic value is based on what makes you special. What can you do that sets you apart from what others do? There are a lot of young artists that can paint an image and make it look dramatic, colorful, and maybe realistic. This is important, but the market is saturated on that end. What is hard to find are artists with refined drawing and design abilities. I always get calls looking for referrals of young design talent—artists that know forms, architecture, design details, and how to draw them well. The best way to teach yourself these skills is to get away from the computer, and work on your sketchbook! If all of your skills are in digital painting, you limit the type of work you can create. On many shows you can't use photo reference, because the whole idea is to design something new. You should be able to show your ideas in a sketchbook before the rendering process ever begins. After you get your foot in the door, then you can get back into the rendering side of your work. The VFX industry is becoming more and more competitive, so there is less money for visual development.

Most VFX companies don't have a staff art department and will only bring in a concept artist for a big show. More concept design is being done by digital artists like compositors and matte painters, who are learning more pre-visualization skills. Most visual effects design is actually less drawing heavy versus digital manipulation. For all these reasons, if you want to be more involved at the conception of a film, I would look into pre-production art departments in films and games versus working at a visual effects company.

The future

I love designing for films and I will always stay involved in it. There are less and less films that get me excited however, so I've become more selective with my time. After spending so much energy on my career I am taking more time for my own artistic projects. I enjoy getting away from the computer and painting in oils and acrylics. I want the art that I do on my own to feel timeless, and I have a hard time getting that feeling with digital art. I still have my bulletin board with my favorite artists and work that inspires me. But it has less science fiction work and more fine art paintings and photography. Artists like Sebastian Salgado, Steve McCurry, Edwin Church, Kent Williams, Bill Henson, and so many others. I think I'm on my next "mission" in my career path, but this time it is for myself. I'm starting there and I'll see where it takes me.

NOVALIS

HOVERCRAFT RE·DESIGN · E3C

HULL 10·02·02

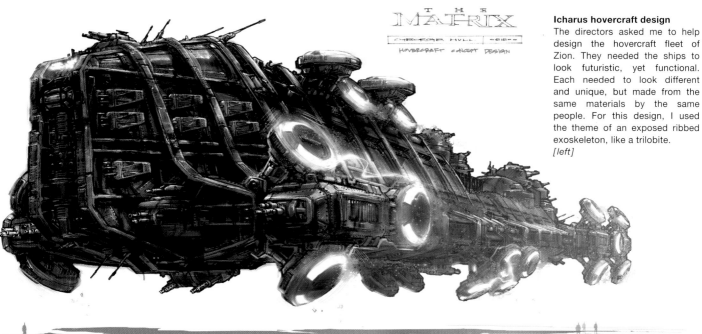

THE
MATRIX

GEORGE HULL

HOVERCRAFT CONCEPT DESIGN

Icharus hovercraft design

The directors asked me to help design the hovercraft fleet of Zion. They needed the ships to look futuristic, yet functional. Each needed to look different and unique, but made from the same materials by the same people. For this design, I used the theme of an exposed ribbed exoskeleton, like a trilobite.
[left]

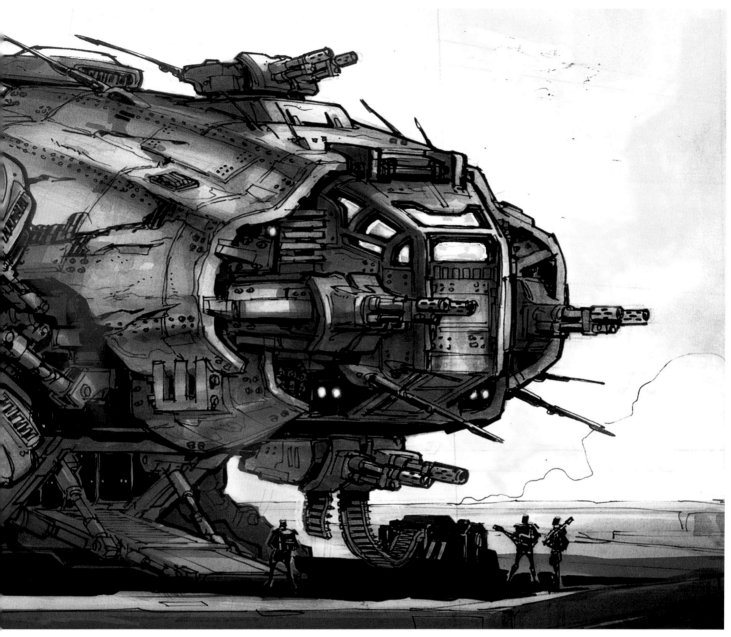

Novalis hovercraft design
Even with vehicle designs, everything should relate to the story ideas. The characters who built these ships were rebel soldiers who used scrap materials for everything. The ships needed to look repaired and battered, like they had been through many Sentinel attacks. I researched armored mine-clearing machines, construction equipment, etc. I wanted to understand what I was drawing and not make up the typical forms. [above]

Matrix hovercraft design
This was the first sketch I did for the films back in early 2000. I was working from home while the directors were finishing the scripts. This vehicle looks a bit dated, but I was still learning and refining my design aesthetic. [right]

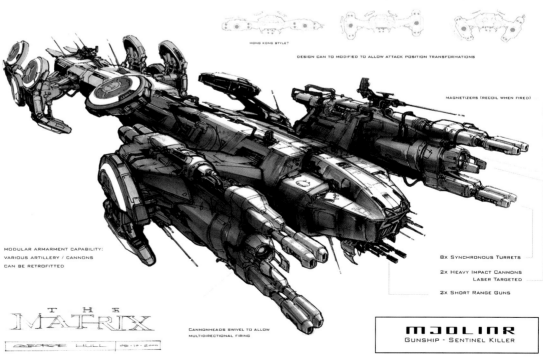

HONG KONG STYLE?

DESIGN CAN BE MODIFIED TO ALLOW ATTACK POSITION TRANSFORMATIONS

MAGNETIZERS (RECOIL WHEN FIRED)

MODULAR ARMARMENT CAPABILITY:
VARIOUS ARTILLERY / CANNONS
CAN BE RETROFITTED

8X SYNCHRONOUS TURRETS

2X HEAVY IMPACT CANNONS
LASER TARGETED

2X SHORT RANGE GUNS

THE MATRIX

GEORGE HULL 28·12·2000

CANNONHEADS SWIVEL TO ALLOW
MULTIDIRECTIONAL FIRING

MJOLINR
GUNSHIP - SENTINEL KILLER

Concept artwork from 'Matrix Reloaded' courtesy of Anarchos Productions Inc.

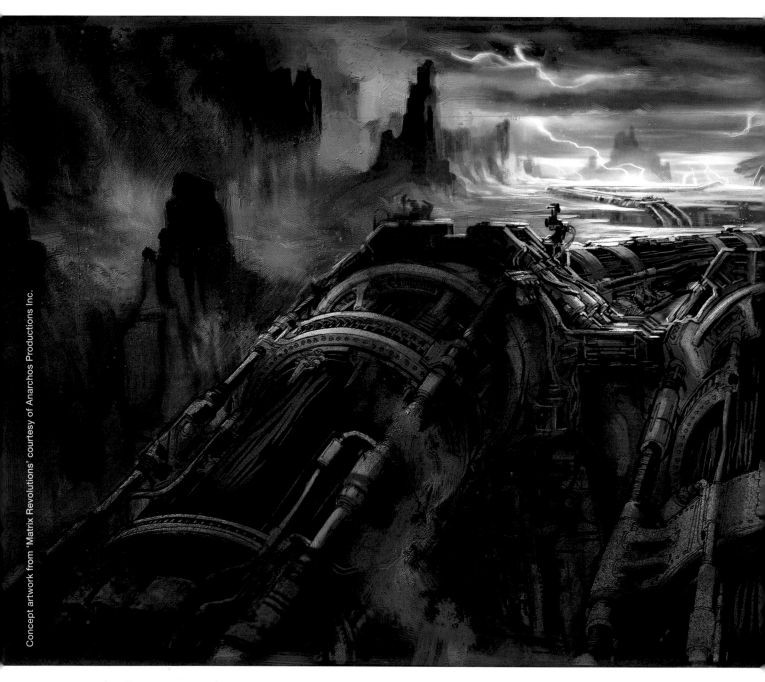

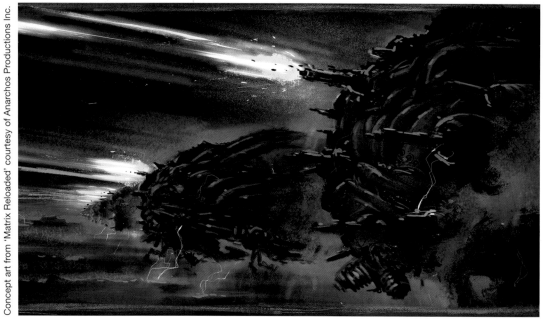

The giant cables to Machine City
In the Matrix mythology the machines harvest humans for electricity, and use the power to fuel their civilization. In this painting, I was asked to design three massive power cables— stretching across the scorched Earth's surface. In the final act the heroes follow them from the power plant to Machine City. I tried to make the cables feel alive with subtle glowing red veins, and to contribute to the mystery of the strange world.
[above]

The Machine Armada
This is a color storyboard from the final act. I tried to be gestural and sketchy, but still show the cinematic qualities of mood and action.
[left]

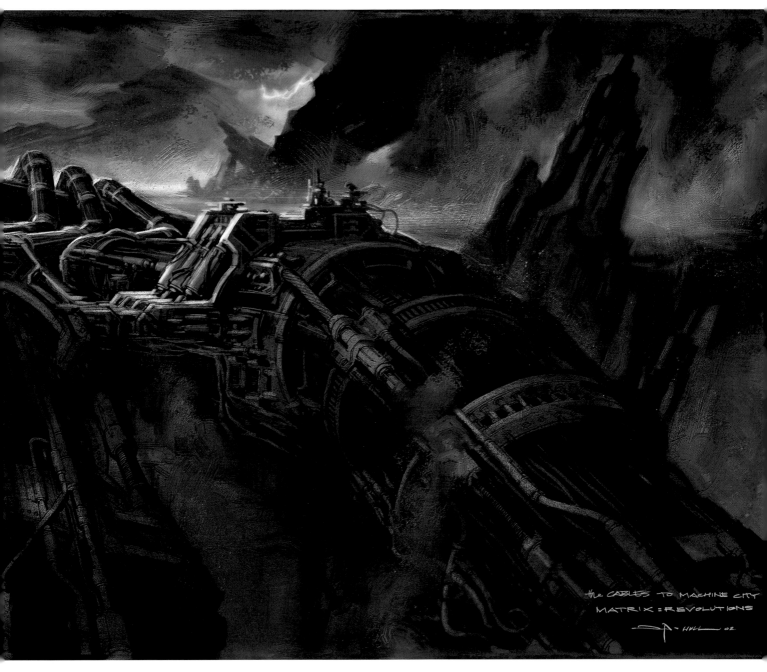

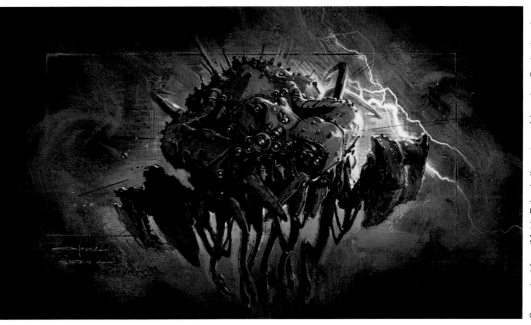

Matrix Revolutions storyboard
This is another color storyboard for lighting and mood. To do many of these quickly, I had to find an efficient process. I always drew and inked the drawings by hand and used Photoshop to paint in the lighting.
[right]

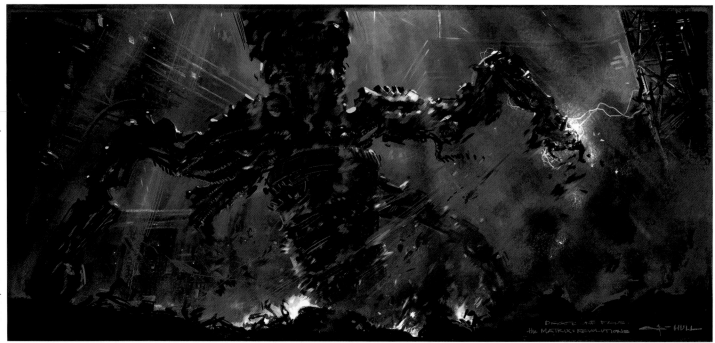

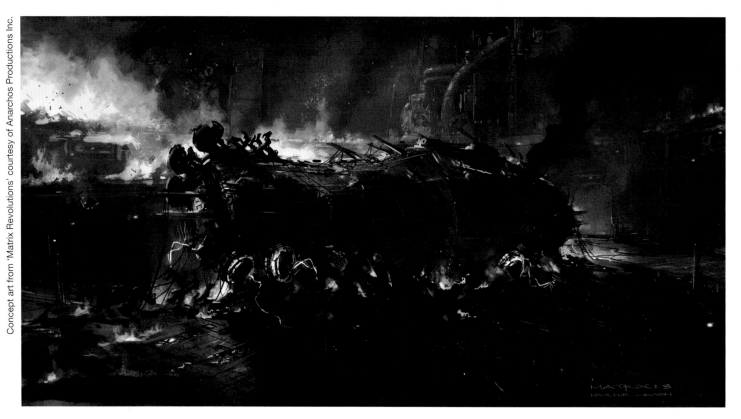

The Siege of Zion: Digger attack
I painted this image to help solve various lighting and set piece issues. I found the best way to provide art direction was to digitally paint ideas into detailed "key-frames". These gave the crew visual targets to help describe precise lighting direction, color palettes, value, composition and atmospherics.
[top]

The Mjolnir hovercraft: crashed in the Zion dock
I try to paint high contrast and dramatic lighting, with aerial perspective and depth. I use all of these tools to design my layout and lighting composition.
[above]

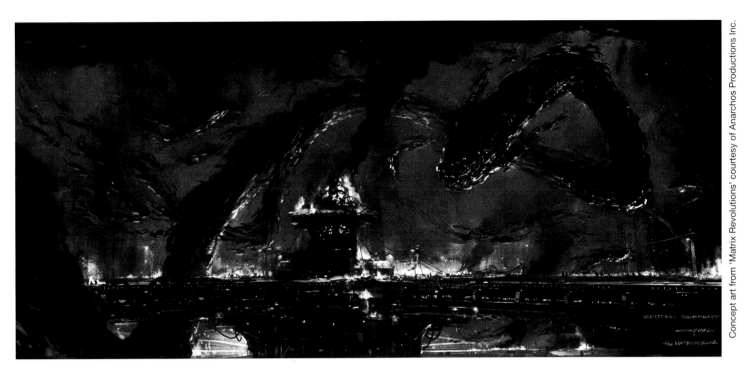

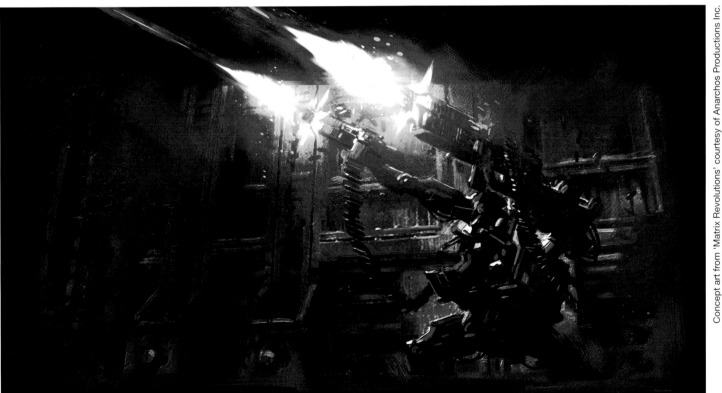

Sentinel Serpent conceptual

My goal was to figure out the color and lighting direction aspects of the siege—after the Sentinels have fully destroyed the dock. I wanted to give the masses of Sentinels a distinctive head shape. I thought this would help the audience see the Sentinel swarms as a more threatening monster of collective intelligence, and make the scene more dramatic. The Chinese dragonhead seemed like a perfect fit. Whenever possible, I try to design a composition from left to right with strong diagonals. The challenge is usually how to lead the eye back into the middle, and keep the viewer inside the frame. I designed the composition of the twisting Serpent using this approach.
[top]

Fighting APU key-frame

By drawing and painting off of the canvas, it helps the viewer see the action—the storyboard is just one frame of a moving camera and or subject.
[above]

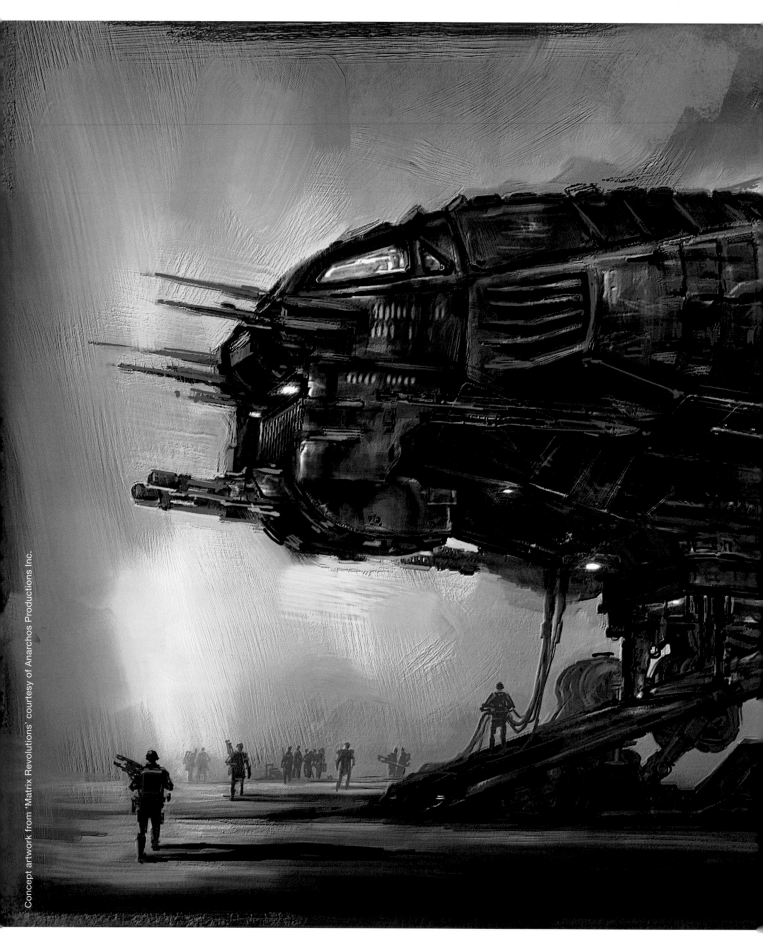

Zion hovercraft and dock lighting

The docking bay of Zion was the backdrop to many scenes, so I decided to paint this image to help define the look. Working as VFX Art Director, I think about elements that make a flat scene come alive. So I painted my hovercraft design with active workers repairing its hydraulics and refueling its tanks. I imagined the engines were still hot with steam pouring out from all crevices.

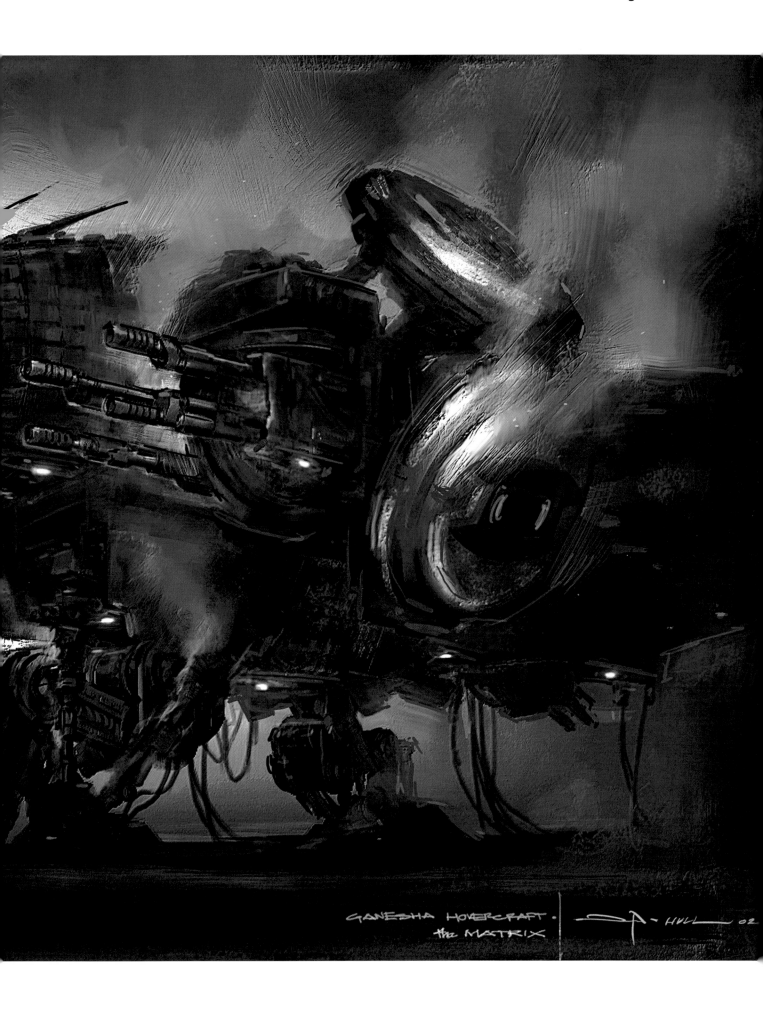

GANESHA HOVERCRAFT.
the MATRIX

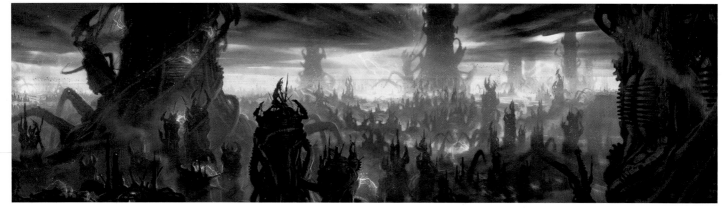

MATRIX REVOLUTIONS: MACHINE CITY

Concept art in pre-production

During pre-production a film is designed by deciphering cues from the text of the script and translating them into images. There are also occasions where I will start work on a film without a script. This requires collaborating very closely with the directors and listening to their ideas. On the Matrix films the Wachowskis had a very descriptive writing style represented in the script which was the basis for all the design work. As a result of their passion for art, and understanding of graphic storytelling, it was very easy to take direction and help illustrate their story in paintings. Because their vision was such a science-fiction epic, everything down to the finest detail needed to be designed from scratch and fit within the Matrix mythology. I was asked to help design set pieces like hovercrafts, massive underground tunnels, the industrial architecture of Zion, etc. After the sets began to take shape, I spent considerable time creating production paintings and color story boards of the film. I love this part of the process—helping the raw idea take shape in its simplest form. It allows me to thoroughly appreciate and enjoy what eventually becomes a complex and elaborate film experience.

Machine City

While working on 'Matrix Revolutions', I drew and painted over a hundred color storyboards to help pre-visualize the film. It was the first time I had ever experienced such a working style. Typically a director only wants a few scenes worked out in color, and a few production paintings. Because these films were set in such fictional places, I had my work cut out for me. The "real" world was the futuristic Earth surface which had been taken over by the machine race. It was only suggested in the first film, so I was excited to help develop the concept further. I read the scripts, highlighted the "hero" moments, and drew thumbnails and notes on the side. For this scene, the directors asked me to paint the moment before Neo confronts the Deus Ex Machine (the central machine AI) and he looks out onto the world for the first time. I imagined an enormous vista of sprawling activity, mysterious and surreal.

Inspiration

I remember staring at my blank piece of paper thinking about the task ahead. I had beautifully intricate line drawings from Geof Darrow of crustacean-formed buildings, but I had to design an epic cityscape. From the line drawings I needed to imagine the mood, lighting, and atmosphere and how it could support the context of the scene. I asked myself "Would a future race of machines need buildings to live in? Would the buildings be giant creatures or a collection of creatures thinking and moving together?" I researched concepts about the biology of machines and the future of AI. In the book 'Out of Control', Kevin Kelly writes about machine social systems being very similar to bee colonies. The collective consciousness or the "hive mind" fascinated me. I was also intrigued by the idea of "singularity". That is, if machine intelligence gains the ability to improve its own programming it would become so powerful we couldn't predict what it might do. At that point, its capabilities could exceed even the power of our imaginations! With these ideas in my head, I started sketching anthill shapes, and giant tentacled machine cranes. I imagined a city being a living organism constantly building itself. My favorite part of creating conceptual art is this process—thinking and working out ideas and concepts to support the visual imagery.

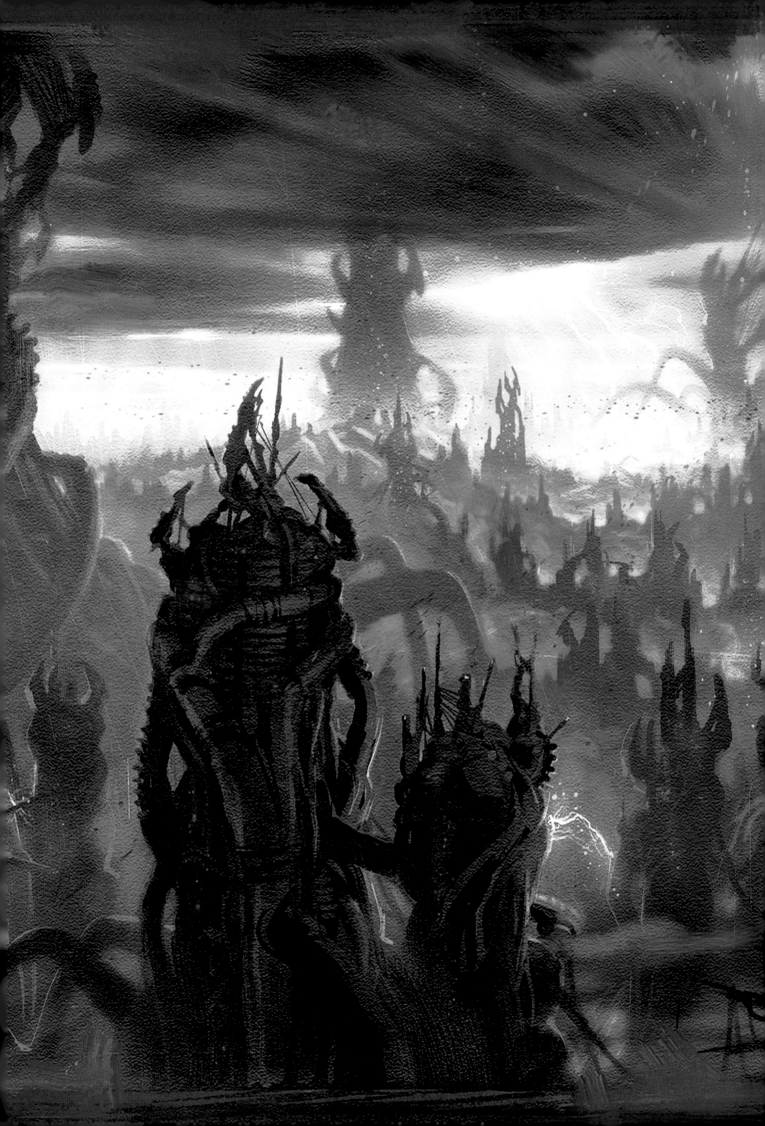

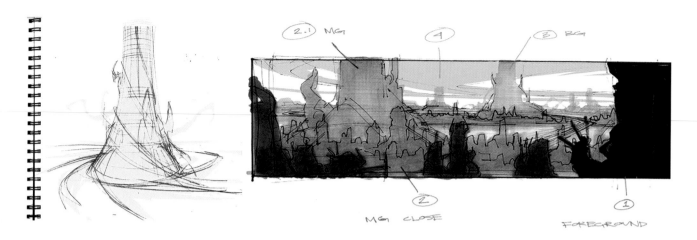

Starting the idea

I started out brainstorming ideas with gestural thumbnails in my sketchbook. For a film "key-frame" I always start by asking "What is the controlling idea? What idea needs to be conveyed?" Even for a simple environment, there is a story-point, or emotion that should apply. This answer leads the way for all visual elements. For this scene, I imagined the viewer should feel overwhelmed by the Machine's civilization. I asked myself: "How can I make it look like a vista of incredible scale? How can I make a bunch of buildings look intelligent and advanced? Would machines need buildings to live in or not, or is a machine building a creature itself?"

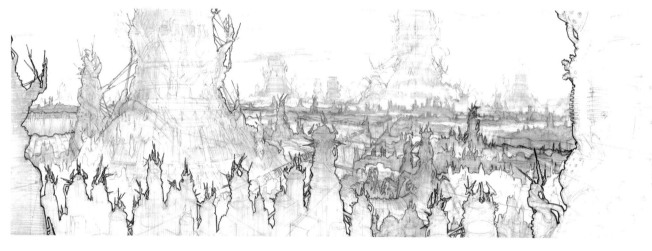

Drawing the layout

Using my thumbnail sketch as a guide, I drew my horizon line and started carving out perspective lines. I had detail drawings from Geof Darrow for reference. I started by drawing them in perspective, and then designing my own giant towers to maximize the sense of scale.

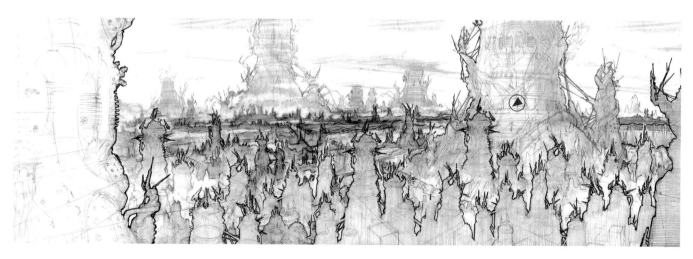

Working out depth in the drawing

At this stage, I explored how much depth I could create within the scene. Knowing how many blocks of buildings you might see outside a New York City skyscraper, I kept drawing more and more levels of mid-ground. I scanned the drawing and brought it into Photoshop where I could quickly copy and paste buildings around searching for the best composition. Flipping the drawing helped me to judge composition and perspective.

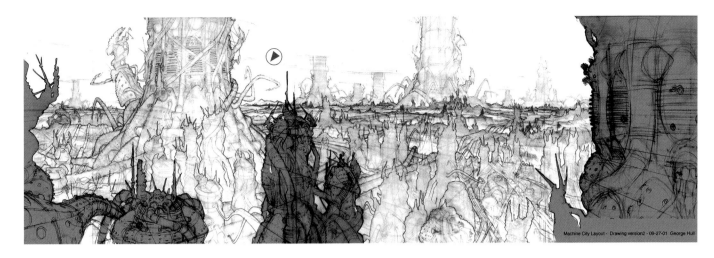

Refining the building designs and ideas

Thinking about the question I asked at the beginning ("How do I make the city look intelligent?"), I began to imagine a Machine City that could build itself! I started drawing the giant towers with tentacle arms that could act like construction cranes. I wanted the entire city to look alive like an ocean floor of giant sea anemones. This might help advance the story idea of the superior protagonist.

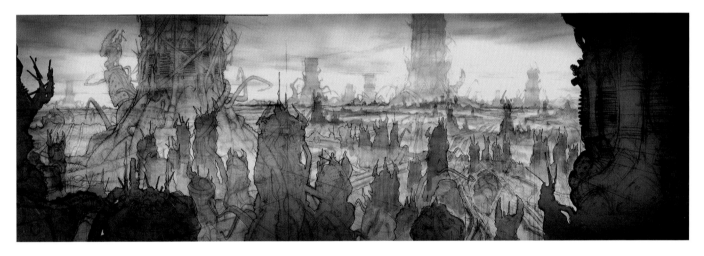

Quick tonal pass

At this stage I increased the contrast to get a quick look at the tonal values in my drawing. I also wanted to make sure I understood enough of the building detail to paint them later.

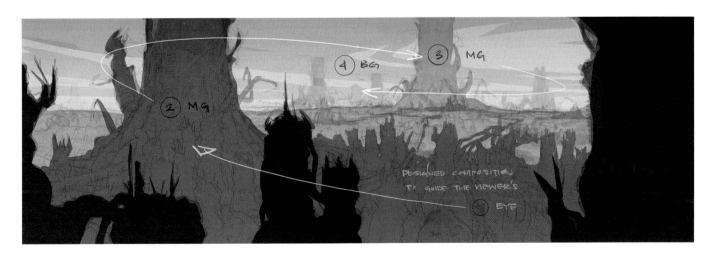

Graphic tonal guide for aerial perspective

This is one of the most important stages to me. By blocking out the value composition in flat tones, I can use it as reference point. I find that it is very tempting to add tonal variation to each picture plane (foreground, mid-ground, background) and easily lose the sense of depth. I've also shown my thinking in designing the composition—to guide the eye around the canvas and support the aerial perspective.

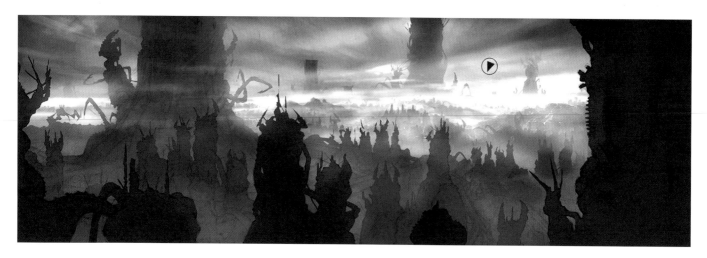

Value composition with key-light

The previous panel used aerial perspective to establish depth, without the use of lighting. Of course, the two are tied together, so in this panel I am starting to work out my key-light. I decided to use a bright source at the horizon with backlit fog. I wanted to create a mysterious mood which would support the eerie feeling I had when reading the script.

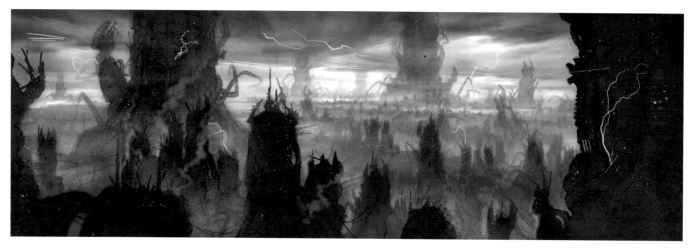

Exploring ideas on a separate sketch

Using a duplicated image, I can explore ideas for the final painting without wrecking my initial art. This is where I scribble ideas and usually make a mess of things. I wanted to know how much electricity I could use as an external light source. I also started adding red eyes to help allude to a sense of scale. It is not a pretty image but that's OK. It's meant to tell me what NOT to do.

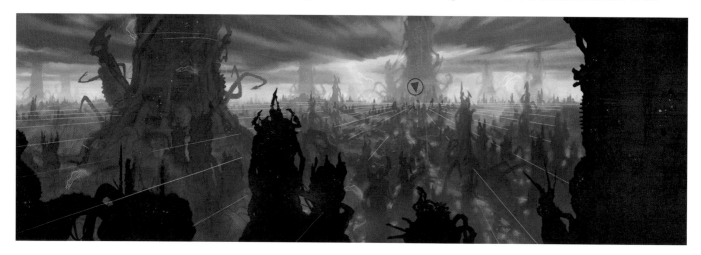

Enhancing the perspective cues

You might have noticed in the layout stage I changed my vanishing point from the center more towards the right. It seemed like a better placement only now the image seemed to lack structure. I then redrew the central perspective lines to help me paint in structural cues. Even though all the buildings are amorphous and curved, there must be some perspective cues to hold it all together.

Working in a scan for ground details

I struggled with painting as much detail as a vista like this would need. I resorted to scanning in an aerial view of New York City. I used Color Balance to start blending it in with my drawing and then painted opaquely to get the rest of it to merge. I also started working up the distant buildings on the horizon.

Placing mid-ground/foreground buildings

Working from back to front, I'm now at the stage where I need to sort out the front layers. I moved the structures around trying to find the best placement to heighten the depth.

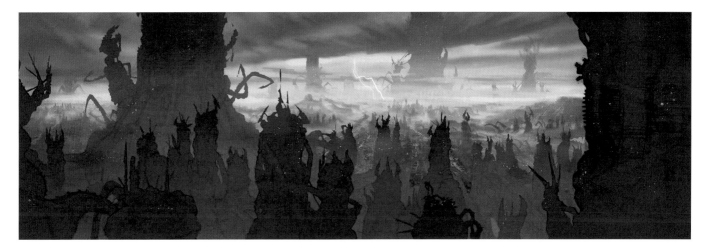

Midpoint review

At this point all the main elements should be in, and the composition should be set. Even though the values are not refined yet, I'm happy with the staggered picture planes. The shapes and placement of the buildings were designed to keep the viewer's eyes moving around the composition.

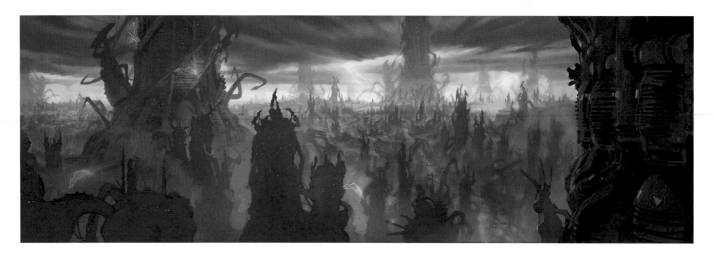

Painting in building details

Using the standard round brush, I started sketching in the foreground building details. This is another instance that the time spent detailing the layout drawing really helped. I could see the drawing lightly in places and painted my shapes based on the forms I had drawn earlier.

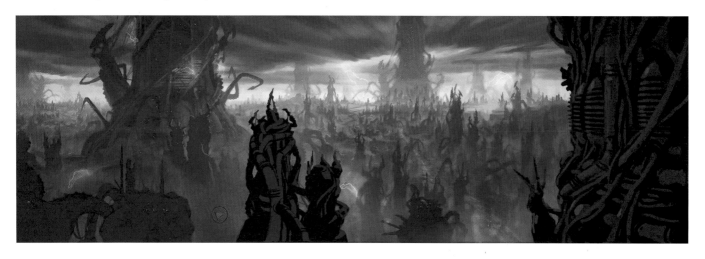

Working up the foreground

With the drawing layer set to Multiply, I could see the lines overlaid above my painting. Here, I am working around the foreground buildings painting in the dark and light shapes. The values are based on my lighting structure (a backlit key-light and a soft ambient fill light).

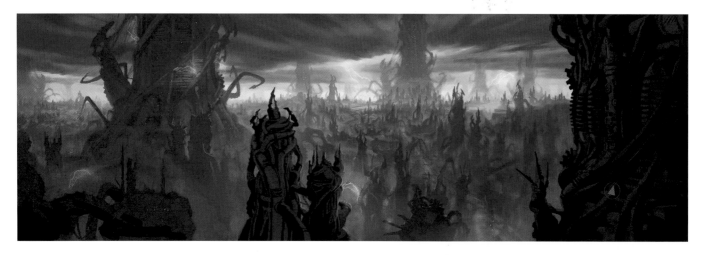

Thinking about detail lighting

At the right side of the image, I am starting to think about how to detail all these similarly toned machine buildings. I had to stay in the palette of the movie which dictated a fairly monochromatic blue. I made up some red lights and eyes to give the buildings just a little character.

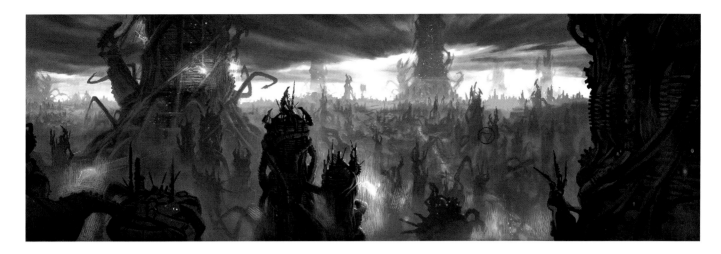

Checking the value composition

By adding a Saturation adjustment layer, I can view the image in black and white, and easily judge the value composition. The foreground to mid-ground has nice spatial depth, but mid-ground to background could use more separations to enhance the depth.

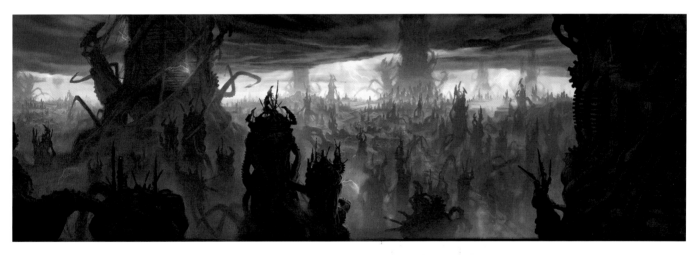

Painting atmosphere and scale cues

By now all the main elements of the painting are established, but it needs thousands of small lights to define the scale. I quickly peppered in tiny dots in all the dark crevices of the buildings. For the last stage, I adjusted the colors to be a more de-saturated green fading to blue cyan.

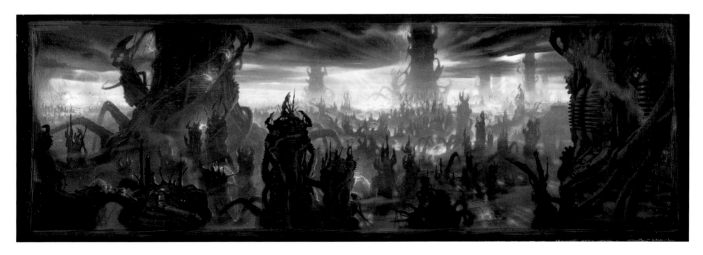

Finishing

Looking at the image now, I wish I kept more of the scanned ground plane for smaller details. But, I remember the directors wanted the ground completely covered with buildings. Stylistically, I don't want my work to look too digital, or over-detailed. Even though I could use more photographic elements, I like the feeling of a loosely painted conceptual that feels visceral and touched by a brush. I even added a canvas texture to keep it from looking too slick.

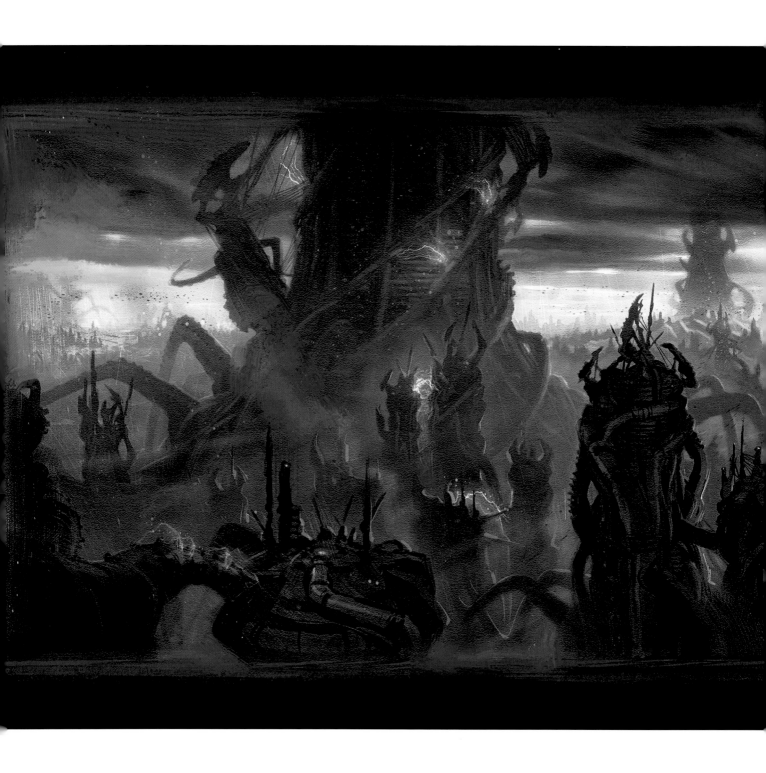

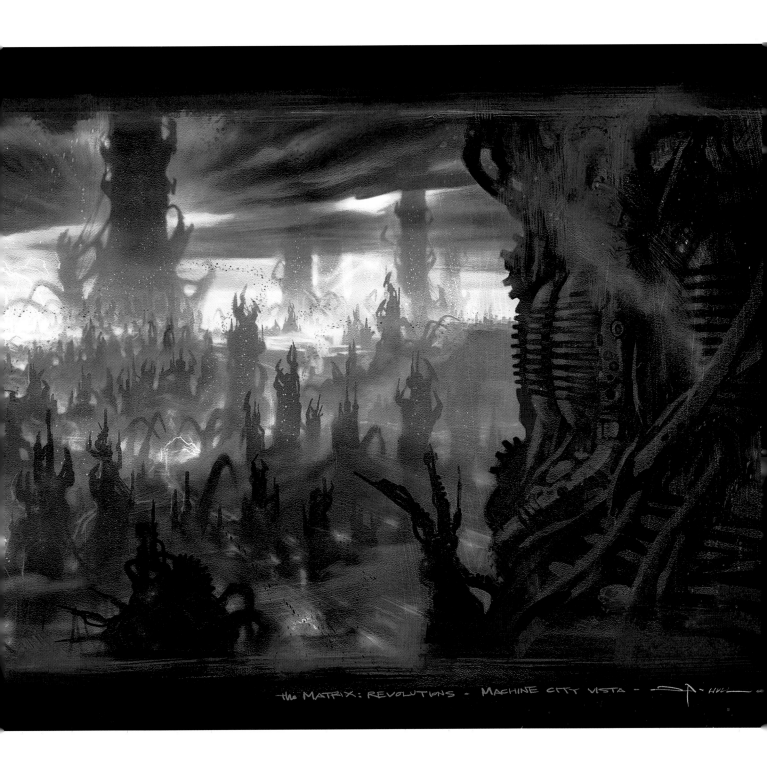

the MATRIX: REVOLUTIONS - MACHINE CITY VISTA -

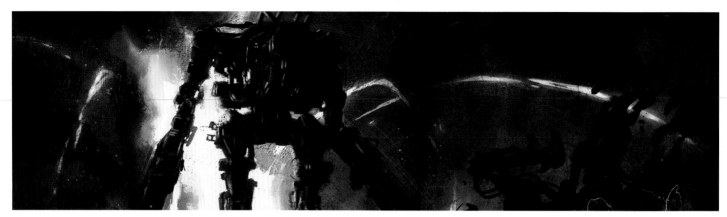

MATRIX REVOLUTIONS: APU BATTLES SENTINEL

Concept art on the Matrix films

During the production of 'Matrix Reloaded' and 'Matrix Revolutions', there were hundreds if not thousands of drawing made in the art department. I worked closely with the directors and production designer Owen Patterson and many other artists to help visualize the futuristic world. The Wachowskis had amazing ideas and could articulate them very well. I was simply asked to draw and paint whatever the directors needed to pre-visualize their story. In all honesty this was a dream project for an artist like myself. I grew up fascinated by the visuals and ideas in films like 'Blade Runner', 'Alien', '2001', 'Ghost in the Shell' and sadly not many more. I wished more storytellers could approach science fiction with adult themes and intelligent ideas. Looking back, I feel my skills grew over the course of the film because I was such a fan of the material as well as the people involved.

The process

The first step is always to read the script. A good drawing or painting is one thing, but the goal of a good conceptual artist is to create the best visual to further the story idea—especially when creating key-frame paintings that are meant to be decisive moments in the film. Often, I'd start by reading the script and highlighting the dramatic scenes. I would take down notes from the script that reflected visual cues and write ideas along the way. Next, I would meet with the directors and they would describe a design or scene more specifically. Sometimes we'd thumbnail around an idea, composition, design cue etc. I'd then simply start sketching and refining until the design goal was achieved.

The Battle to Defend Zion

In the script, the directors called for humans to defend their city of Zion from attacking Sentinels with APUs (Armored Personnel Units). Storyboards and 3D animatics were being done, but nothing to describe the lighting, color or mood. The directors didn't ask me for this one—I simply had an idea that I wanted to explore. I asked myself how I envisioned the scene in my head, and what would make it dramatic? The goal of the artwork was to place the APU in a battle scene with interesting lighting and mood, highlight the heroism, and explore a visual style. I had an idea of combining some cues from Japanese Anime with the action in the script and that got me started.

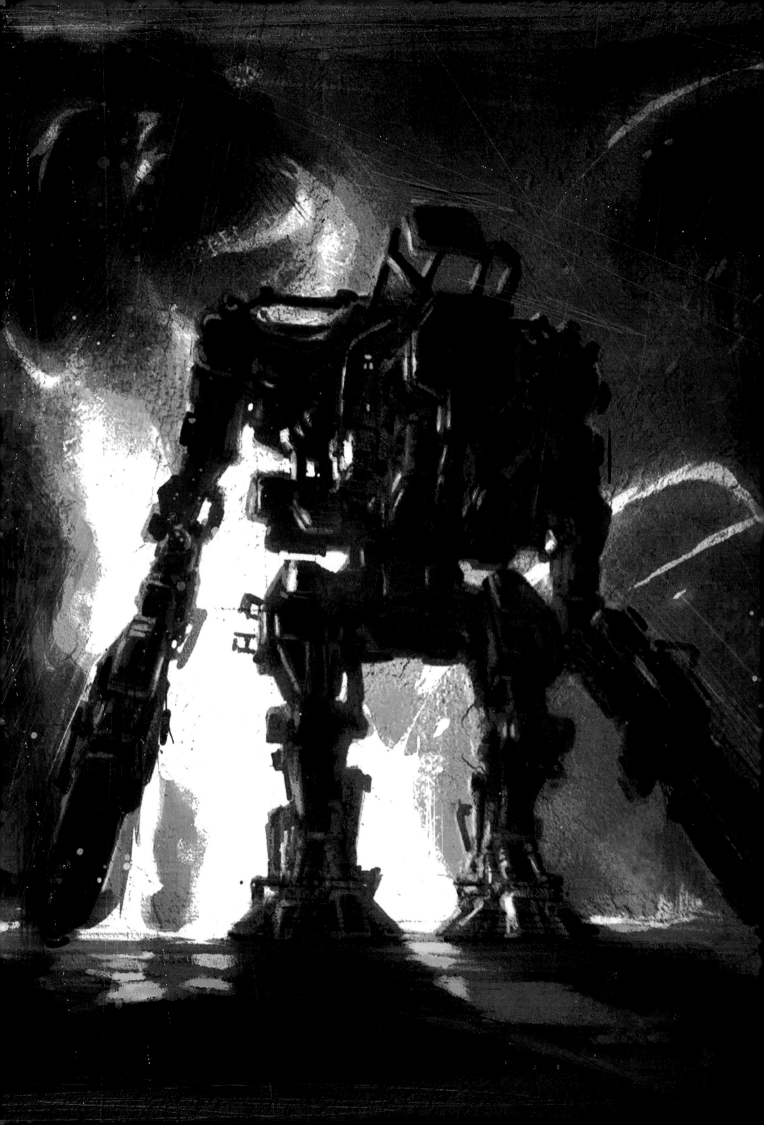

Starting

From the beginning, I know I want to show the character (APU) from a low angle (heroic), and backlit from an explosion. I wanted the explosion to look stylized and graphic, not photo-real. Perhaps the VFX crew could use it as inspiration for a 3D anime aesthetic. The first thing I did was establish a horizon line and perspective. Next I used the Gradation tool to fill a simple background. Then I forced myself to paint in an explosion with only three tones and no blending for the graphic 2D look (Lasso and Fill tools).

Blocking in the character

Using a standard hard brush, I drew in the APU with flat strokes. At this point, I'm only looking at the silhouette and the composition of the fire behind. I tried smaller sizes to make the explosion look big, but decided on this size so the focal point stays on the APU.

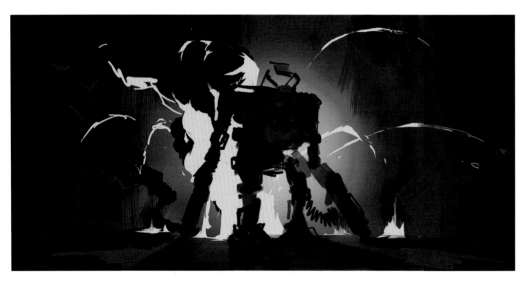

Blocking in the explosion

I used the Lasso tool to simply draw out the shapes I wanted for the explosion tendrils, and filled them in with the yellow fire color. By filling in this way, it gave me a more graphic 2D aesthetic. It is also a fast way to block shapes in without worrying about edges or brush strokes.

Painting in the APU values

Now I am ready to start painting in the shapes and rough forms of the APU character. I know the local color of the APU will be a de-saturated metal tone, so I'll use the warm palette of browns, sepias, umbers and oranges. I start by filling in the dark shapes and blocking out the lighter ones.

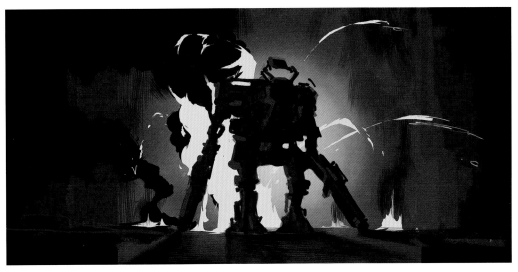

Exploring value and color contrast

Even though the dark APU in front of a lighter background was working, I knew the battle scene in the film would most likely be dark. The mood should be ominous and aggressive—Sentinels could attack out of the dark at any moment. So the palette might be blood red and high contrast to psychologically heighten the tension. I darkened the background but as expected lost the dark APU. I then added some light glow behind his shoulders to keep him forward. I also looked at adding more cool tones as complementary hues of the red background.

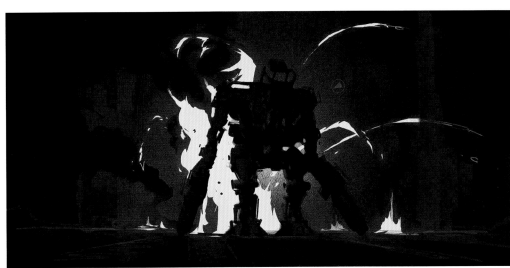

Extending my canvas

For a better composition and film format, I needed to have a wider canvas. I should have started this way, but I was in a rush. I simply copied my background and pasted it over. I also extended the tendrils and created an area for a destroyed Sentinel. Lastly, I tried to push the limits of how saturated and graphic I could make the image. Yikes, the red is way too cool—or too magenta! Even this was helpful to explore and see it break early on.

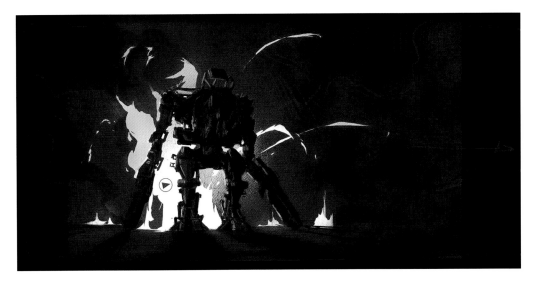

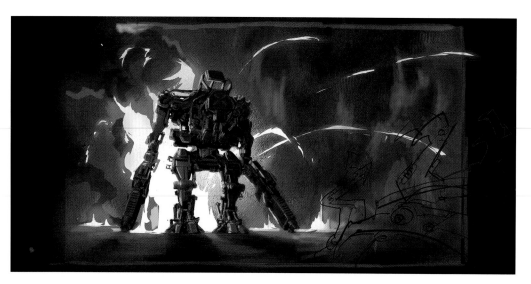

Working with the APU lighting

First, I needed to get rid of that awful red/magenta color. It is easy to get too saturated too quickly. Since this painting was done so early on in production, I was really making it up and discovering as I went. Next, I started painting in the edge lighting from the light source behind him. I quickly sketched in a fallen Sentinel to start thinking about the best pose.

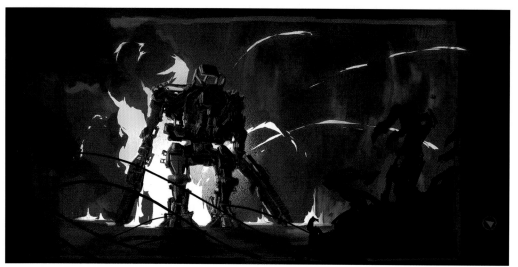

Blocking in the Sentinel

Using a standard round brush, I drew in a twisted fallen Sentinel carcass as an extreme foreground object. I used black to give me maximum contrast up front, that I could later tone back.

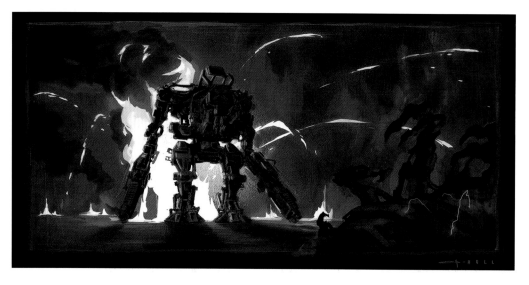

Roughing in Sentinel lighting

After the Sentinel silhouette was blocked in, I needed to model some of its forms and give it definition. But, not too much to keep the visual hierarchy on the APU first, then the foreground. I could have cast warm light from the explosion on it, but I wanted a reason for a temperature change. I decided some cyan blue electricity coursing over the ripped open carcass would work. Plus it makes for a good visual cue to add in CGI.

Judging the value composition

At this point all my major features are together, so I need to dial in the right values and color choices. By looking at a flipped black and white version, I can take a new look at my image. I see that the value range is too shallow or limited. For more depth, there should be a layer of atmosphere between the foreground and the APU. Also, the fire could have more contrast and a whiter core.

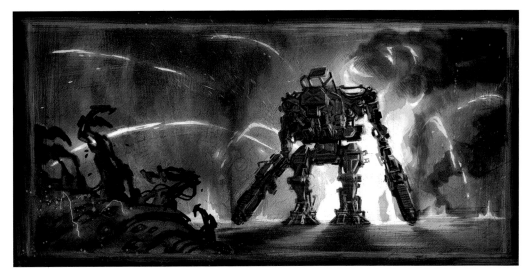

Adjusting the explosion color

Here I'm struggling with my palette because I didn't have a clear idea when I started. My problem is to get a range of hues within an image I've already detailed monochromatically. I know I want the highest degree of color and value contrast at the focal point. In order to make the explosion feel hot the surrounding areas need to be cooler. So I tried taking out some warmth of the background and painting in more yellow at the explosion's hottest areas. Then I used Color Dodge very lightly to punch it up, but only in the hottest sections.

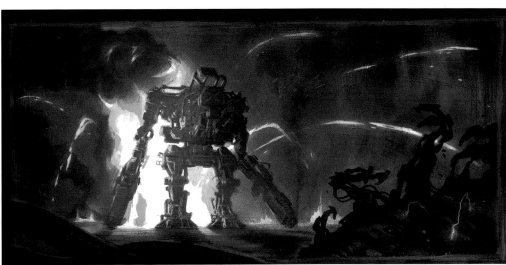

Finishing

I could add more and more detail to the APU and Sentinel as both are very rough. However, the basic idea and visual goal were reached and I knew things could change easily on the film, so I didn't want to waste time. I spent the last few minutes on the warm color wrap around the APU legs like a building behind a bright red sunset. I was happy to learn the directors liked my visual concept and I later refined the graphic look during the post-production stages of the film.

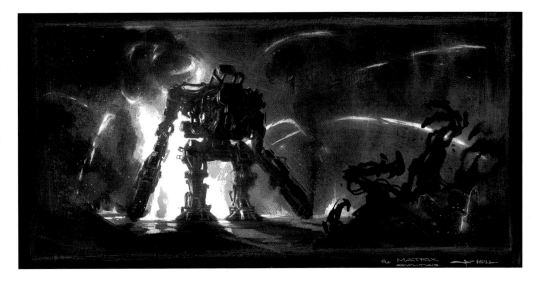

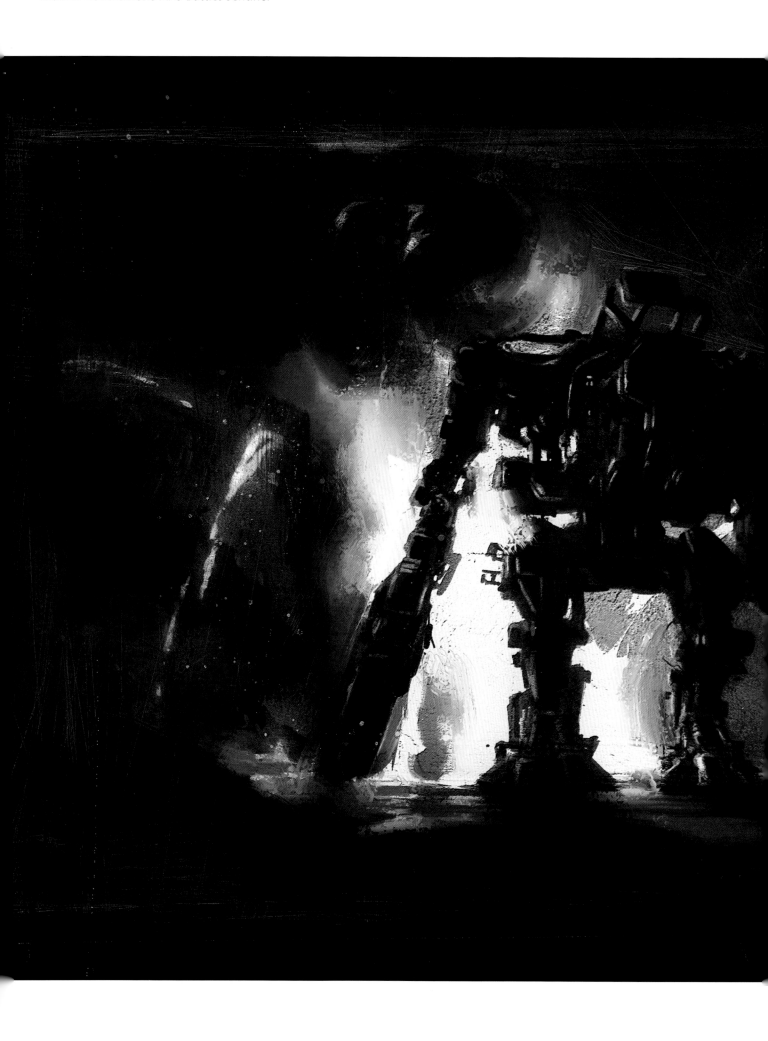

the MATRIX

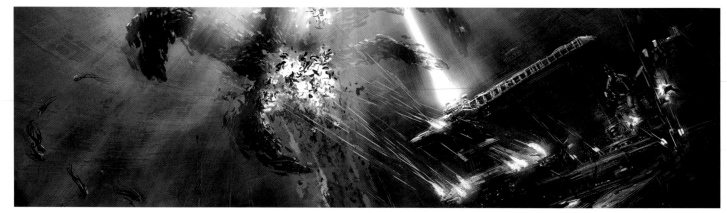

MATRIX REVOLUTIONS: HAND OF GOD

Concept art and art direction for VFX

As previously mentioned, there are three stages of film making: pre-production, production, and post. Generally, pre-production is the process of designing the film from scratch. This involves working closely with the director and helping him/ her to visualize the script. Production is the actual filming of the actors on stages or on location. Post involves the implementing of visual effects, sound etc. Typically, most concept art is done in pre-production because the movie needs to be visualized before the cameras start rolling. First and foremost, sets must be designed so that they can be built on the stages. Next comes the props, vehicles, costumes, characters, and anything else that needs to go in front of the camera. Large visual effect elements such as ship exteriors, CG landscapes and the like are only loosely designed during this phase—just enough to depict the basic ideas and to budget the work. With so much to do in getting a film ready to be shot, the artwork for post-production is fairly rough. This applies even for a massive FX film like the Matrix. A visual effects company tasked with executing complex computer graphics often needs additional artistic support. This is the job of a Visual Effects Art Director—to take the base concepts in pre-production and elevate the look into its final look. This is also how I began my career in film design at ILM back in 1993.

The process

VFX concept art is basically a more refined version of pre-production art. This refining can happen over and over again until the artwork represents as closely as possible the desired look of the final computer image. This artwork can then be given to VFX lighters, layout artists, modelers and sometimes even animators to help them visualize their task. This is a collaborative process where many people are adding to what will be the final still image. For this reason, I was initially hesitant to include this process in this book, but it is such an important VFX process that I thought it might be helpful. I would like to credit the fine talents of the ESC modelers and texture artists who supplied me with the base image which I then used to paint the following artwork.

The Hand of God concept

In Matrix Revolutions, Zion is an underground fortress and the last refuge of the human race. The protagonists are a machine race that attack with massive swarms of Sentinel machines. The directors wanted a scene where the machines swarm together to form a unified collective consciousness. A mass weapon to attack Zion's defenses. I knew this was a key moment of the sequence so it had to look dramatic. The shot was in development so most of the assets were still being created. I knew if I could paint a target image that the directors and supervisors could agree on the production and crew would run much faster. Less trial and error could mean weeks of time saved. I requested a simple rendered background frame, and then painted on top of it. I could explore how I thought it should be visualized in just a few hours. This process is essential for any VFX Art Director.

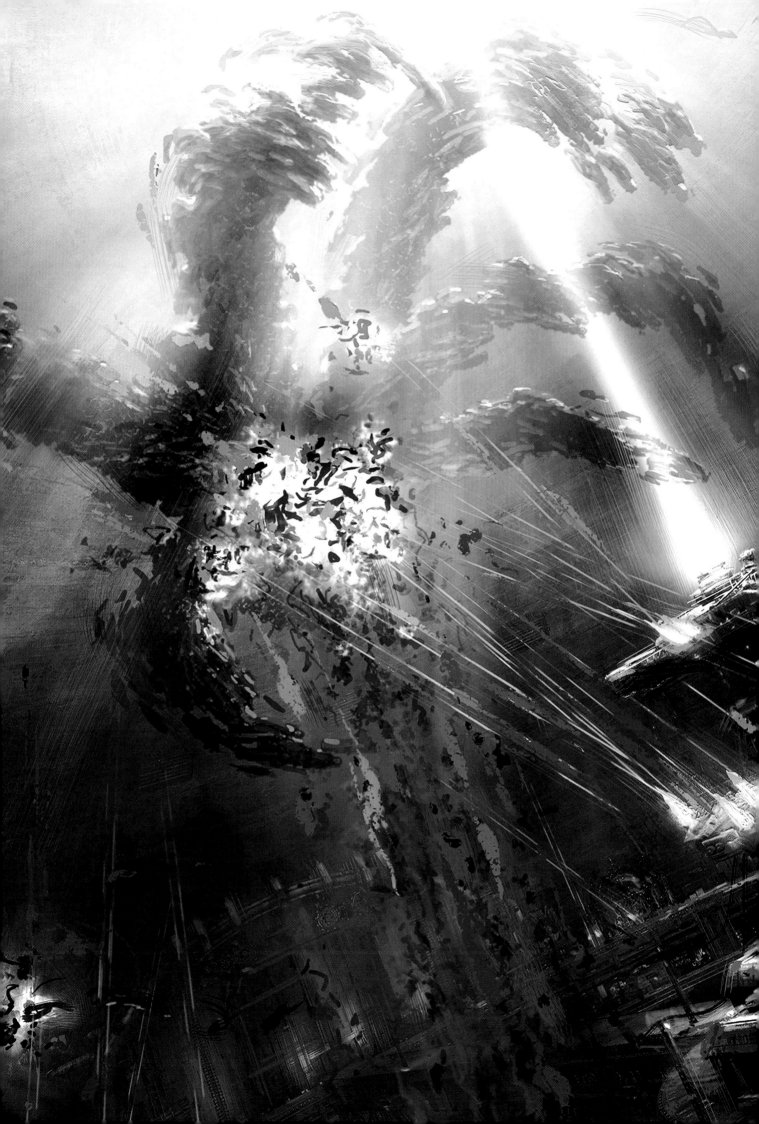

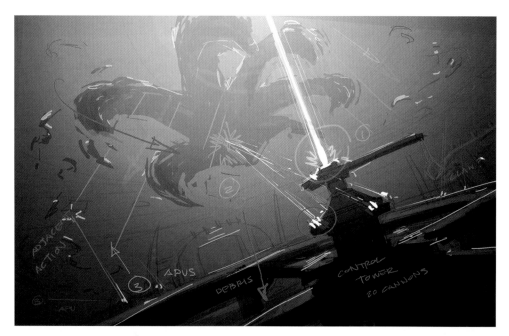

Starting

My first step is to look at the script and/or storyboard and read the scene as it is described. It is easy to jump into the hundreds of elements and lose track of the controlling idea—especially in computer graphics where the mindset is primarily on the technical execution of a shot. It is important to ask yourself "What is the most important idea and feeling that needs to be conveyed?" Since most shots are only a few seconds, it has to read immediately. Use this answer to judge all other decisions. In this case, the attacking machine swarm is about to strike Zion defenses. It must look ominous, deadly, and impossible to escape. But, it could look slightly evocative like a dark tornado backlit by the sun. This is the time to research and think creatively.

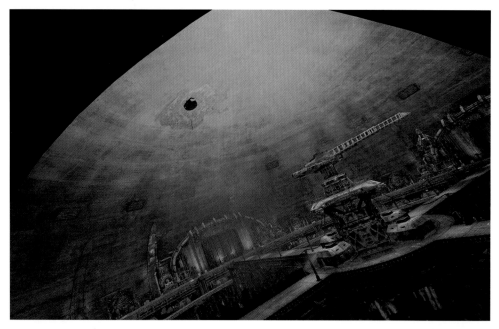

Rough sketch

Before getting too detailed too fast, start with a fast sketch. This shouldn't take more the 5 to 20 minutes max, depending on the factors you are trying to sort out. I almost always have the same set of questions to solve. Based on my answer to the question above, I typically ask these questions: "What kind of mood should there be to support the central idea (CI)?"; "What is the established light source?"; and "What can I do to make it support the CI?". Same for the palette, composition, contrast and most importantly, the focal point. The first panel is my rough sketch to sort out the camera position, and basic elements. I then took this sketch and asked for a rendered frame of the background to paint over.

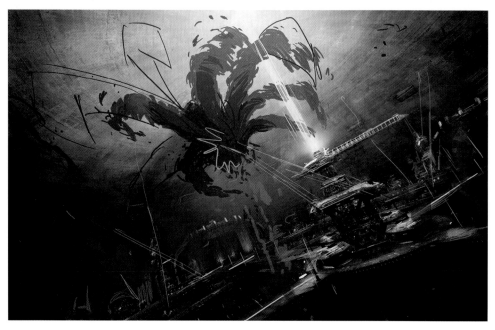

Blocking in the main elements

First I had to paint in the main light beam. I drew a selection of the shape, feathered it and painted it in with white and blue. Using Levels and paint, I created a gradation of light from the center dome outward. On a new layer, I blocked in the shape of the machine swarm. It needed to look like a vicious claw, but not overly literal. I used some reference from the 3D swarms in progress at the time to refine the shape of the painting. I wanted the silhouette to look like a single claw, but still have enough individual shapes to show it was made up of thousands of smaller machines.

Building layers

At this point, I know what the end image needs to look like. I can begin building my layers from back to front. I know that I will have the defensive guns shredding the Sentinel swarm. There will be cement and metal carcasses raining down from the epicenter of all the gunfire. I know that I'll need some light values behind the debris for it to stand out. I decided to use the smoke and cement for this purpose. I blocked it in here with a textured brush.

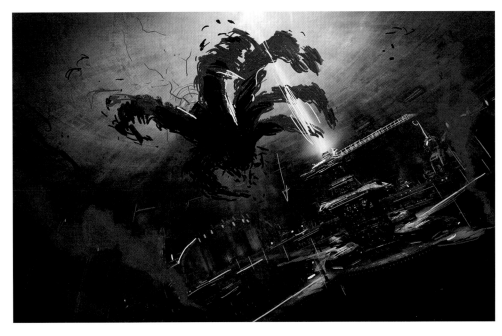

Blocking in Sentinel shreds

Using a round brush, I painted in crude shapes of silhouetted Sentinel shreds. For the story point to read quickly, the center where the Sentinels are getting hit needed to be clear. This is why the "Hand of God" is forming: in order to divide/split the gunfire long enough to reform into an attacking serpent. I chose my contrast level accordingly, and painted in a bright epicenter with more saturated hues than the rest of the image.

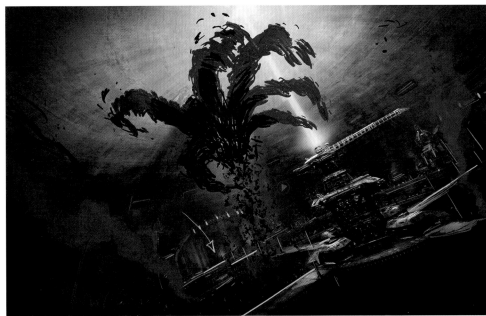

Blocking in gunfire

Using the Lasso tool, I drew out the shapes I needed for straight tracer lines and muzzle blasts. I painted them in using yellow first then orange. After erasing out the separations of tracer lines, I used Color Dodge to give a little more glow. Also at this stage I added some dark smoke and grit to the scene.

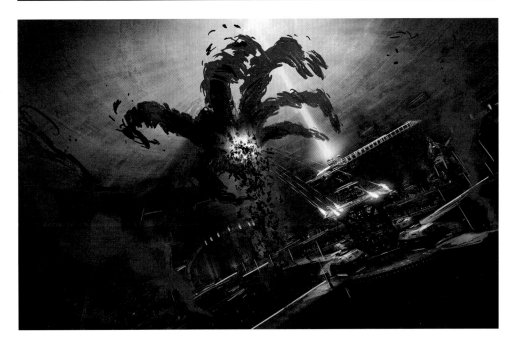

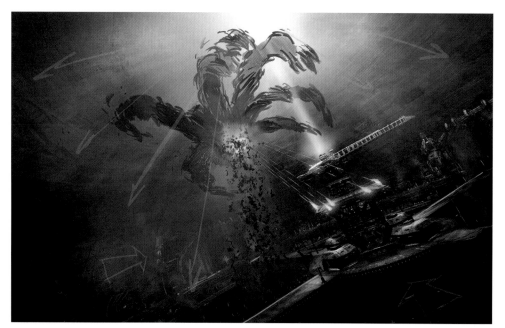

Painting atmosphere

Using a soft 500-pixel brush, I lightly painted in some atmosphere with medium to dark tones instead of light tones. I tried it with light values first, but I found my mood was losing its oppressiveness, and looking too calm. I remembered my first rule and started over. I then figured with all of the blasting and destruction, you could justify dark soot and smoke filling the air. This would help the mood and also justify the visually wonderful, and often overused, light-rays.

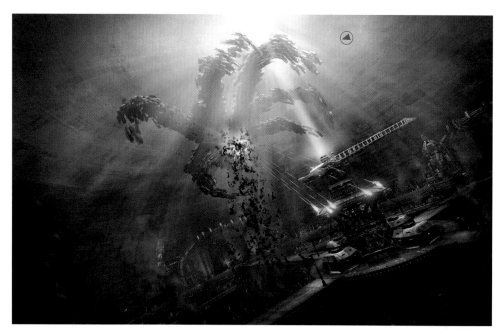

Painting in light-rays

Using a large soft brush first, I painted straight lines for the light rays. I then used a textured brush for harder lines and painted in separations. I thought of how a tree separates sunlight in a morning fog, or one of the many cinematography moments that every professional has stored away in their brain as reference. It's not particularly well painted here, but just enough I felt.

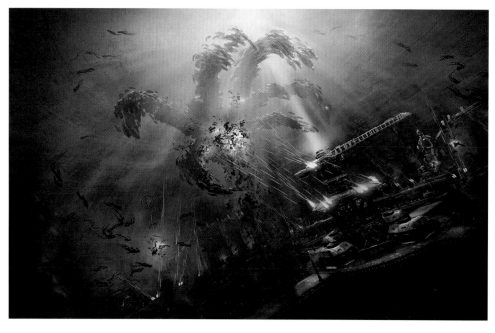

Adding surrounding action

Using a standard hard brush, I drew in other Sentinels flying, attacking and getting hit by humans in APUs. I knew that painting in a lot of detail for this would be unnecessary as the main issue was the Sentinel swarm. So I quickly sketched in the action for a fast impression.

Painting impressionistic vs. detail

Even in advanced key-frame painting for visual effects, it is still important to keep a gestural, and loose quality to your work. I find that having detail everywhere doesn't mean my artwork will be more helpful to the VFX crew. You might think otherwise, if it should look like the final frame of CGI. But, when I study frames of real photography I find reality is far less detailed than most VFX artists want to believe! This artwork should help in that effort. I aim for a transition from impressionistic to detail painting from the borders to the focal point. The same goes for contrast of value and color if possible. These things all help to sell the story idea and CI as fast as possible. With detail everywhere the eye can get lost and swim around the image looking at "detail" but not reading the idea.

Adjusting color temperature

Using Color Balance and a soft wide brush, I glazed in some warm tones to complement the aquamarine blue glow around the light source. My palette is mostly determined by the set design or film photography. The Zion docking bay was designed as de-saturated concrete and metal, so I used a small amount of saturated color in the light sources for color contrast. As all painters do, I look for warm shadow colors in cool light, and vice versa. Also, painting complementary colors at the focal point will also help draw the eye where it needs to go.

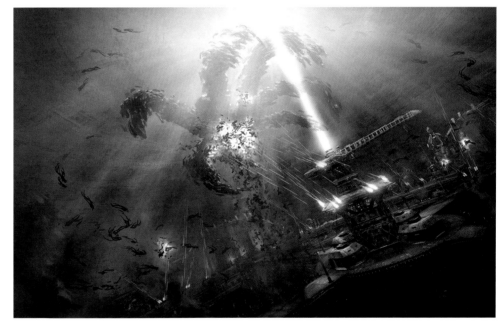

Finishing the "key-frame" painting

When finishing a painting, I remind myself of the controlling idea, and ask "Is it reading?" and "What can I do to improve it?". I'll work all over the image looking for areas to pull forward or push backwards to maximize depth and highlight the focal point. Painting highlights and cast light over surfaces will make the object stand in front. If the object is dark and I want it to pull it forward, I'll look to add some lit smoke or steam behind it. If the object is too flat, I'll use light or dark atmosphere to graduate the value. Honestly though, I painted this image just enough to get the idea across and moved onto the hundreds of other VFX shots that needed attention.

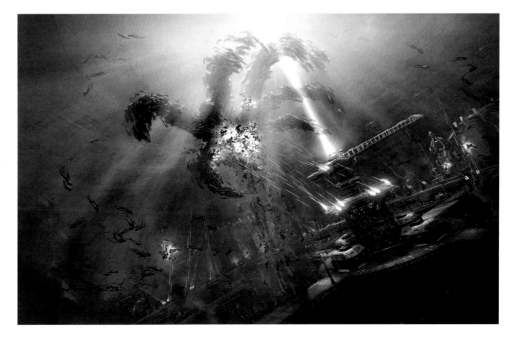

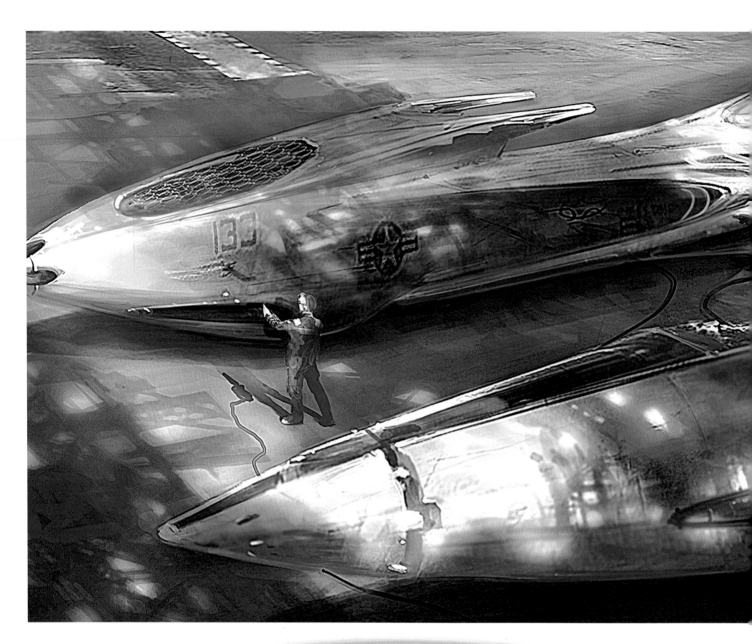

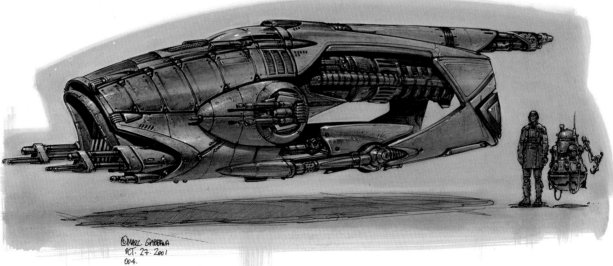

Preparing for Race
Photoshop
Jung Park, USA [top]

George Hull
The lighting in this artwork drew me in right away. I like the scattered light and shadows from overhead trees or foliage.

The soft shadows and treatment of the ambient light is handled well. I'd like to see the same level of observation applied to the vehicle designs and details. Perhaps in the landing gears or if there were a few engine hatches open. Something to tell me these fantastic forms are still machines. It is still great work!

Big Daddy
Tria inks, Prismacolor markers
Marc Gabbana, Iceblink, USA
[above]

George Hull
I love the look of Marc's concept drawings; just pen and ink and probably

done in an hour or so. This is a very important part of concept art—fast exploration of forms and design details. Without jumping into the rendering or Photoshop stage, this is still the best way I know of to really work out a design—especially for mechanics and vehicles.

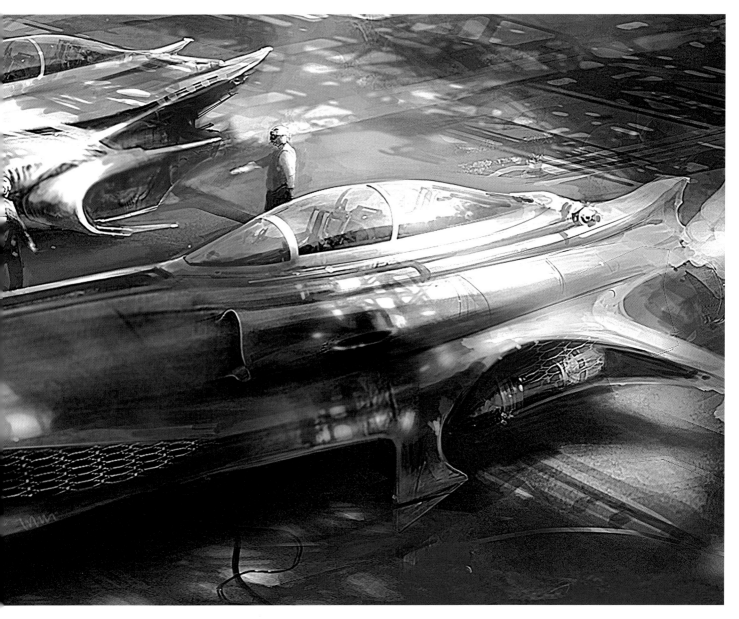

Lucky13
Tria inks, Prismacolor markers
Marc Gabbana, Iceblink, USA
[right]

George Hull
I love Marc's line work and simple marker sketching. The lines have different weights, and the marker tones are limited to two or three values. The design is very solid with a dynamic silhouette. I like his indications of mechanical realities: joints, cooling fins, hydraulics. All these help make this wild form look more believable.

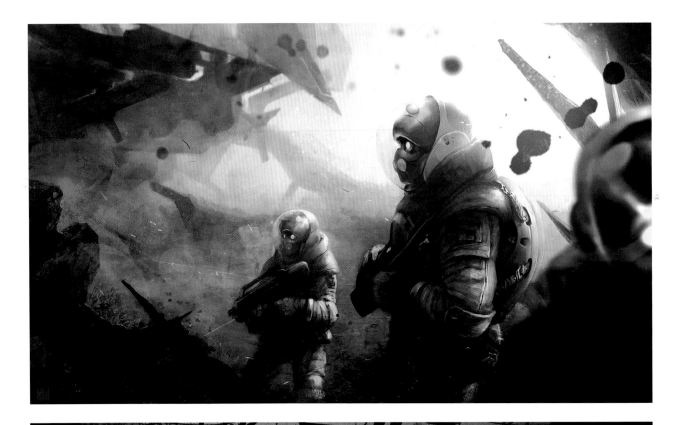

Explorers
Photoshop
Thierry Doizon,
Steambot Studios, CANADA
[top]

George Hull
Thierry has done a great job of making this art feel like a moment in a film—right down to some dirt on the lens and depth-of-field camera lens effects. Nice color palette and abstract background shapes as well.

Industry 9
Photoshop
Ales Horak,
CZECH REPUBLIC
[above]

George Hull
Ales has done a great job in making me want to look into this image. My eye travels all around, and I still wonder if I'm seeing some mountains in the background. Nice texture work and atmospheric perspective.

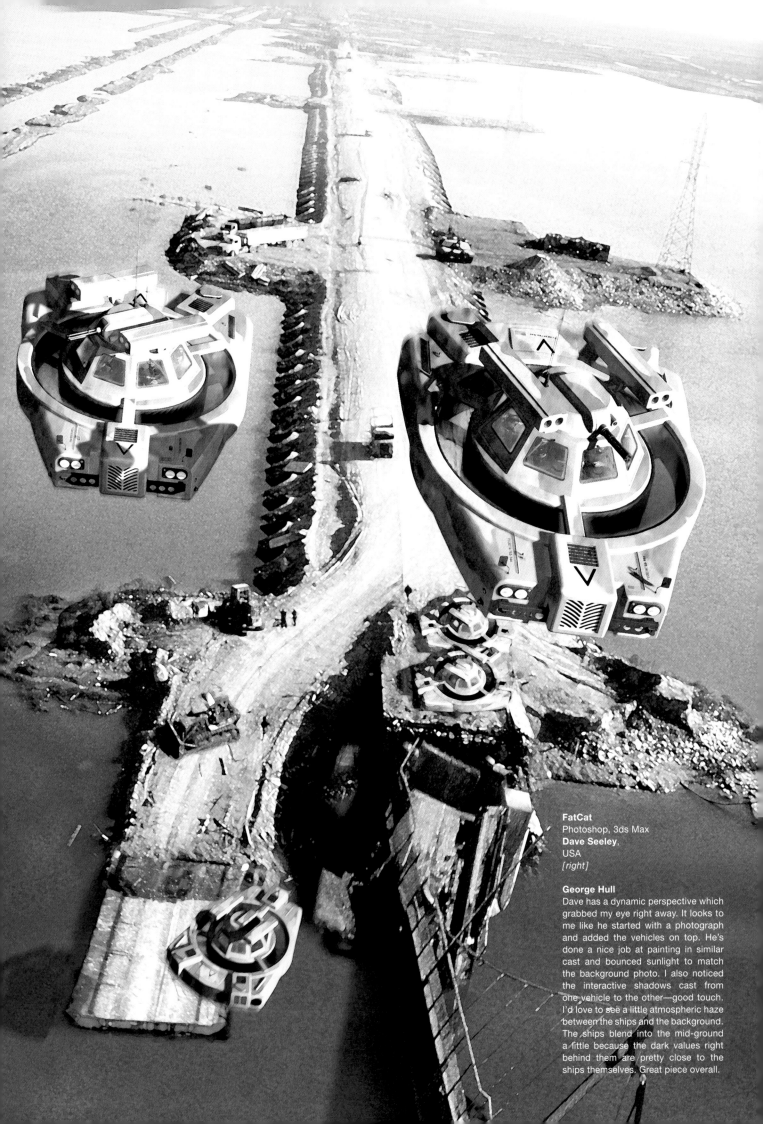

FatCat
Photoshop, 3ds Max
Dave Seeley,
USA
[right]

George Hull
Dave has a dynamic perspective which grabbed my eye right away. It looks to me like he started with a photograph and added the vehicles on top. He's done a nice job at painting in similar cast and bounced sunlight to match the background photo. I also noticed the interactive shadows cast from one vehicle to the other—good touch. I'd love to see a little atmospheric haze between the ships and the background. The ships blend into the mid-ground a little because the dark values right behind them are pretty close to the ships themselves. Great piece overall.

Puppet II
Photoshop
Client: Guild Wars Factions
Daniel Dociu, Arenanet, USA
[top left]

George Hull
The pose for this character sketch is very dynamic. The twists in the forms are great. For the rendering, Daniel has a nice palette of warm and cool colors. His warm key-light and cool fill-light give a great sense of volume to his design.

'Lux Lucis' character studies
Photoshop
Chris Thunig,
GERMANY
[above]

George Hull
I love the use of simple lines and basic lighting in Chris's art. He has a great technique for sketching ideas quickly but still communicating a lot. From his drawings, I can tell he's thinking about a story and relationship between the two characters.

Snake
Photoshop, Painter
Maciej Kuciara,
POLAND
[top right]

George Hull
The rendering of this character sketch is really wonderful. I love the painterly brush strokes and muted palette. I get the impression that Marciej sketched this out directly in paint because of its loose and fluid marks. The attention to hard and soft edges is particularly well done.

Wild Jasmine
Painter
Hong Kuang,
SINGAPORE
[right]

George Hull
The detail in this piece is amazing. The artist is pretty inventive with his forms and details. Instead of using typical designs for motorcycles or speederbikes, Hong has created something very unusual—not an easy task. I think I even see a turntable and circular saw in there! Nice work!

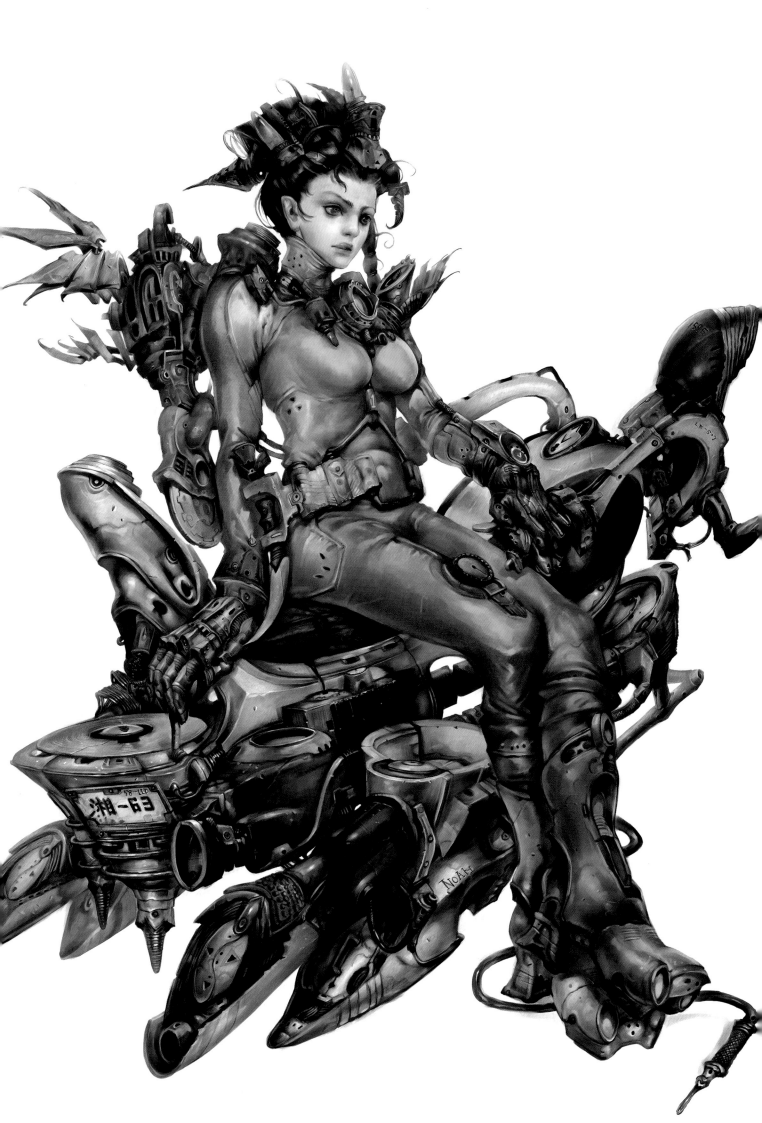

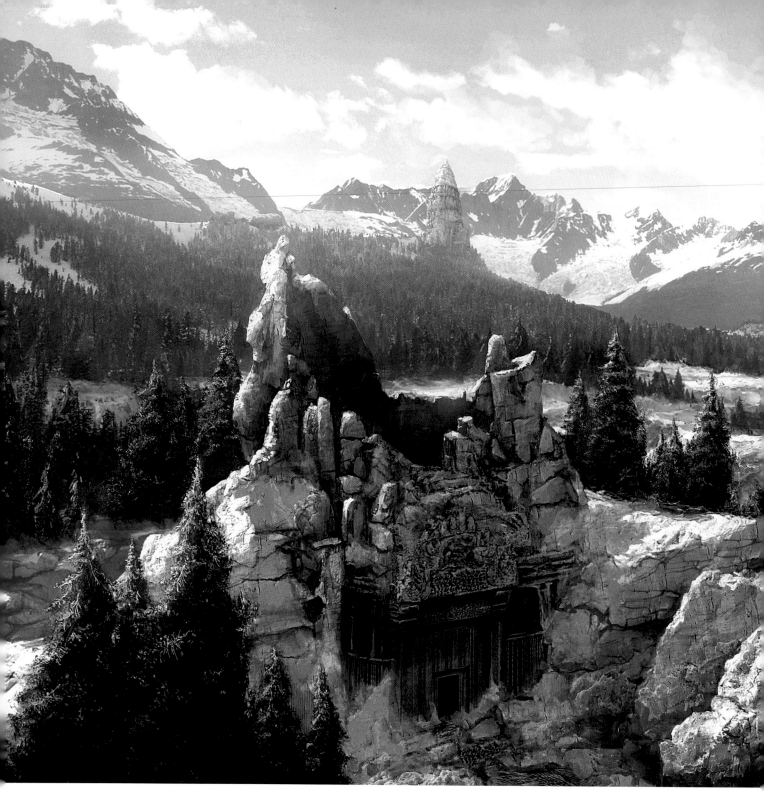

Frozen Ruins
Photoshop
Shane Roberts, USA
[above]

George Hull
Shane's painting is very captivating on both a conceptual and technical level. I'm intrigued by his juxtaposition of Asian temples set in a Siberian or Alaskan landscape. The composition draws me into the frame from left to right and my eyes pan around the frame enjoying all the details. But, the focal point is still easily readable. The painting of the white snow shadows is particularly amazing. For a full daylight scene filled with forms of bright white snow and lots of bounced light into the shadows, Shane chose a difficult subject. But, the result is quite impressive.

Futuristic cemetery procession
Photoshop
Emmanuel Shiu, USA
[right]

George Hull
Wow! This painting looks like one of Albrecht Bierstadt epic landscapes—mostly in the bright sun and lit atmosphere. This has a wonderful sense of scale. I am most intrigued, or maybe frightened, by the idea of this concept. It looks like Emmanuel is imagining a funeral procession of some futuristic Christian dictator! To me a compelling idea is the most important aspect of conceptual art, more than having good technique. Very impressive work.

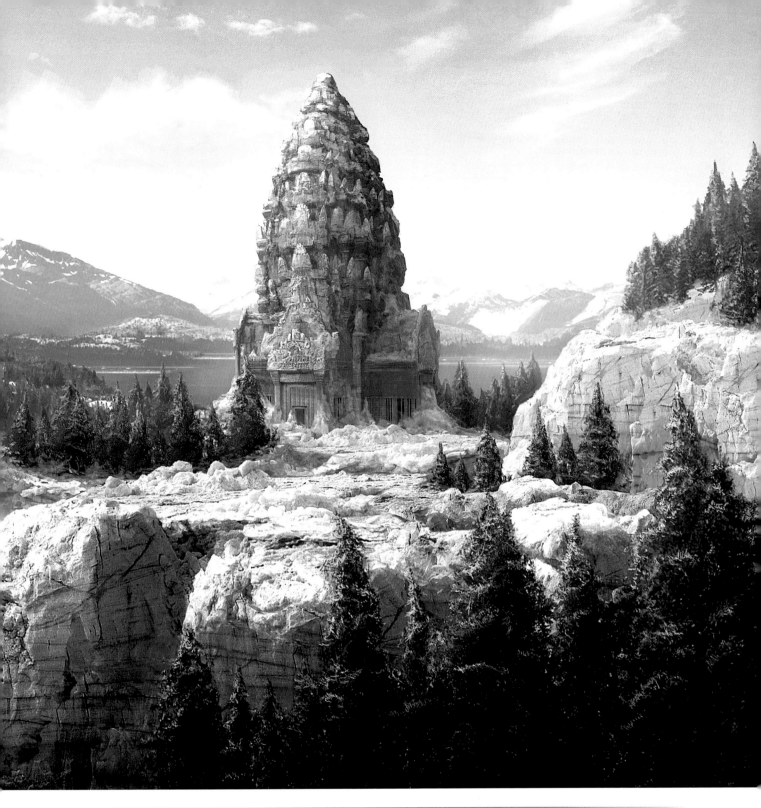

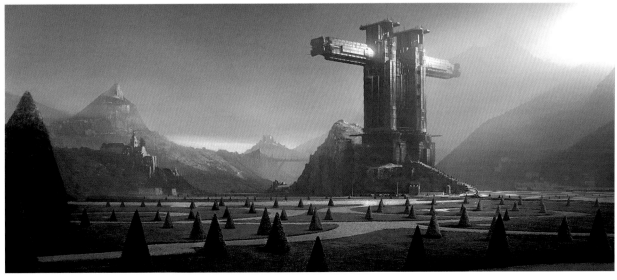

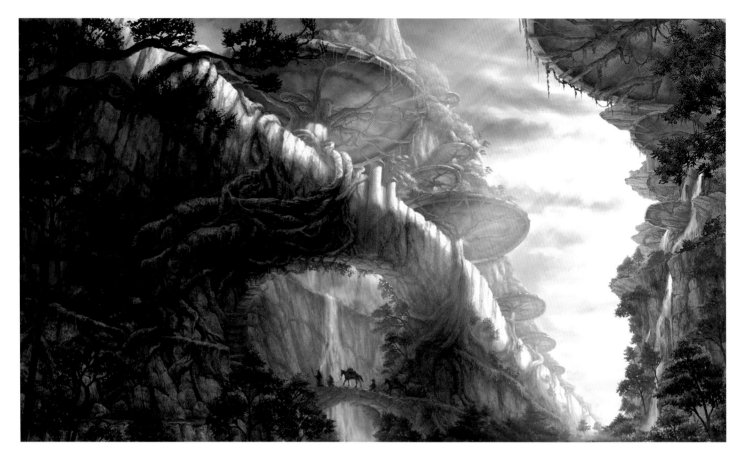

© Automatic Pictures

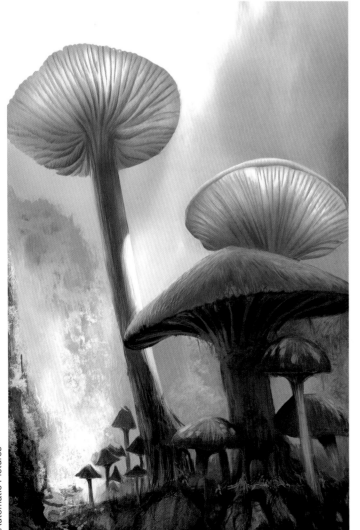

Fantasy Forest
Photoshop
Sung Hoon Park, Webzen Inc,
KOREA
[above]

George Hull
Sung Hoon has a very nice composition with this piece. Left to right with a strong diagonal. The repeated mushroom shapes add a nice sense of distance and depth. Even though the figures, bridge and waterfall all line up together, he has kept the lighting subtle and low contrast.

The valley of mushrooms
Photoshop
Brian Flora, USA
[left]

George Hull
Brian has a great sense of lighting in this piece. I like how the mushrooms are in shadow, but the tall ones reach up into the light. The back lighting creates a great mood and the painting technique is fantastic. I love the mixture of brushes and textures. Even with a simple mushroom environment, Brian makes it look dynamic and way too easy.

Ascalon City
Photoshop
Client: Guild Wars Factions
Daniel Dociu, Arenanet, USA
[right]

George Hull
This piece by Daniel caught my eye because of its great brushwork. It looks like a conceptual of a giant fortress or castle wall. The idea is straight forward, but the execution makes this image so interesting to me. I get a good sense of scale and basic design. I like how it is not labored, and I can see the hand still within the digital medium. Great work!

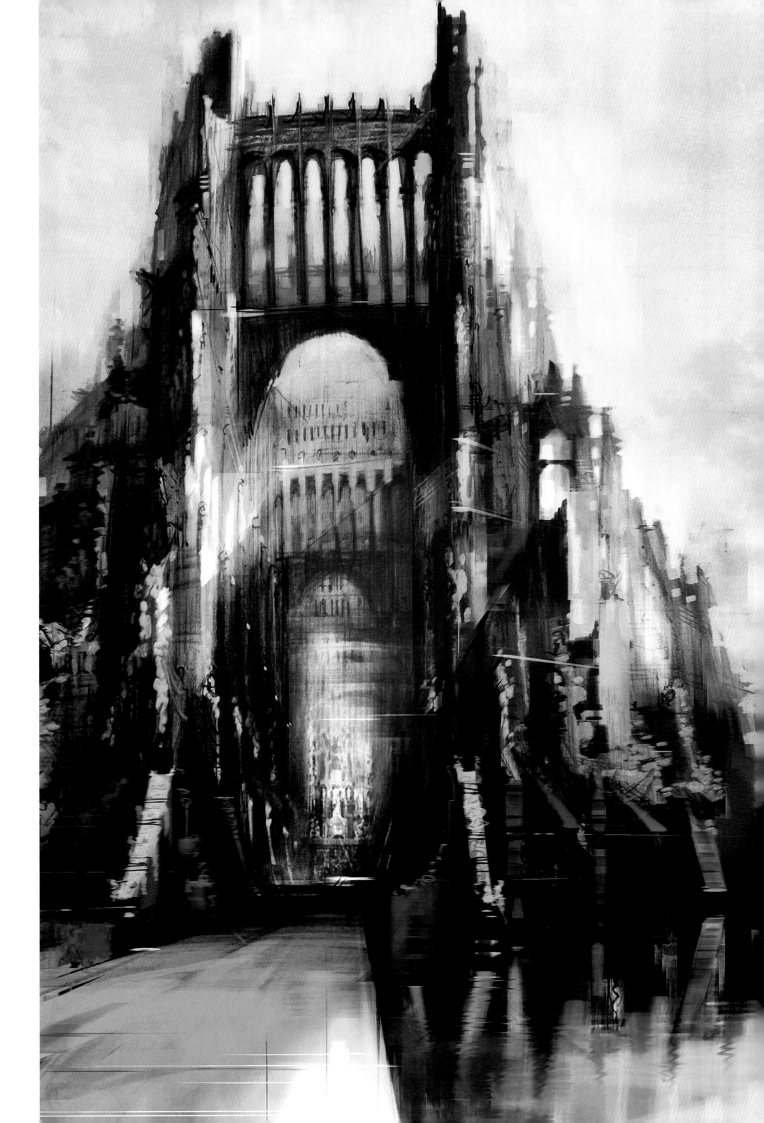

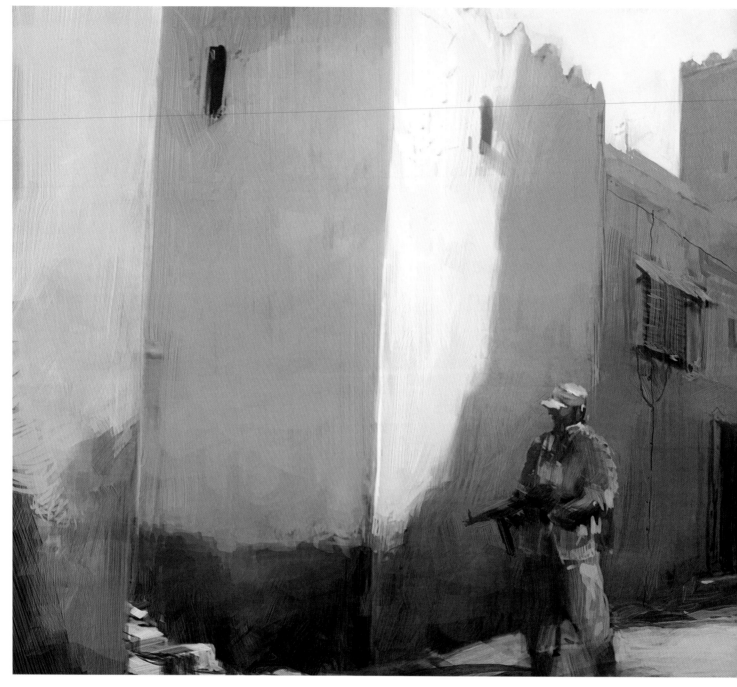

Armoured Advance
Painter, Photoshop
Client: Forgotten Hope
Evan Shipard, AUSTRALIA
[above]

George Hull
I love how this painting looks like a
scene right out of a film. It looks like
a fast color sketch, without the details
that aren't necessary to communicate
the idea. Nice cast lighting design and
atmospheric depth.

The Forgotten
Painter, Photoshop
Evan Shipard, AUSTRALIA
[right]

George Hull
Evan has painted a wonderful color
sketch that feels very cinematic. Nice
simple composition for the eye to easily
follow. I love his painting sensibility. He
can make even this calm scene look
interesting. No robots, no guns, just light,
shadow, and an old church. Very nice.

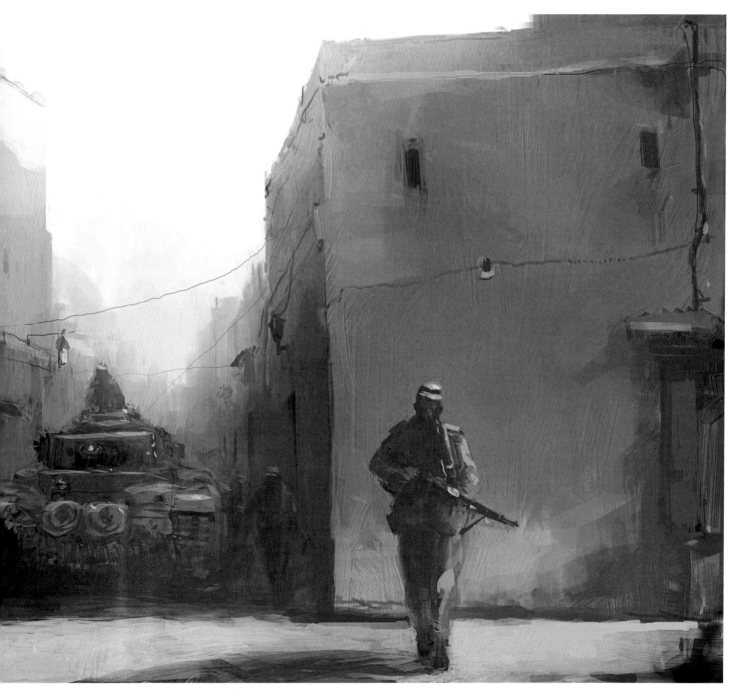

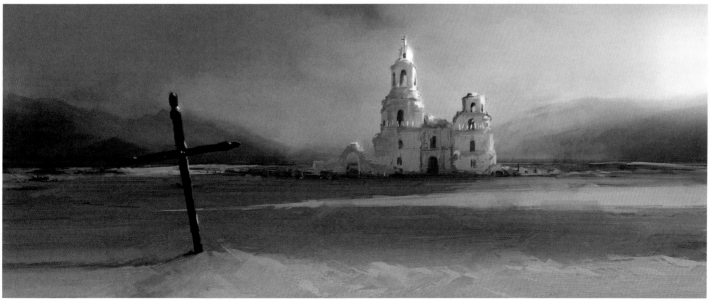

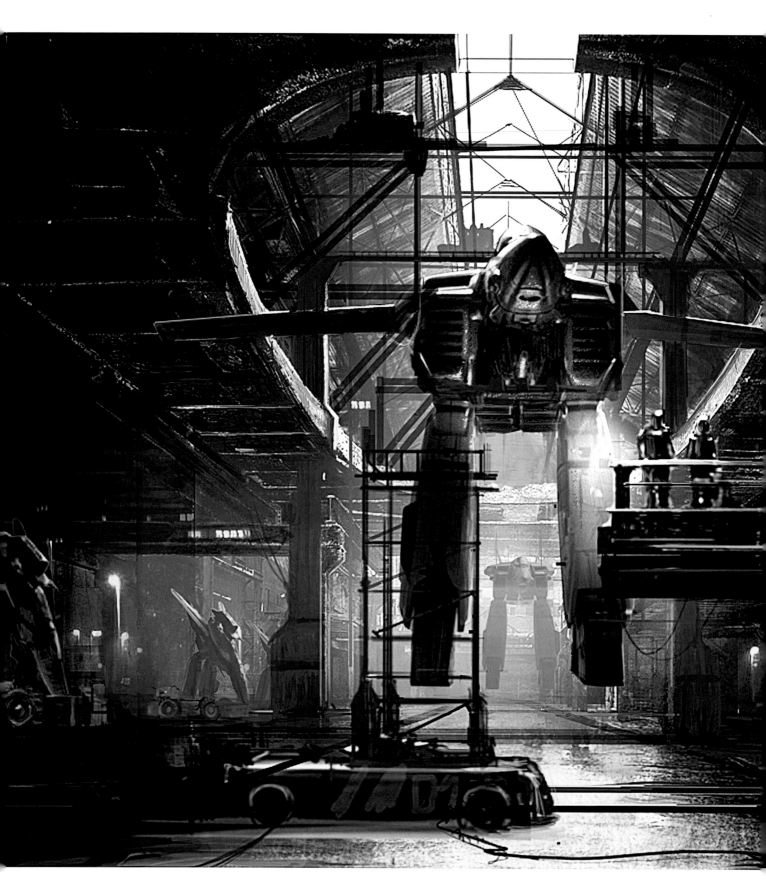

Base
Photoshop
Emmanuel Shiu, USA
[above]

Environment: Deadwood
Painter, Photoshop
Daniel Kvasznicza, I-NetGraFX, CANADA
[top right]

George Hull

Emmanuel has a great sense of depth in this conceptual. The image pulled me in with the atmosphere and receding color tones. I like his graphic layout and overlapping shapes. This all helps make the hanger he has illustrated look big and impressive. Nice work.

George Hull

Daniel has a great composition here with this piece. My eye nicely flows around the image because of his great design choices. From the Cross to the flying creatures, to the background towers, all are perfectly placed. I love the dramatic cloud and sky as well. Great work.

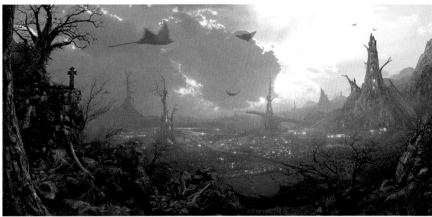

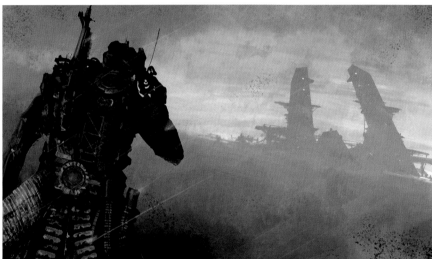

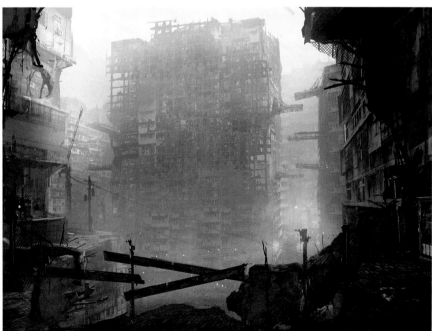

Scout
Photoshop
Kan Muftic, streamatica, SWITZERLAND
[center right]

George Hull
I like how simple this image is—but it still communicates
the visual idea quickly. Even though there only a few values
and a monochromatic palette, it still has atmosphere and
depth. Perfect technique for a fast-painted storyboard.

Slum city siege establishing
Photoshop
Jung Park, USA
[above]

George Hull
This painting grabbed my attention. I can imagine a story
taking place in this eerie environment. Jung is thinking about
the way people might live and cross on the makeshift bridges
from building to building. Very nice atmosphere and depth.

ANDREW JONES

Andrew Jones is the Creative Director of Massive Black, a high calibre outsourcing studio for the video game industry. Andrew's vision has guided the visual direction of Nintendo's AAA Metroid Prime franchise, and he has also worked on PC, console and handheld games. Andrew began his career working at Industrial Light and Magic. He has since gained recognition as a leader in the digital art field, is a co-founder of www.ConceptArt.org, and teaches conceptual art workshops around the world. Andrew's current creative passion is airbrush bodypainting of naked models, circus performers and acrobats.

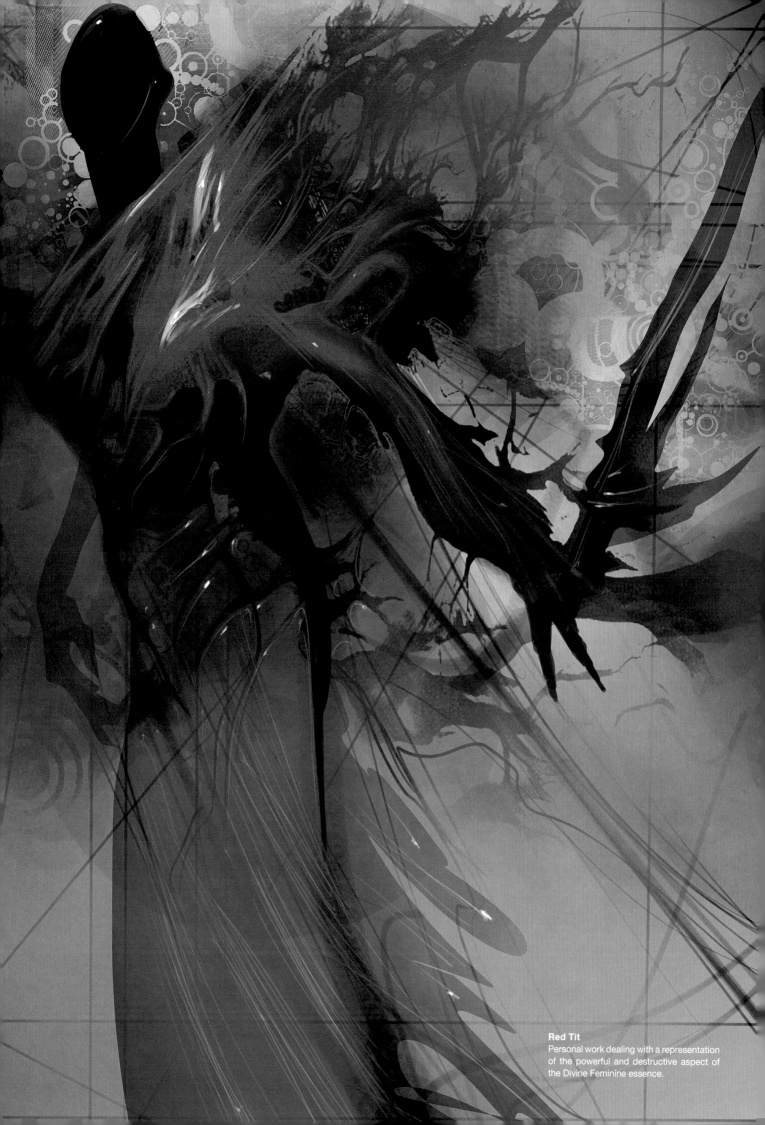

Red Tit
Personal work dealing with a representation of the powerful and destructive aspect of the Divine Feminine essence.

CONTENTS

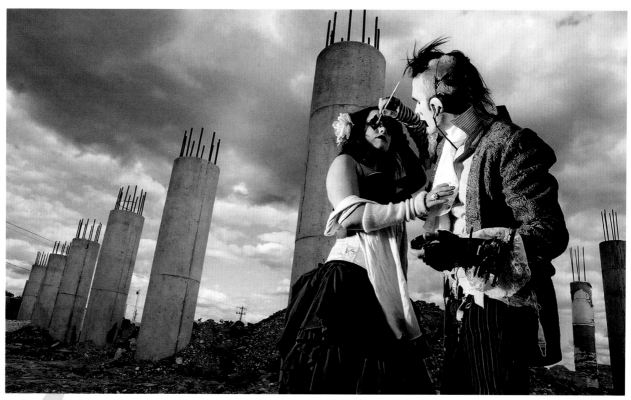

Photo by Celesta Danger (www.celestadanger.com)

Post-apocalyptic paradise with Johna

Beginnings

My parents were painters and while in preschool, I painted a picture of a caterpillar which the teacher thought was something really special. So she encouraged my parents to get me into private lessons and that started my life as an artist. I've been painting ever since. I've done a lot of life drawings, and this is something I feel I was influenced heavily by. There was a lot of time to do life drawing because I lived out on a farm, and I drew stuff for entertainment. I really had a lot of time on my hands.

Education

I went to a school called Ringling School of Art and Design in Sarasota, Florida where I gained a Bachelor of Fine Arts degree in Computer Animation. At Ringling, I was learning computer animation and Maya, skills that I used to translate into being a more efficient concept artist. At the Boulder Academy of Fine Arts,

I received classical academic artistic training from master Elvie Davis, which included cast and figure drawing, life painting, sight-sizing, lots of color and shadow theory. I took a semester off and went to medical school to dissect cadavers. I used that time to really get in close to these cadavers and learn anatomy. You don't really forget it once you cut open somebody's back. It's a great way of burning images into your mind.

Digital

I was exposed to the digital side of the arts pretty early. I remember fooling around with Painter 1.0 when it was sold in something like a paint can. I was playing with it before Wacom came along so I was only using a mouse. I remember experimenting with it, but it wasn't as satisfying as the 'traditional way'. At the time, I was really into markers, and pencils, so it was hard for the original programs to

compete with that. I remember when the first Wacom tablet came out, I was experimenting with that towards the end of 1998. At that point, I really got stuck into Painter with the Wacom. I never really looked back, because I was sold on the digital medium from then on.

Career start

During my schooling, I took a job with one of my art school peers, Jason Wen. I was working on a personal project of his called 'F8'. He saw some of my concept work and wanted me to collaborate. This was my first job, working as a Concept Artist, working solo on the digital direction of a film. Doing the sceneries, characters, vehicles and guns—practically the whole universe of elements. 'F8' has become a cult classic, initially shown at SIGGRAPH when it came out. That was really a great experience because it was the first time that I was able

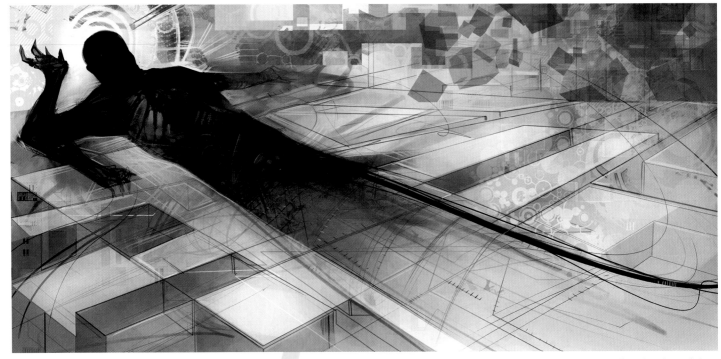

Decadence: "Everything screams entertainment to you, but people are completely missing the point. They think entertainment is living in a self-made prison of drugs and silly amusement. They don't realize their own folly. They just keep tumbling down their own narrow paths into insignificance." — Marko

to see my concepts actually in 3D, after seeing the updates and the models in LightWave. I remember getting really excited about the potential of drawing something and having someone else modeling it and taking it to the next level.

Tools

Painter seems to have a certain spirit to it. It's definitely the most intuitive of programs. There is an element of chaos and unpredictability to Painter. I'm just that much more comfortable using Painter than any other program. In fact, I use both Painter and Photoshop in conjunction for the majority of my time but when I'm painting and drawing, I always have Painter there with me.

Fun and games

Nintendo Metroid Prime has always been one of my favorite

games. I spent so much time playing that in my early years. I moved to Europe because I needed a change from living and working in California. I actually sold everything and quit my job and was living in Europe as a portrait artist, just working, living off the street, just traveling around in a real gypsy-like, nomadic life. It was a great time for a few months, until of course with the holidays approaching, I was looking forward to going back and seeing my family. Then I got an email from a friend of mine I went to art school with, who worked at Retro Studios. The email said that they were looking for concept artists for the new 'Metroid' game. So I sent in my portfolio, and they liked what they saw and offered me the job. I remember, on the plane ride over to the interview I did a drawing and

I showed them the picture during the interview and I think, you know, they got along with me, I got along with them, and I got the job. It happened really fast. It was great working for Nintendo. I had a lot of true freedom. I was the only concept artist on the project so I had pretty much free reign for all the characters. It's a heap of fun to develop a whole world, to develop a whole eco-system and the structure between the enemies. It was also nice to work within the structure of a predefined franchise. The batch of characters had their own history as well, so I had to make them seem real for the established fan-base. I also had to work on making it interesting enough for the next generation of players. I felt it was a really great, creative challenge and I really enjoyed working with them. It was a great experience. As the Nintendo projects went

on, I gained the trust of the original 'Metroid' creators and all the art directors. I felt I was given more freedom as I went on. There was definitely more freedom in 'Metroid Prime 2' and in this last game 'Metroid Prime 3', it was definitely much more of an open canvas to work with them. I also did 'Metroid Prime Hunter' which is the Nintendo DS version.

Vocation

Concept work is where I have found most freedom, and the ideas have kept coming to me. Once I came back from Europe, and Nintendo gave me the job, I knew I had a place to stay and a genre to follow. From there, not only did the ideas keep coming, but the work kept coming to me as well. The ideas are still fresh, the work is great and the projects are always exciting.

Agenda: Another piece in the original series of six. This was by far the most abstract of the series. It was the most violent and impulsive. The work of the futurists and the palette of Nazi fashion inspired me. This was printed out 6-feet long and used as a backdrop for one of the model runways during fashion week in New York.

Massive Black/ConceptArt.org

Massive Black is a fairly high calibre outsourcing studio for the video game industry. With a large studio in the Bay Area, it is home to 15 of the world's leading concept artists. I'm Creative Director there and I am actively developing a lot of our own intellectual property, which involves our own video game ideas and other projects. Most of our friends here at Massive Black are pursuing fine arts careers as well. We do gallery shows as well as setting up workshops and many of our projects are either in planning or concept stage, so I keep fairly active. Jason Manley was working down in Southern California and I was at Nintendo in Texas. Between the two of us, we knew a lot of really great artists. A lot of these guys had their own web sites, but the idea was to combine forces and have something that would pull a lot

of traffic. So we started it up and got more artists onboard. Then we attached the forum system on it and it was one of those things that just started and got big of its own accord. It was just something we could use to keep in touch and share our art with each other. Conceptart.org was a great place to meet other artists, to learn and critique each other.

Plans

My current plans at the moment are to continue in many directions, but just lately I've bought an airbrush. I've been really active in body painting. I've been airbrushing on naked women and other models, circus performers and acrobats. At E3, Sony had this big party, and they hired a bunch of acrobats, performers and dancers. It's kind of like doing live concept art because you 'concept-art'

the characters and airbrush the designs of the characters, onto real people. So that's the most exciting thing for me lately. I want to pursue my bodypainting career right now in my free time. It's very much like Zen-Buddhist sand-painting, you know, it's 'only there for so long'. It's like performance art in that I've had to use some good photographers to take pictures while it's there. I've done a lot of traditional work, but now that I've been doing digital work for so long, it comes naturally to me. Digital is great—don't get me wrong. You get light, pixels and energy; it's a beautiful medium but it does leave you wanting more from the tangible world. I really find painting in liquids and drawing in charcoal have a tactile quality that you only get with physical mediums.

I've found with bodypainting, it's the most tangible of all because not only am I using real medium, like propellants, airbrush and stencils, but I'm painting on living canvases. Everything about it is so alive. It really helps with balancing out all the digital work that I do. It's really interactive and you make a lot of friends. My current list of projects I'd love to do is to go to 'Burning Man' and some of the big festivals and put on a show. Out in the desert with the fire and all the people wanting inspiration. My future plans lie with my projects with Massive Black as mentioned, but I suppose I have plans later on of buying some land in Costa Rica and getting out of America, and preparing for the year 2012. I think around about that time I want to have my own cultural retreat away in 'Maya-land'.

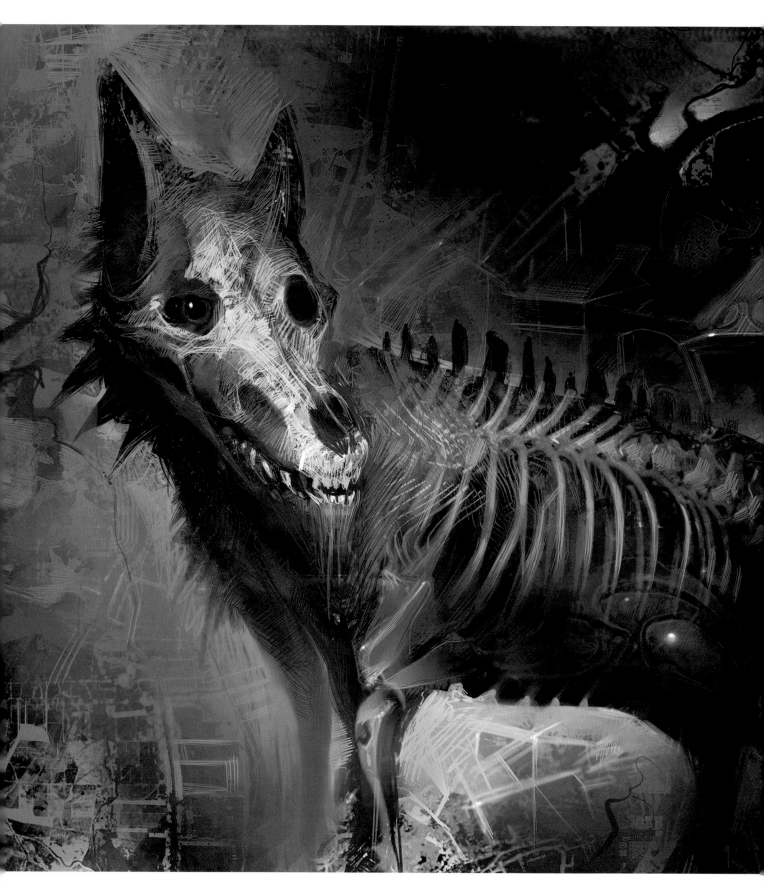

Hunger
This is homage to the nature of addiction. Be it drugs, sex, women, love, alcohol, cigarettes, money, self-destruction, oxygen, food, water, or air. We are all born into this world addicted to something. As a human being with my own vices the hungry wolf has stood as a personal symbol to me of how I choose to dance with my addictions.

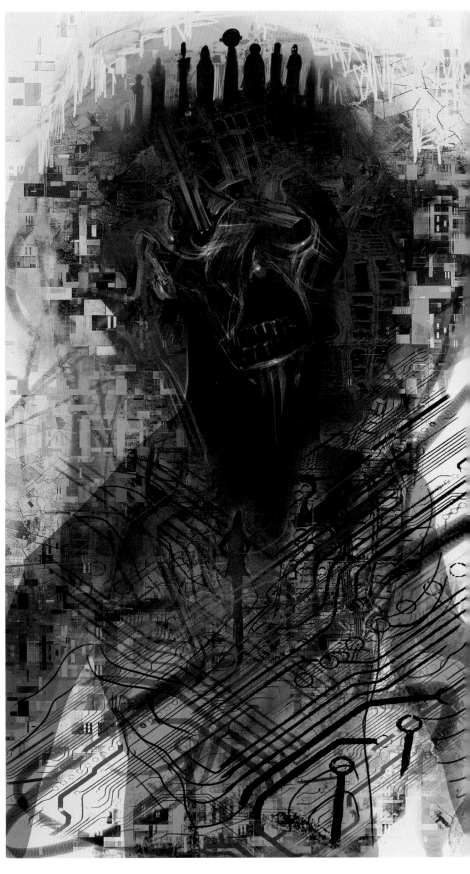

Company man
A self-portrait dealing with the conflicting feelings I was having about moving to San Francisco to start my own company. There are many emotional perils and consciences when your love and sense of purpose seem to oppose each other.

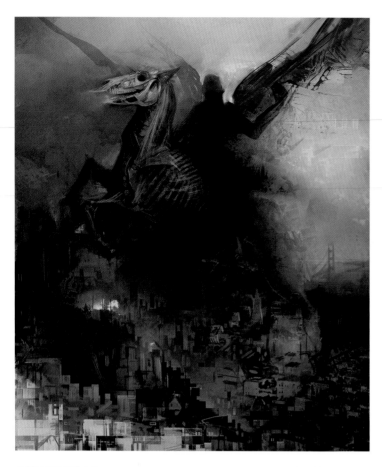

Die SF
San Francisco is a city on the verge of a great change. At night I dream of geological cataclysms— giant waves towering over the horizon; fires and destruction. This is a manifestation of my fears and also my intuition. I choose to live here. I have front row seats for the end of the world. I painted this image to warn others that may choose to prepare another fate for themselves. *[top]*

Edge on entropy
"The contradictions of this world couldn't be stronger; it's like living on the edge of entropy, silently watching the decline of humanity. Day by day the parade continues." — Marko *[above]*

Self-portrait #938
This was from the 1000 self-portrait project. I remember making the initial sketch in the underground grotto of the sundown saloon in Boulder Colorado. My friend Derek asked whether I could make a drawing of a face shaking back and forth. This image was my response to his drunken challenge. *[top]*

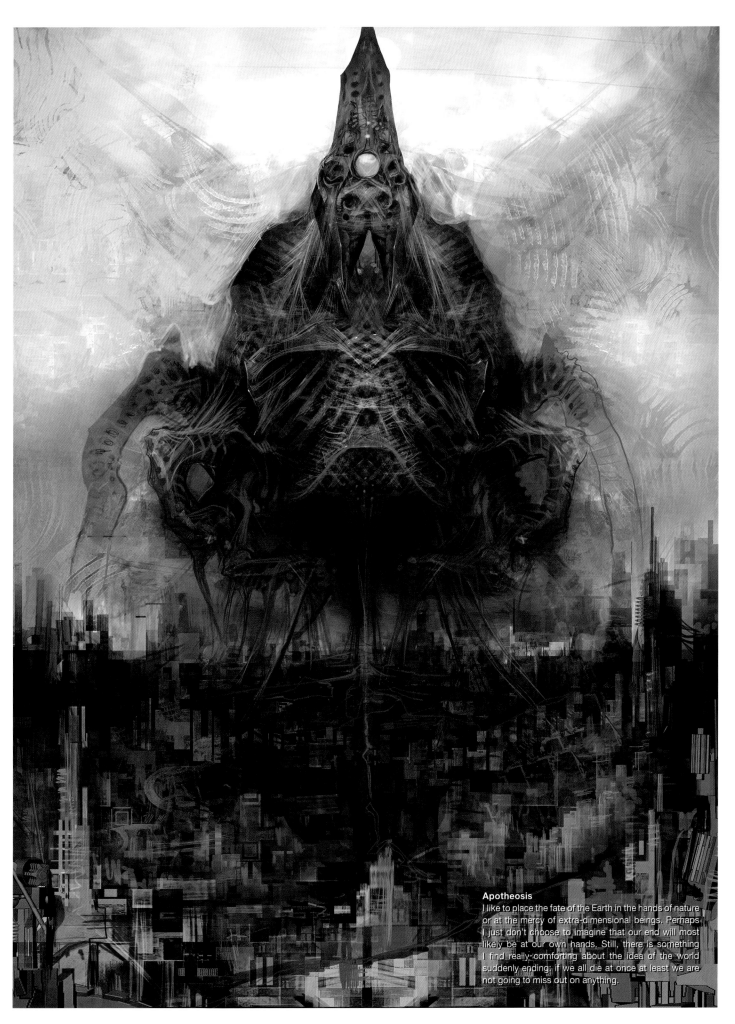

Apotheosis
I like to place the fate of the Earth in the hands of nature
or at the mercy of extra-dimensional beings. Perhaps
I just don't choose to imagine that our end will most
likely be at our own hands. Still, there is something
I find really comforting about the idea of the world
suddenly ending; if we all die at once at least we are
not going to miss out on anything.

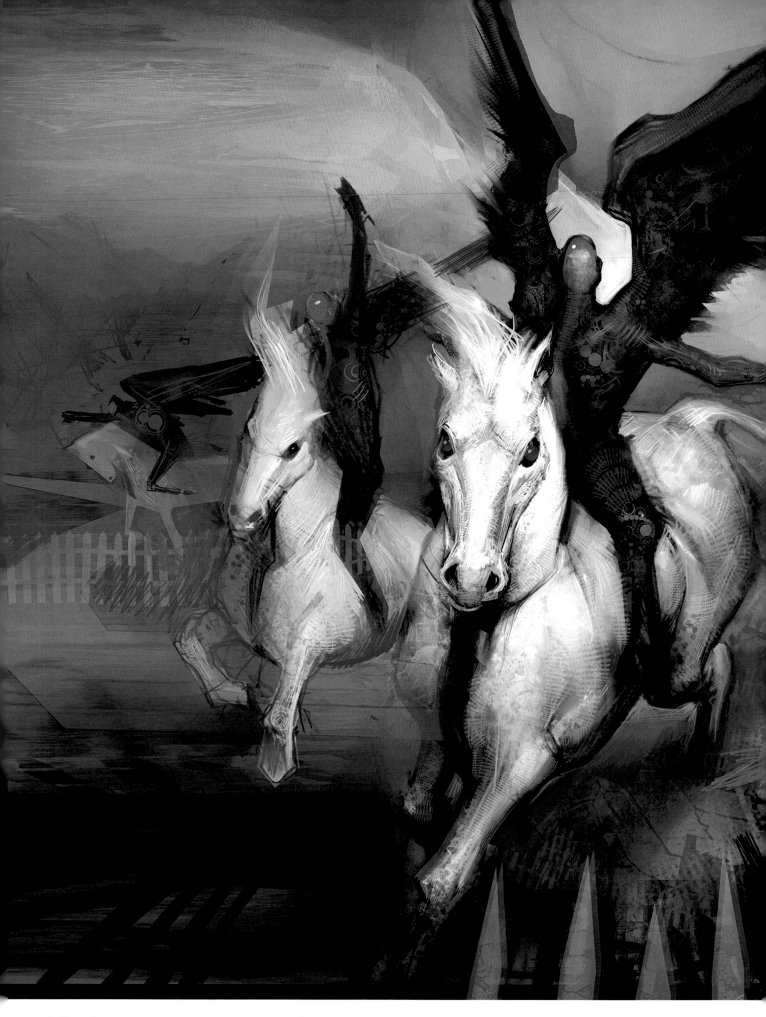

Black angels

"Black angels go marching onward, into battle for your soul...
Needing no special weapons to defend themselves from evil..."

The Black Angels are one of my favorite Austin Bands. I made this just because I love their music so much.

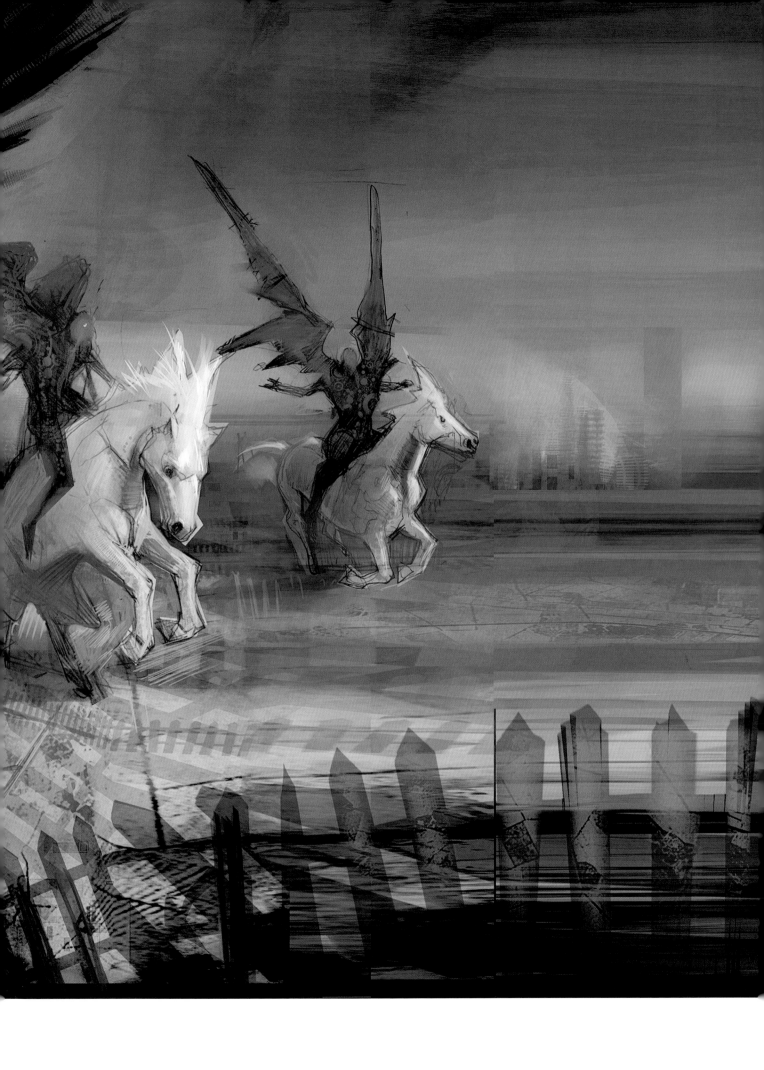

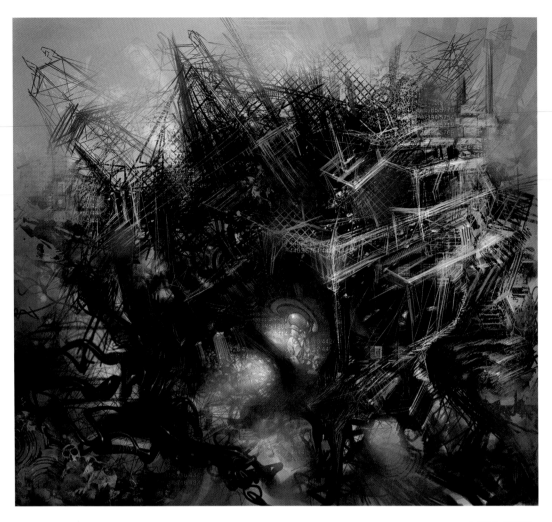

Diethylamide temple
It is my belief that Albert Hoffman is one of the most revolutionary beings of the 20th century. I painted this on his 100th birthday. I was listening to Aphex Twin really loud while painting. *[left]*

Uriel
When one is depicting the forms of angels and demons, one must be aware of what you invite into his or her personal realm. I try to create more angels than demons, but the demons are so vain they love being redesigned over and over. Angels are much more elusive to capture. *[right]*

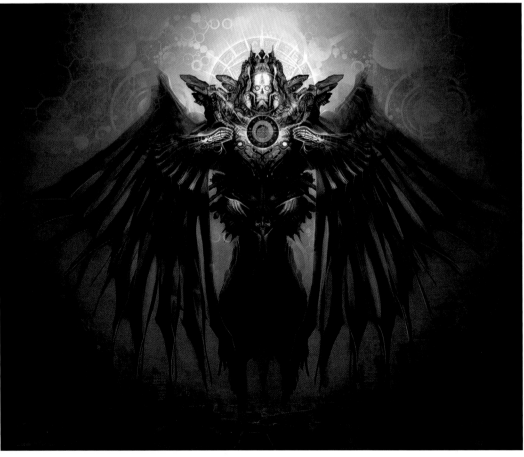

2012: Quetzalcoatl
26,000-year cycles go by really fast—especially when you're living at the end of them. I painted this after meeting Daniel Pinchbeck at the Synergenesis conference in San Francisco. We share similar world views on how our story might end. *[left]*

CONCEPT ART: SEEN IT ALL

Inspiration and subject matter

It's a beautiful Friday evening in Austin Texas, and there is a warm electric breeze in the air. I'm spending time with my beloved and just when things couldn't get any better, my cell phone rings. It's Jason Manley, my partner, President of Massive Black, co-founder of ConceptArt.org: "Dood we got a new job in. Korn needs some custom art for their new tour!" "Cool", I said, "sounds great". Apparently, the music business operates on "cocaine time"; 5:30am is an acceptable time to turn work in. I'm always one for a challenge so I accept the job. I download the newest Korn album from the net and listen to it several times in a row—over and over until I could really get a feeling for the angst and passion in Jonathan's voice and lyrics. There wasn't too much direction from the Art Director. They wanted something to fit the visuals of the existing album art which was a mix between 'Alice in Wonderland' and bad Mark Ryden. Oh and not only did they want a painted image, they wanted me to record my strokes with an image capture program so they could project a five-minute video of my creation behind Korn during their tour.

Technique

Pressure. I have to say that it was the challenge, the stress, and the pressure to perform under a totally inconsiderate deadline that really pushed me to create this work. There is something about knowing that time is running out with every stroke that adds a great deal of life and immediacy to your game. It gives you much less time to second-guess yourself. It builds confidence and sharpens your gifts by making you bury yourself into your edges. Because I was recording my strokes there was an added element of performance—I knew that my work would be seen by thousands of people in the future. I believe that the real struggle was keeping myself grounded in the moment, and not letting my fears or anticipation of its future reception take me away from the now.

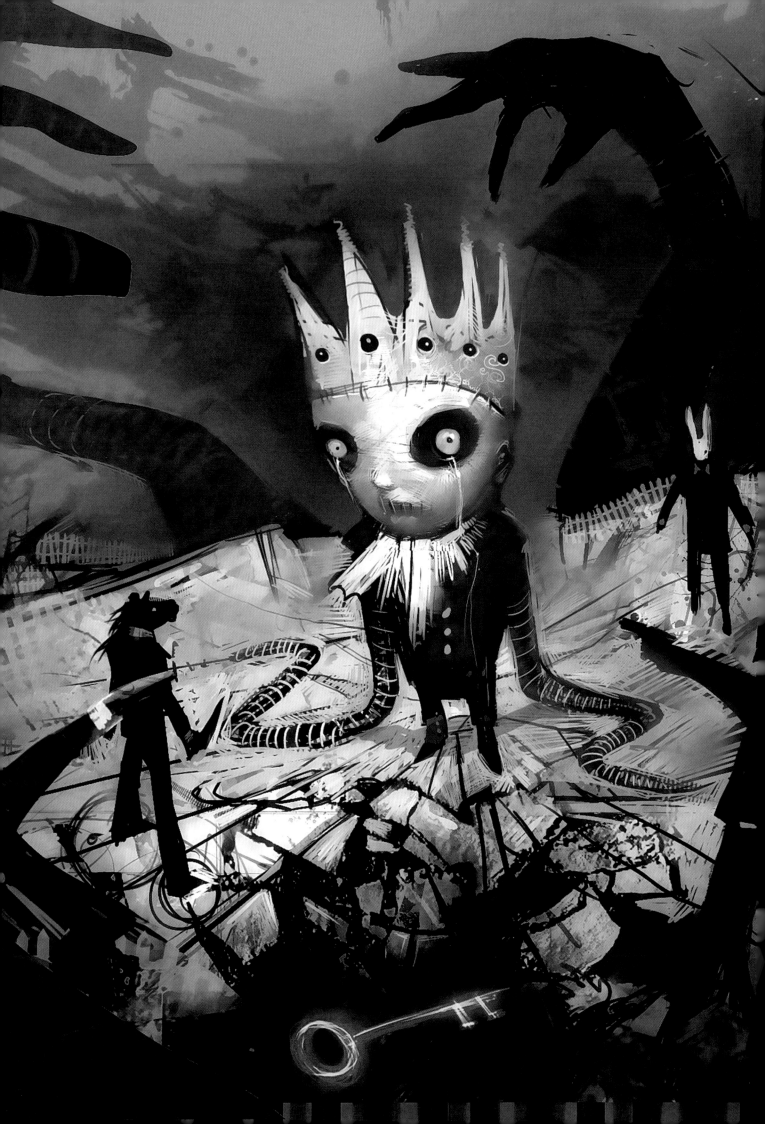

Starting point

I didn't really have a clear idea of what the Art Director wanted, so I concentrated on the music as I listened to the album the first time. I cued in on any visuals they had in the songs that could make a cool painting. I opened Painter and just began to scratch out a bunch of thumbnails. One of the songs on the album began to stick out to me as something I wouldn't mind having to listen to for the next few hours, so I selected it and put it on repeat. I don't want to quote the lyrics, but it's more of the same: "Nobody understands me." So, I concentrated the thumbnails on that martyr theme.

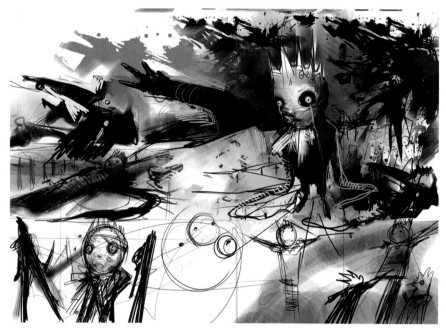

Sketching

One of the sketches begins to resonate with me more than the other does at this point. So I choose it and begin to invest more attention in it, filling in some of the detail and alluding to what the background may be.

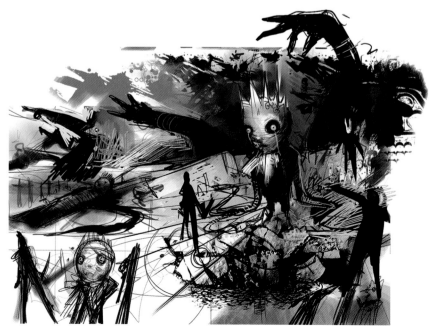

Texture

I add some textural Painter paper elements. This gives the painting more of an edgy feel. At this point, I'm just adding elements I either pick up from the lyrics or shapes I think will look cool on the canvas. The big black hands in the background seem to serve as a good metaphor for forces in the world out of your control. I'm really trying to empathize with Korn's key market of 14 year-old boys alone in their bedroom.

Adding elements

I add atmosphere and a few washes of mood over the painting. The one thing they did want to see was figures from some of the previous album's artworks. I have no idea what they stand for, or mean. I am sure I could make up something deep, but I don't have the time or patience. I make a picket brush pen in Painter using the Pen Pattern tool. It takes a bit to figure out how the Pattern Chalk tool works, but once you do it's pretty cool. The picket fences are a symbol of the American dream home.

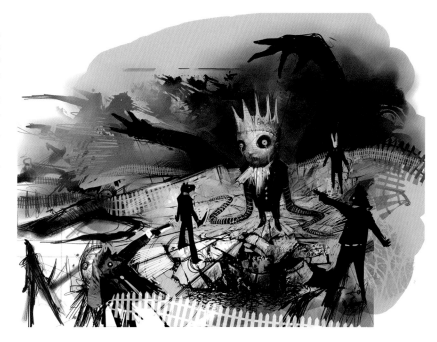

Crumbling reality

I throw down more atmosphere and textures begin to appear in the piece. I'm using close-up pictures of blood vessels and veins to make spooky dead tree shapes. I want the ground beneath the character to feel like cracking ice or reality that is crumbling all around him: "Oh woe is me!" As Marko would say: "Cheer up Gothy!"

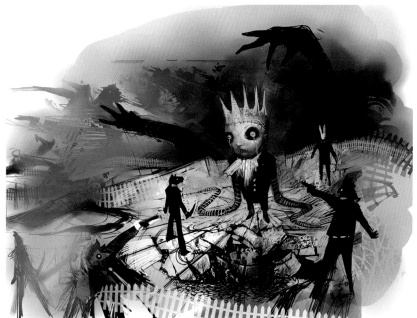

The black hand

In order to push the space, I add a giant black hand that reaches in. Its fingers mimic those of a puppeteer controlling the anthropomorphic characters tormenting the poor boy. I add in a border to help me pretend like this piece is almost finished.

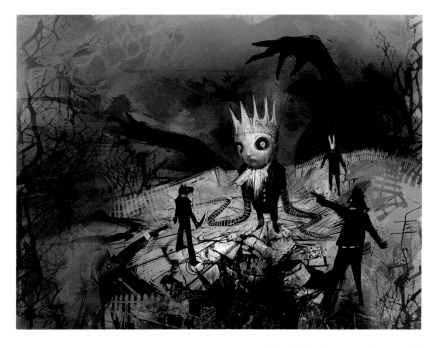

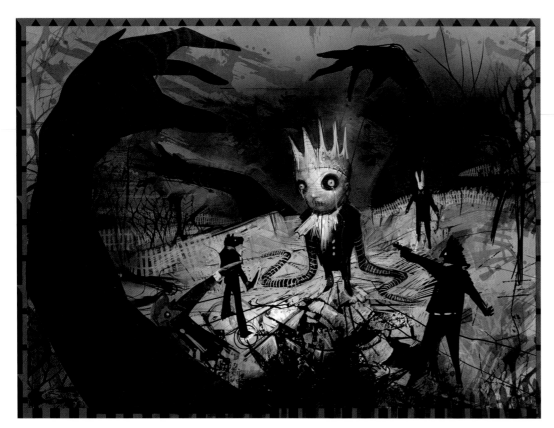

Big head

I decide to make the boy's head even bigger. I cut out the head and take it into the Photoshop Liquify filter to increase the overall size. I feel this adds a lot more focus on the main character. I have no idea what the crown means, or the stripy tentacle hands—no idea at all. It just seemed to make him look more helpless and pathetic.

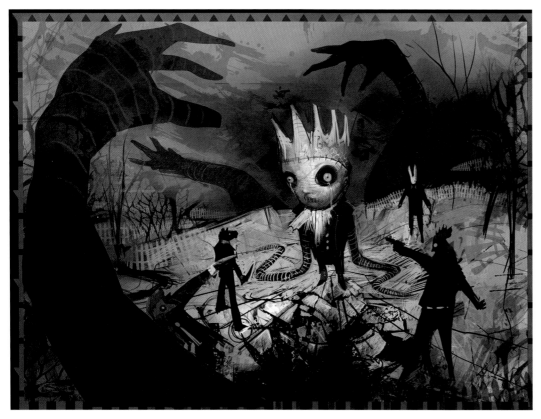

Tearjerker

I take the Just Add Water brush in Painter and soften a lot of the edges to give it that soft dreamy surreal feeling. I enforce the tears on the boy because one of the songs on the album is called "Tearjerker". I throw in the key at the bottom of the piece. I leave it up to the viewer to decipher its meaning. Give up, there is no meaning—none at all.

Polish

I soften it a bit but am not happy with the results I have so far. The sun is beginning to come up, and I'm really exhausted. I lower the saturation a bit and play with the contrast.

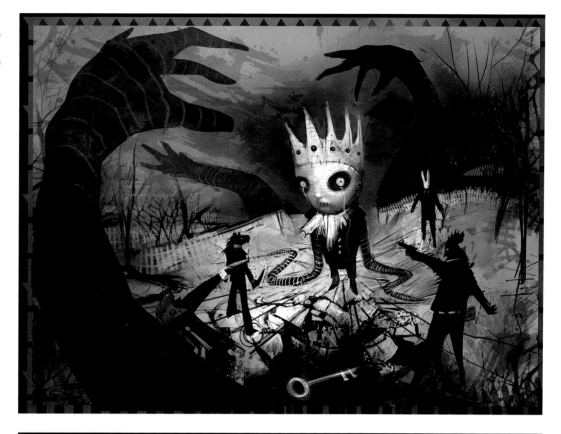

Final

I am freaking finished. I get grumpy late at night when I have to work on something that is not of my own inspiration or liking. But, I did the job. It was later approved, and I am still waiting for the free concert tickets that the Art Director promised.

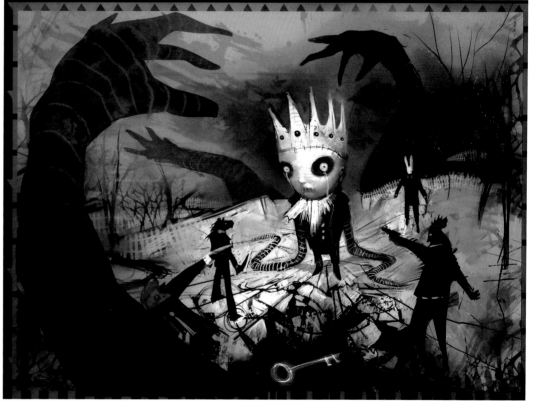

CONCEPT ART: STUDIO CITY

Inspiration and subject matter

It was a Sunday morning. I rose out of bed suddenly. I was disoriented, and didn't know where I was. My body was freezing cold. Was I still dreaming? The air was completely still. As I surveyed the room, I noticed a naked female body laying in my bed—her head turned away. My hand touched the swell of her back. Her body felt cold as well—fear grasped me for a moment, but she was still alive. Memories started filtering. I walked naked downstairs to my studio. Everything felt off, foreign, alien, like a moment caught from time. I stepped outside the back door of my studio to a brightly lit San Francisco alley. I smoked four cigarettes one after another just trying to feel something, to look out at the streets for some sign that I was still alive

and a part of reality. The landscape gave me little reassurance. I closed the door and went back inside the studio. I couldn't shake this strange detached feeling of existence. I felt like a ghost that was haunting his own life. I didn't know what I could do to feel alive again, but I knew I had to do something with this feeling. I sat down in a tattered green leather chair that used to belong to my father. My laptop and Wacom were waiting to receive me. I sat down and began making marks, fast and furious, nothing in my mind. I wanted to capture this feeling inside or the total lack of feeling that dwelled within me. The piece that developed was a cry, a scream to the world that I was alive—that in that moment I existed and that this was proof.

Technique

I opened Corel Painter 9.5 and created a canvas of arbitrary size and resolution. I used a variety of different brushes and a few paper textures. I used some Photoshop for image manipulation and a few filters. I incorporated a few ZBrush elements and gave it a final once-over in Painter again. As I began, I had no destination in mind whatsoever. The work evolved from a stream-of-consciousness desire. What manifested in the end was a surprise to me and at the same time it was a window into my subconscious state of mind.

Starting point

I sit in my chair, Wacom in hand. My studio feels so alien and detached. The walls feel like the edges of a petri dish. I stare off into the corner of the studio like I had never seen it before. There is my drafting table, an easel model stand, miscellaneous boxes, supplies, and a giant metal arrow I bought at an antique store in Texas. I impulsively base my first strokes on the shapes I see in the corner. At this stage, I'm more involved with the furiously erratic movement of my wrist and hand across the Wacom. I'm almost more entertained by the dance of my own fingers than what is appearing on the screen. To be honest I'm looking at the screen very little at this moment. Most of my attention is fixed on "feeling" the objects in the corner. The corresponding strokes are more of a blind contour drawing of what I'm seeing.

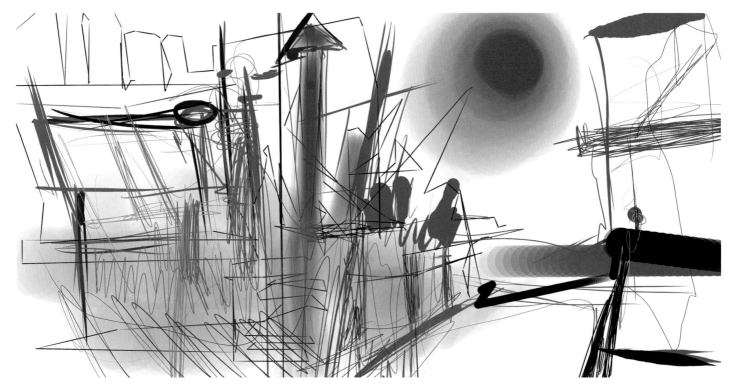

The red circle

I begin to make my initial introduction of color. The walls in my studio are white. It creates a very sterile environment and that mimics the mood I'm in at the time. The metal arrow in the corner dominates my attention, and I feel that its color dominates the feel of the composition. I place an impulsive red circle down. I pause to consider its purpose. It felt accidental in its initial creation, but as I stare at it begins to take on more intent and meaning. I begin adding more value to increase the contrast and begin to define space, shapes, and the forms.

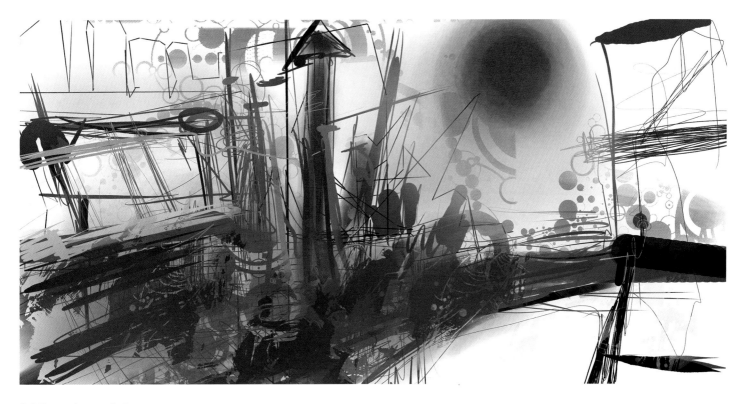

Adding value and shapes

I continue adding more value. I apply some organic shapes using a paper texture and the chalk brush in Painter. This allows me to impulsively block in abstract shapes. After laying down some new shapes, the composition is beginning to come into focus. I can see an environment take place. Correspondingly, I can begin to feel a bit more life in my veins, as I start to invest more energy into the work. I am giving less attention to the question of my presence as a human being on the Earth. I can begin to hear the trucks drive pass on the 101-freeway bridge that looms outside beyond the studio wall. I have a loft space above my studio. I can hear the sounds of another female guest stirring above me—the casualties and benefits of a hedonistic lifestyle.

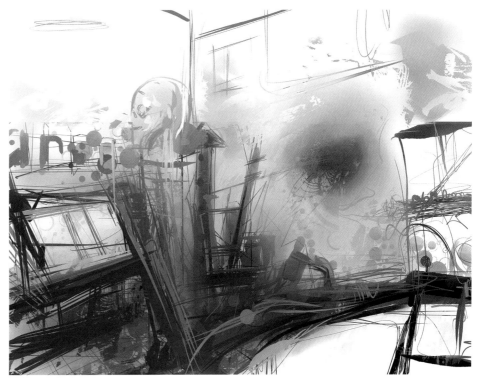

Chaos of the composition

Things are happening faster and faster now. As my vision expands, so does the size of my canvas. I have high ceilings in my studio with small square-ish windows that look out into the city. I begin to incorporate their shapes and the perspective of where the wall meets the angled ceiling. There is a head that begins to materialize in the center—a mind. The chaos of the composition is a mere reflection of the inner chaos inside me. My choices and decisions are becoming less grounded, and second thinking begins to set in.

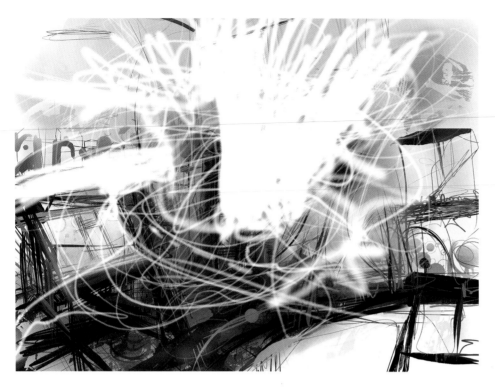

Destruction

To hell with it! I become so frustrated I take the glow brush and begin to destroy any semblance of representation the work was beginning to take. I feel defeated, and the hollow feeling that inspired me to begin with has only increased. The work echoes my hopelessness back at me. As I consider giving up all together, the guests from the night before descend into the studio. Their feminine energy is a welcome refuge from my current state of mind. They can see the look in my eyes and my need for human contact. With loving and nurturing gestures of embrace, they inspire the humanity within in me again. I surrender to their compassion, and they envelop my vulnerability.

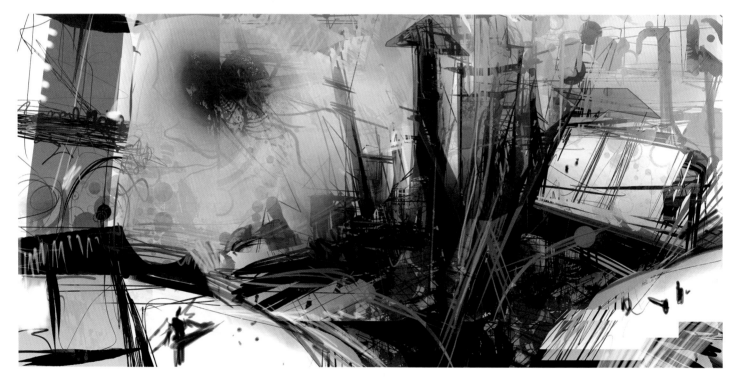

Back from the brink

Thank God for undo! My muses make a graceful departure and I feel alive again. I feel beyond alive. I feel life itself inside of me, pouring out from my fingertips. By the magic of Control-z I undo the reckless self-destruction of my last steps. I see everything new again. There's a quote about traveling which I think of sometimes when I am stuck on an image: "The trick is not venturing to new horizons. The trick is looking at the same horizons with new eyes." My new eyes look deep into the image and begin to explore and extrapolate its dimensions. The scratchy abstract marks weave together to become giant pillars of twisted steel. The red spot becomes a bleeding sun against a white sky. There is a chaotic feeling of tension and desolation beginning to unveil itself and I pursue it.

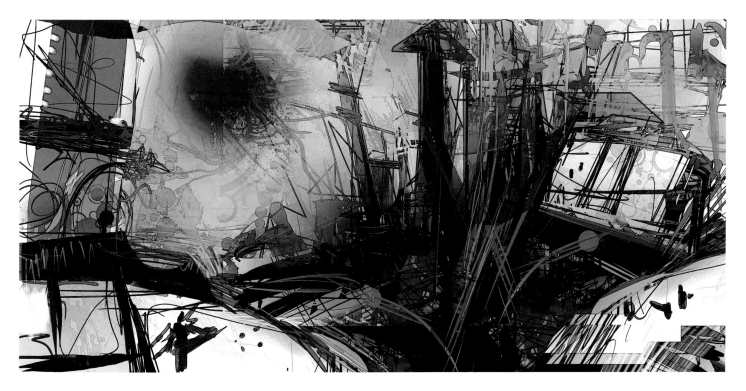

Increasing the complexity

I bring the image into Photoshop, and create a duplicate layer. I apply the Find Edges filter, decrease the saturation, set the layer to Multiply and lay it over the original canvas. This adds a really gritty layer of complexity into what is already a chaotic composition.

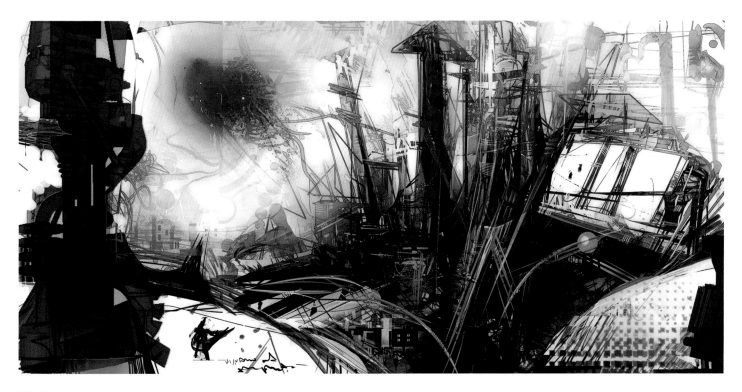

Final touches

What began as a desperate gesture became a finished painting. It is a world created out of chaos. I add some washes of color to enhance the surreal mood. At this point, I zoom deep into the picture. I want to explore the world I have created, adding small details, and making a few final aesthetic decisions to complement the composition. I am at a finishing point. As I reflect back on the mood, I decide that this piece would make a cool level of a video game. Being the Creative Director at Massive Black Inc. gives me the luxury to make such decisions. I approve the concept and apply it to one of the IP (intellectual property) titles in development, codenamed project "IMPULSE".

CONCEPT ART: LESSER EVIL

Inspiration and subject matter

On a late evening in San Francisco, just after midnight, I was at the Massive Black studio. My best friend Marko and I were up late, talking shit, and painting together as we did often back then. I was listening to my favorite late night am radio show "Coast to Coast AM" with Art Bell. If you're not familiar with the program, it's the most comprehensive source of news available. They cover lots of interesting subjects. The show is a constant reminder to what a dark, beautiful, mystery, the world we live in is. On this night, I believe they were interviewing Stephen Quail on the subject of the Nephilim and the old gods. Fallen angels and such. I always enjoy those kinds of stories. That must have been what was creeping inside my skull at the time.

Technique

At the core, the best art I can create is a form of meditation. I strive to achieve a state of "no mind" when I am painting. It is a place of impulse and intuition, free from the constant judging and questioning chatter that can infest the thoughts of my unconscious mind. Being and maintaining a sense of present moment awareness is by far the most important technique I could offer someone. Not just in art, but in all things. There are moments when I can surrender to the beauty of the art I make in the moment and relinquish all control to the point where I am simply watching my hand make perfect strokes that are totally independent of my will. Moments like that bring me to tears. The pursuit of those moments is why I will die an artist.

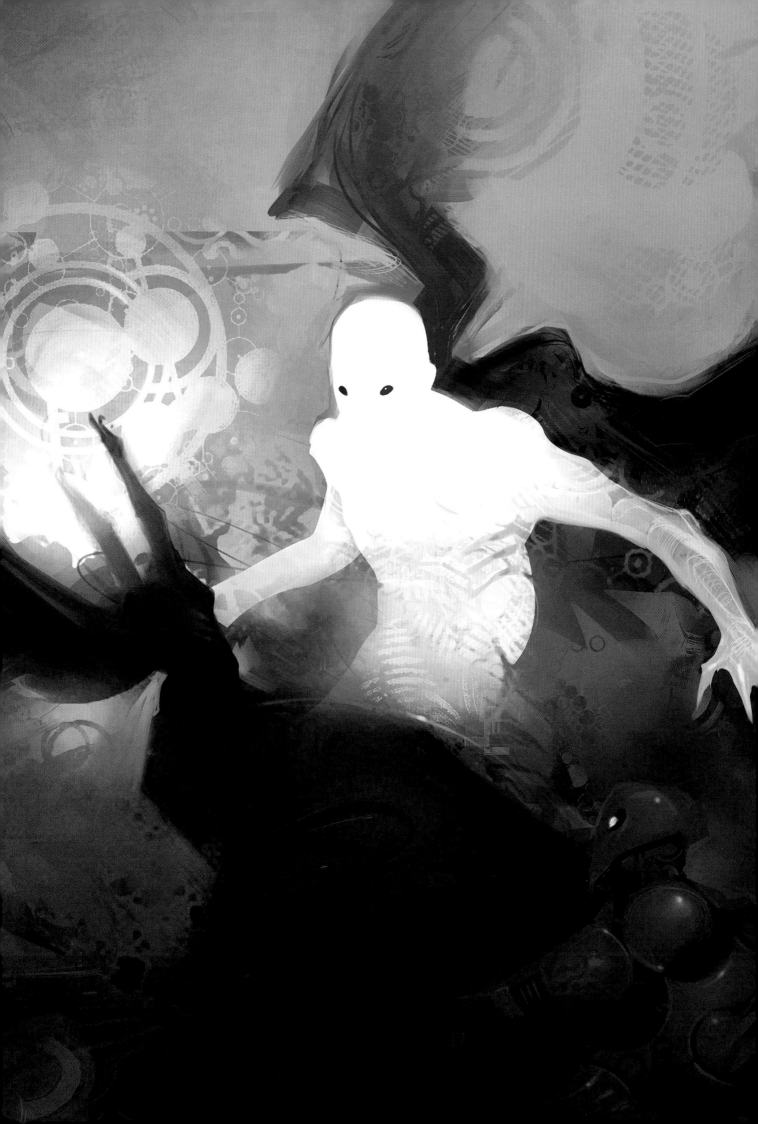

Chaos

Like madness, I was laying down marks and colors at whim. I consciously let go of any direction or expectations for the painting. At this stage, it is a dance of shape and colors. The palette is a reflection of my mood at that very moment. There is a subtle low saturated harmony developing which reflects pleasantly back at me. This stage lasts 5-10 minutes. Beyond what develops later, this is my favorite part; it's a meditation for me. It is a spiritual practice of presence in what I do. As I write this tutorial from a future place in space and time, I label it as step one. But, I'm transcending the idea of steps; each stroke is the most important stroke. Steps imply a means to an end. The perspective from which I make these lines deliberately attempts to defy the idea of a means or an end. Just the "now".

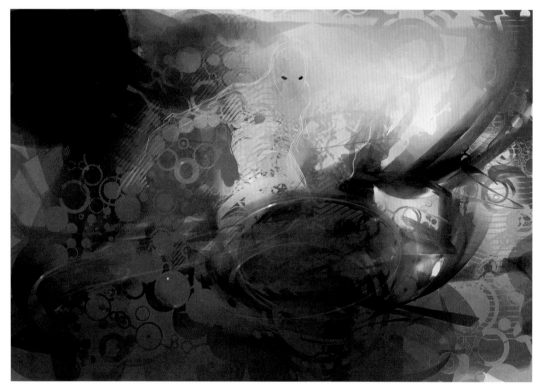

Searching

It has been said that Art is the spontaneous creation of beauty out of the chaos and failure that is your life. That statement would qualify this as a piece of Art for me. Out of the chaos, forms and shapes begin to emerge. Two figures in conflict begin to reveal themselves to me. One larger figure dominates the space and the other smaller foreground figure stands in opposition. I'm aware of the influence the radio program I'm listening to has on me. Or perhaps, the whisperings of my godless friend's reaction to the program begin to settle in my subconscious. As I sit back and my eyes linger on the image, I begin to imagine a battle between fallen angels—not conflict of good vs. evil, but a conflict of a greater evil against a lesser evil. These concepts now guide the remainder of my creative decisions.

Focus

The central figure takes presence in the picture. I want to create a very graphic look and feel for this being of light so instead of drawing it in I use the Lasso tool in Painter 9.5 to select the silhouette of the character. I then apply the Glow brush to burn the being of light into existence. I add two black eyes to give direction and intent to the figure. His visuals are loosely inspired by the description of Lucifer as the light bringer or morning star. I imagine a being made entirely of light.

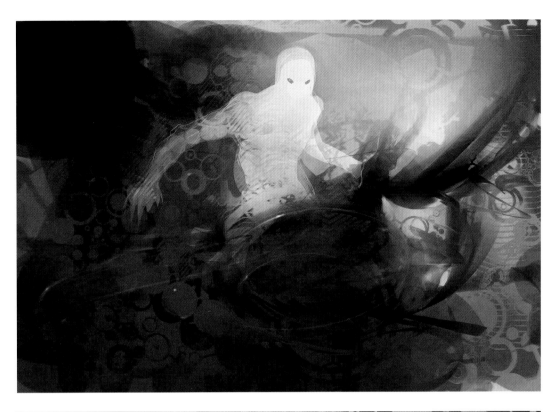

Contrast

I zoom out to see the image as a whole. I really want the Luciferian main character to stand out, so I add contrast to the scene. I am using the figure to create a more dynamic composition. The secondary figure is also taking on more form and meaning, as he raises his hands and wings in the air for a fierce strike against the larger opponent.

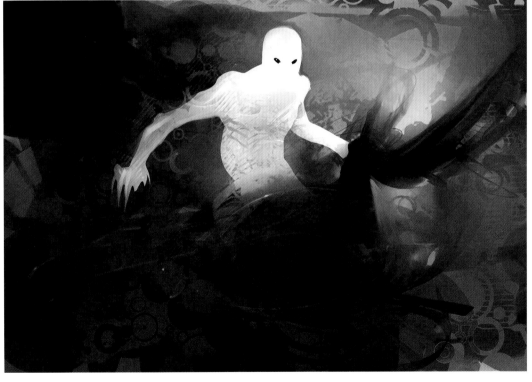

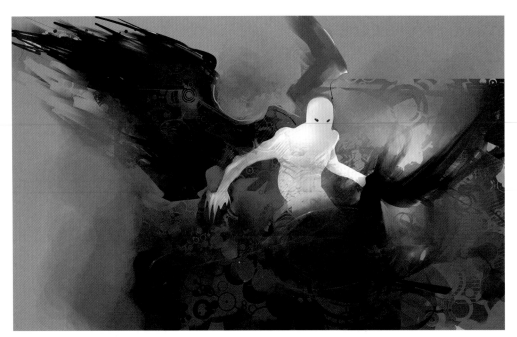

Composition

This devil needs room to breathe. I increase the canvas so he can spread his wings. This opens the composition and gives the wings a lot more momentum and strength. Again, I am using the Lasso tool to carve out very deliberate and intentional abstract shapes. I also use Corel's Loaded Palette knife to refine the shape and give it more edge variation and contrast.

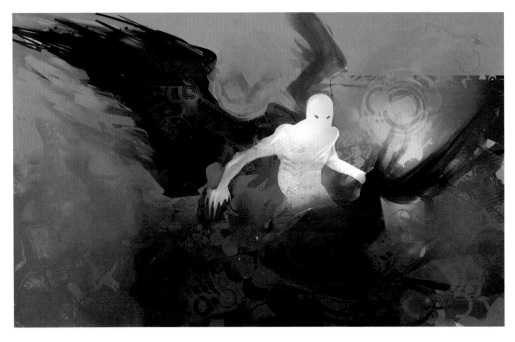

Surfaces

Paper textures are now applied over my strokes to create layers of complexity and more abstraction to work on top of. I'm paying close attention to how busy I want the background to be, and starting to think about what kind of world these two figures are existing within.

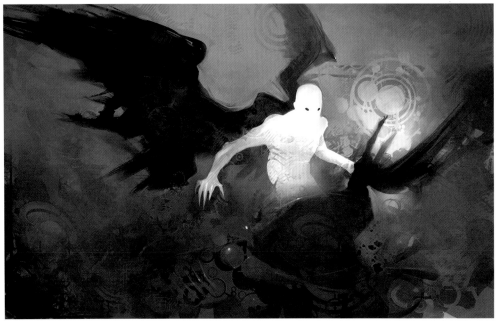

Presence

I make a slight change to the central figure's eyes. This instantly gives him more of a sense of presence, intent, and emotion within the scene. He is now focused directly on the opposing character. The tension between the figures has been increased. I move around the composition, adding elements that will serve to increase the feeling of tension and conflict, while bringing the eye of the viewer to the center of the action. I even out the tone of the background and add frays and torn edges to the wings in order to enhance his silhouette and guide the eyes of the viewer.

Detail

More textures are added to enhance the abstract quality of the work and to increase the drama and visual vocabulary. Buildings are added to the right hand side. I add them to serve a sense of scale and give myself something to relate to. This also places the image within a frame of contemporary time and space. A few new forms begin to call out to me; one is a diving robot character in the foreground and a tumor-shaped being on the far left. I don't want these two new creatures to distract from the central action, and I don't want to delete their existence. So as a benevolent creator, I decide to let them stay.

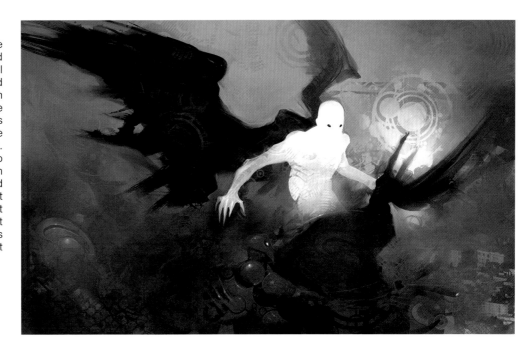

Flipped it

I horizontally flip the image to give it a pair of fresh eyes. This helps me see the image in a new light, and often anything worth fixing will become glaringly obvious to me at this point.

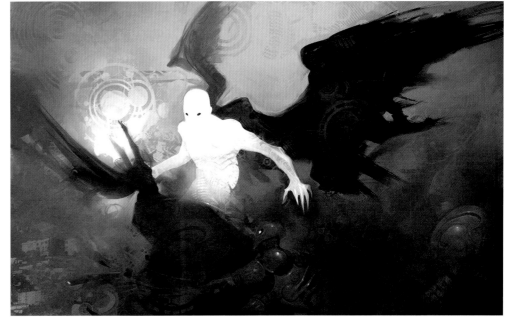

Conclusion

I do a final adjustment of contrast and take the Just Add Water tool and finesse the edge sharpness and softness to complement the visual focal points and add to the illusion of depth. I show Marko, and he gives it the thumbs-up; that's usually how I know how I'm doing with something. Marko is the harshest judge of artwork in the world and he is my toughest critic. A thumbs-up from Marko is like five gold stars in first grade. This piece is ready to get printed out and taped onto the refrigerator.

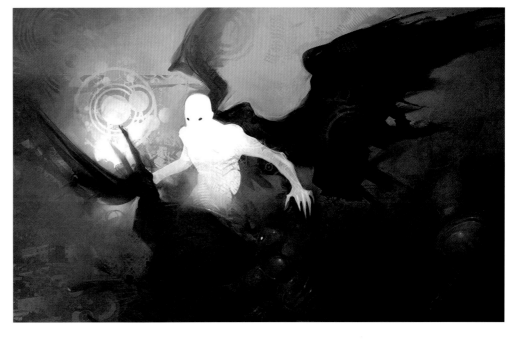

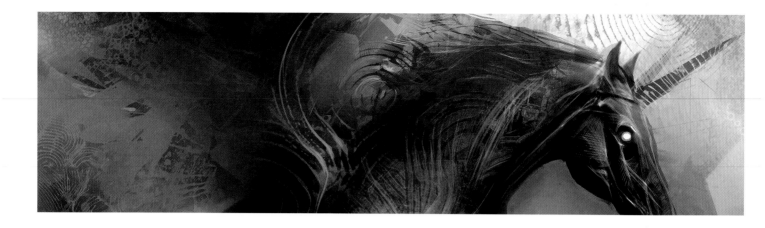

CONCEPT ART: UNICORN OF THE APOCALYPSE

Inspiration and subject matter

I'm in San Jose. I hate San Jose. I'm at GDC (Game Developers Conference). I hate video game conventions. I'm at the Corel painter booth. I love Corel. Corel has graciously invited me down to the convention to show off Painter 9.5 to the wandering masses and I willingly accept their generous offer. I arrive, see a giant plasma display behind me and plug my laptop into it. I sit down, fire up Painter and begin. It hits me that I have about five hours to draw whatever I want! This may come as a surprise, but after a decade of Art Direction the idea of creative

freedom can be startlingly refreshing. I breathe deeply and empty my mind. A small crowd of people begins to form around the booth, mmm...an audience! Then the idea of what to paint comes to me. This would be a brilliant opportunity to combine two of my favorite things: unicorns, and the imminent apocalypse! BOOM! And I'm off.

Technique

Because it's a Corel demo, I stick strictly with Corel Painter 9.5. I start off with

impulsive, chaotic marks and textures. I slowly begin to focus on the shapes that my instincts dictate as the most attractive and relevant to the message I am trying to convey. And what is that message you ask? The message is "The end of the world is coming, and we are living in the end of times!" A warning if you will. It is my belief that we must prepare mentally, physically and spiritually for the Biblical end times—but hey that's another story for a different book. Enjoy the tutorial and don't forget to learn to swim!

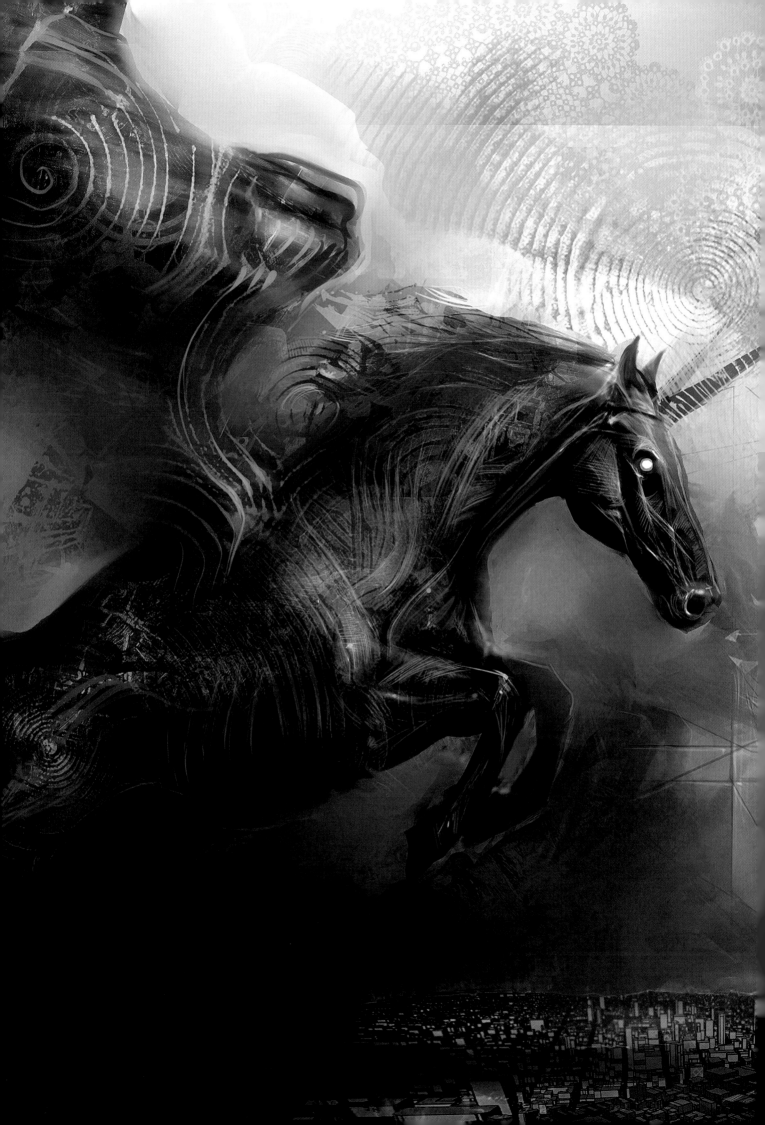

Starting

Breathe deeply through your nose, filling your lungs into your belly. Hold it for a moment and exhale. Imagine the air escaping your body rising up the spine. Repeat this at least five times. I can't stress how much it helps me to become fully present before I start off on an image. If I approach something distracted, it will most likely end distracted. I lay down discordant visual noise of marks and shapes as I search for the inspiring forms. I know what I want to paint, but I still don't hold myself to an image of what I want it to look like. I always find it so much more satisfying to let the painting tell me what it wants instead of me dictating the direction of the work. I know I want an overall dark, moody and monochromatic palette with a few splashes of red to juice it up! I have a traditional oil painter's palette in my mind (Venetian Red, Burnt Sienna, Ivory Black, Yellow Ochre, and Titanium White).

Adding to the chaos

Using the Lasso tool and some paper textures, I add to the chaos party already in progress. The composition is beginning to simmer to a boil in my head. This stage is sometimes the most fun. It's like looking at clouds—clouds that you made that don't move, and the sun never gets in your eyes. It's a window into your own psyche. I am sure someone else wouldn't look at this image and see a giant apocalyptic unicorn passing like a tsunami of destruction over San Jose, but that's me, and since it is my piece, I am special.

Textures

I use the Lasso selection tool to make a rough outline of the space I wish for my Pegasus unicorn to live in. I approach the form as a graphic compositional shape at first and I will concentrate on rendering the form later. I lay down some more textures on the edges in preparation for the surreal dystopian city they will become.

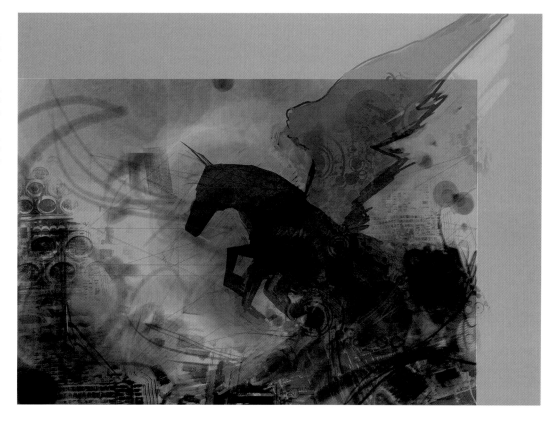

Doily fetish

More intention is now applied to the painting. I increase the contrast to give the horse figure more power and strength as a shape. Steve from Corel makes a comment about why I don't ever paint pink bunnies. Recently, I developed a bit of a doily fetish. Actually, it came to me in a dream. I was looking through some girl's sketchbook while dreaming and saw she was gluing doilies down and drawing over them. While dreaming, I thought it was the most brilliant idea, and regretted not thinking of it first. As I awoke I realized that it was my dream and I own all the contents, so in reality I did think if it before she did. I love when that happens. Hence, the doily influence in my art was born. I previously scanned doilies into Painter and now use them as paper textures.

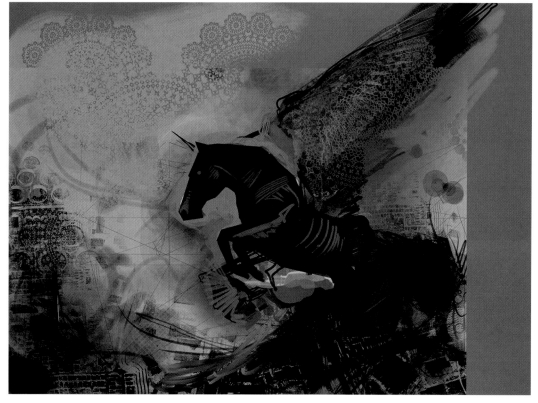

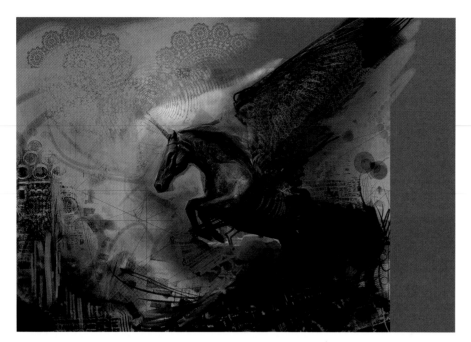

Rendering and detail

Now that I'm comfortable with the placement of my horse, I begin to render out the form, add detail and texture. Rendering is not my favorite thing in the world, but it's a good meditation, and it really seems to impress people. So every once in a great while, I indulge in it. But, I prefer impulse to patience, always. I also make the decision to add in a red mail tail. I don't know why red black and white work so well together, but they have for centuries.

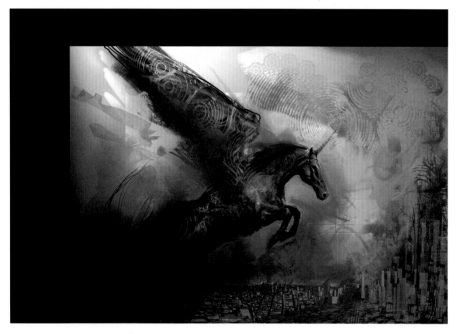

Flip it up

I'm at a mid-point in the painting and I decide to swap visual hemispheres on this bitch. I also increase the canvas size. The unicorn does not have the recall presence I want it to have yet. It's menacing, but it doesn't quite have that "Repent! The end is upon you!" feel yet. At this stage, I begin to render some of the city below. The textures I apply to the wings are from a photo of micro bacteria. Get it? Virus. Plague. The end of the world? Never mind.

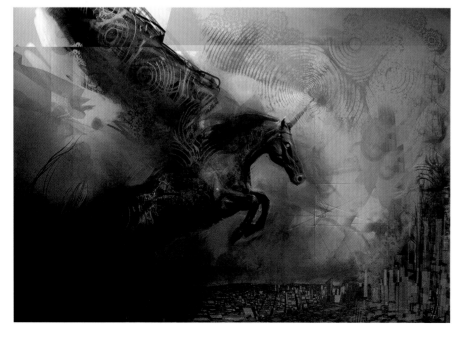

The evil eye

I increase the overall size of this bad boy. Now that says "End of the world as we know it". I also decide that a red glowing eye is just not serving this creature of doom and destruction, so I make it a deathly white—yeah that feels much better.

The eclipse

Boom, another step up in size just for good measure! At this stage, I have incorporated a very important element to the composition: the total doily eclipse of the sun. Actually at the time I painted this, the full solar eclipse was about a week away. At the time, there was a lot of rumbling about what would happen after an eclipse. A solar eclipse in the month of Aries usually means war and destruction, but we managed to make it out ok. Some of my friends flew to Turkey to watch it. That must have been pretty cool.

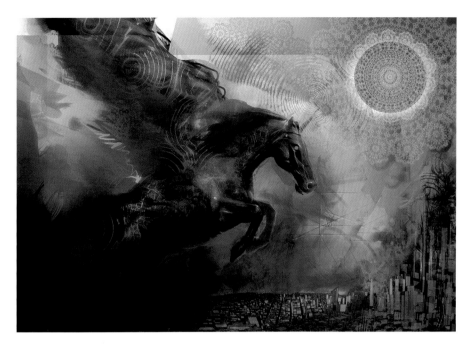

Darkness

At this stage, I'm trying to push the tone and contrast to see how far I can push it. It's always better to push something too far and then bring it back if need be. If you don't push it, you never know what you might have left undiscovered. That's an old Ian McCaig-ism. I almost tried to steal it and pretend I came up with it. Anyway, I also add a shadow of the unicorn over the city. I don't really know what shadows look like during an eclipse, but it definitely makes the unicorn scarier and more threatening against the city.

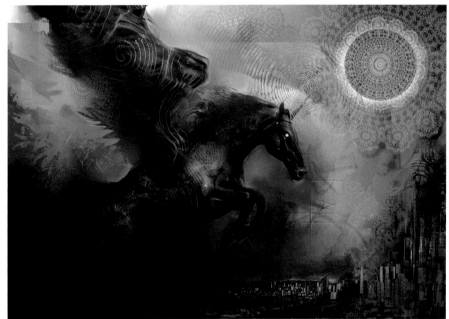

Finally

I bring the darkness back a few degrees. I boost up the contrast a bit and soften a few edges to relieve some of the busy qualities the image has. As a final image I am happy with its outcome. Marko digs it so I know I am on the right track. Jason Manley had been patiently asking me to make a workshop poster for the ConceptArt.org/ Massive Black Montreal Workshop and because the poster I made for our Prague workshop happened to be an apocalyptic horse, I figured if it ain't broke don't fix it. Marko added a little typographical graphic magic and the Montréal poster was born. Consider yourself warned.

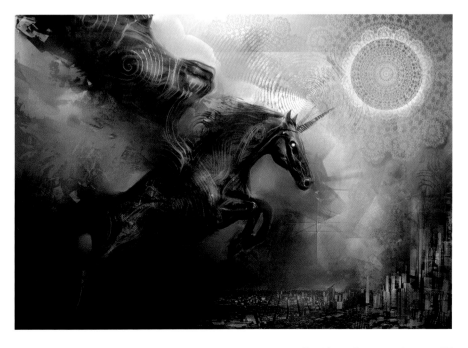

Team Avalon!
Photoshop
Calum Alexander Watt,
GREAT BRITAIN
[above]

Andrew Jones
On ConceptArt.org I know Calum by his alias "Salary man" and every time he updates his online sketchbook the whole Massive Black crew becomes giddy like little schoolgirls. His work has confidence, style, and grace, and he deserves a lot more attention.

Sherbetci bot
Painter, Photoshop
Emrah Elmasli, TURKEY
[left]

Andrew Jones
Sometimes it's nice to see a robot that doesn't look like it wants to take over the world.

Botsuit
Photoshop
Kemp Remilliard,
Massive Black Inc., USA
[far left]

Andrew Jones
I've had the pleasure of working alongside Kemptron for the past year, and the joy of seeing his progress on ConceptArt.org for much longer than that. I remember seeing this robot for the first time at the Concept Art SF Workshop. This is one of the pieces that got him a job at Massive Black.

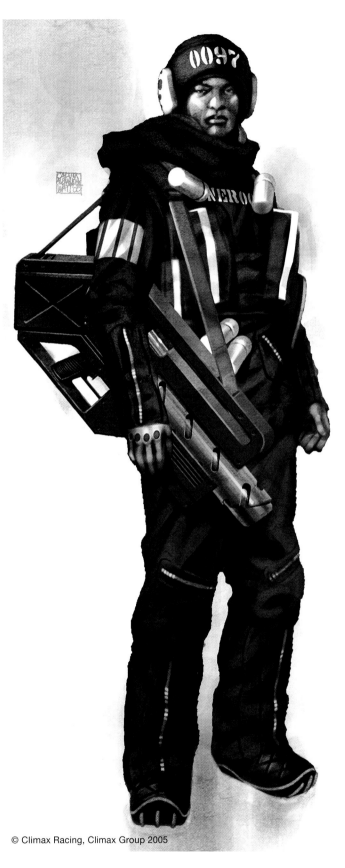

Rebel
Photoshop
Calum Alexander Watt,
GREAT BRITAIN
[above]

Andrew Jones
I like how much attitude this character exudes in his pose. I can imagine his expression behind his mask.

Trooper
Photoshop
Calum Alexander Watt,
GREAT BRITAIN
[above]

Andrew Jones
The gun design really stood out to me on this character. There is a rhythm in his design choices that interweave all the way down to his toes.

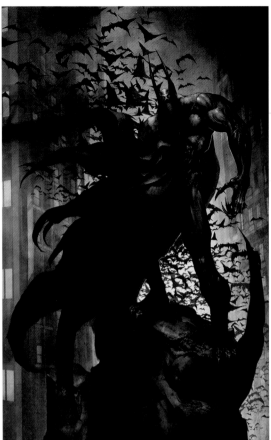

Might and Magic Red Demon
Photoshop, Painter
Client: Magiclab for Ubisoft
Aleksi Briclot, FRANCE
[top left]

Drift before Dark
3ds Max, mental ray
Suli Li,
CHINA
[above]

Homo sapiens macrotus
Photoshop
Francis Tsai,
USA
[top right]

Andrew Jones
Aleksi just happens to be one of the most brilliant innovative and creative artists I have ever met. Over the years, he has been a great friend and a huge resource of inspiration. He also has awesome hair.

Andrew Jones
When I saw this image it really struck me, and I took a few moments to really appreciate what I was looking at. I still find myself staring at it marveling at what a creative and mysterious composition it is.

Andrew Jones
I really like the head design. The complexity of all the bats add a nice layer of depth to the work.

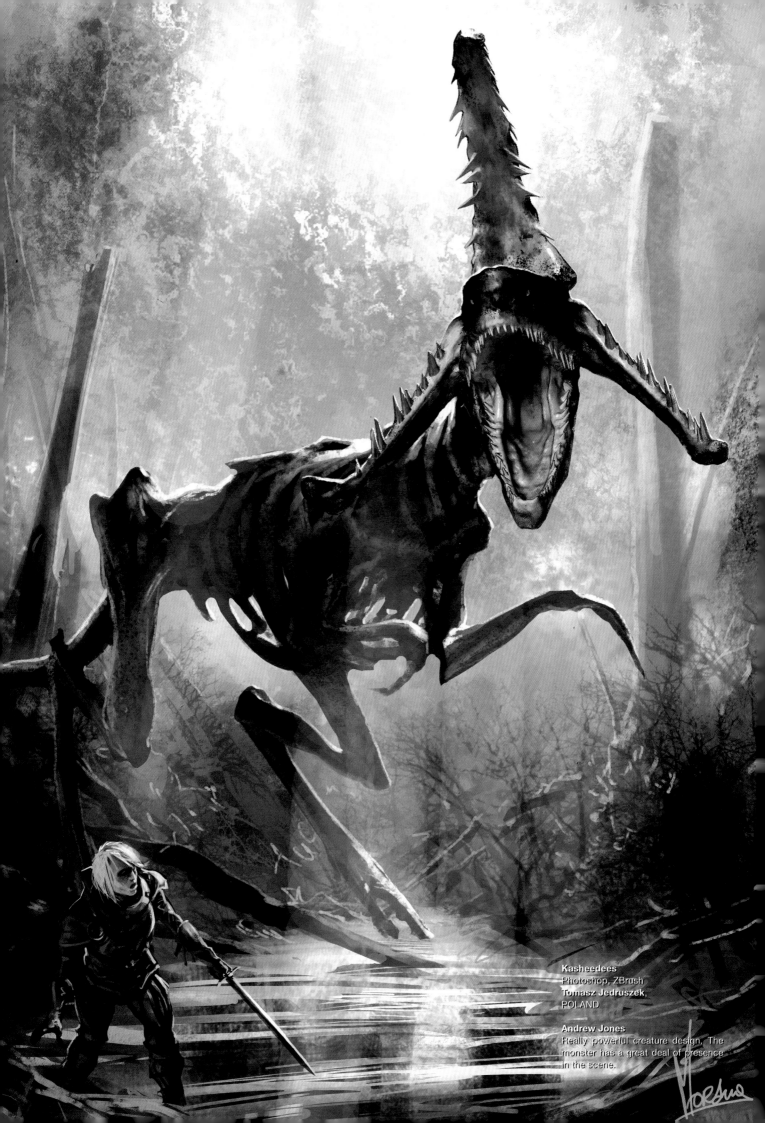

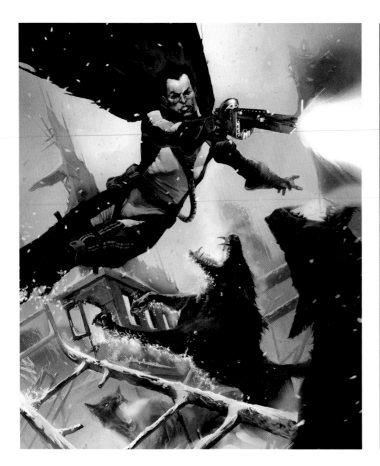

Adrian
Photoshop
Marko Djurdjevic,
Massive Black Inc., USA
[top left]

Andrew Jones
Marko is my best friend. He doesn't believe in God, but the placement of this image on this page makes him believe in destiny.

Trio
Photoshop
James Kei,
Massive Black Inc., USA
[above]

Andrew Jones
At the Massive Black studio, we nicknamed James "Kodak" because he can capture light like a camera. This has been a favorite of mine for a long time.

Nine Inch Snail
Photoshop
Jelena Kevic,
SERBIA
[top right]

Andrew Jones
Notice how Marko's character has his gun pointed towards this character as he jumps in her direction. I love how this world totally freaks me out sometimes.

Memories Lost
Photoshop
Hoang Nguyen,
USA
[right]

Andrew Jones
So many subtle details make this image beautiful. Few digital images make me sit up and stare with my nose to the monitor—this is one of them. Even the concept of a picture of a man holding a picture creates a subtle paradox.

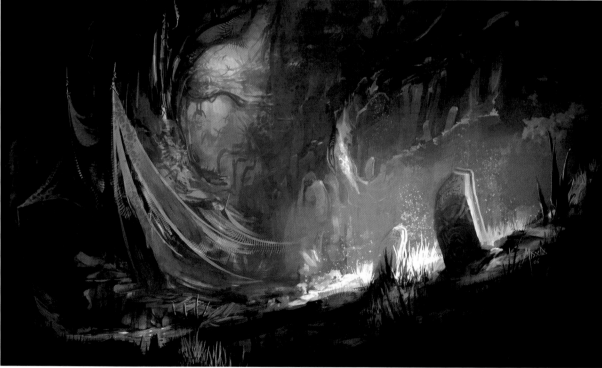

Root Forest
Photoshop
Raymond Swanland, USA
[top]

Andrew Jones
There is a great sense of space and atmosphere in this image. The color choices and lighting really promote a smooth visual eye-flow through the composition.

Near the Trap
Photoshop
Maxime Desmettre, CANADA
[above]

Andrew Jones
I liked the lighting contrast in this work a lot. The particles achieve an almost underwater surreal feel to them.

Canyon Fortress
Photoshop
Raymond Swanland, USA
[right]

Andrew Jones
I like the cooler tones and the vast space this concept creates.

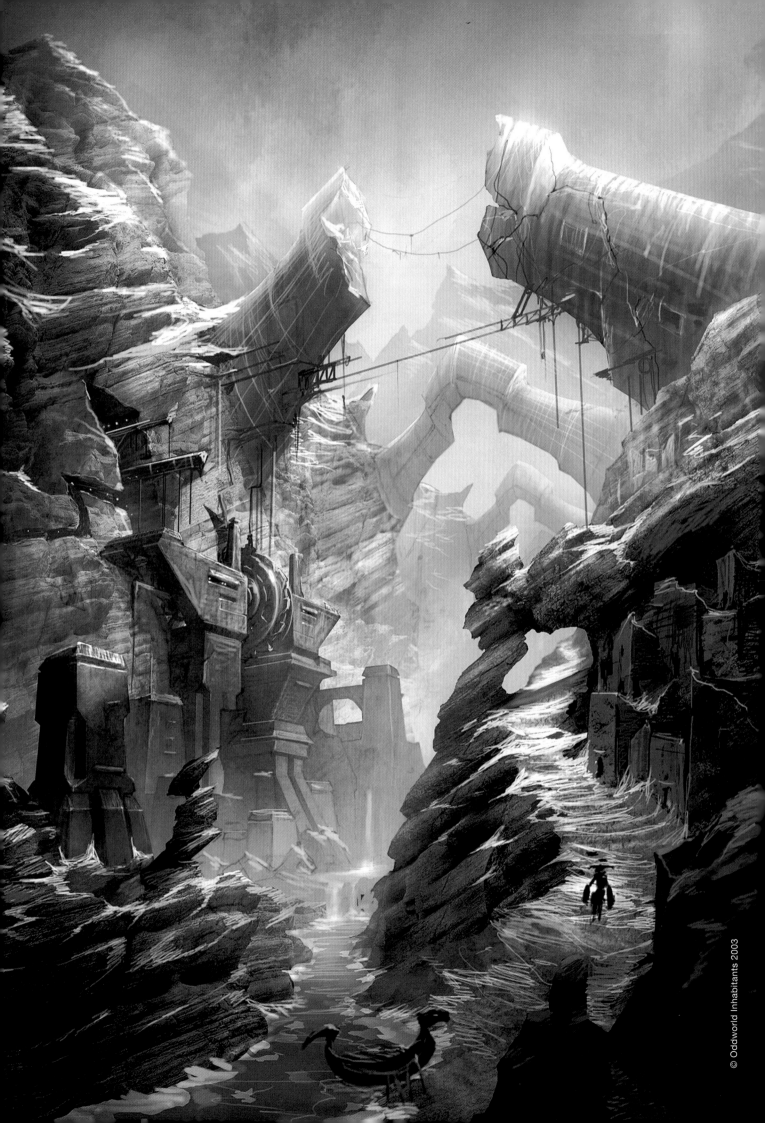

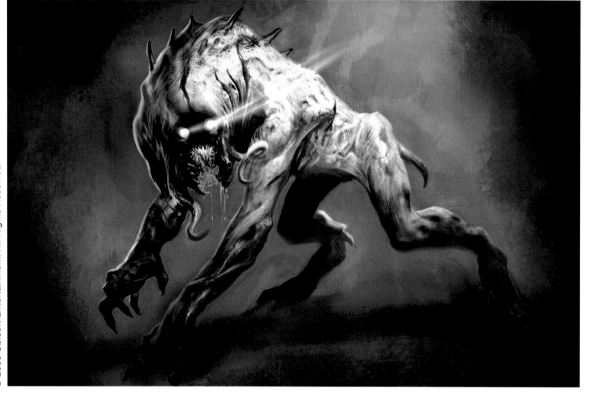

Demoness
Painter, ZBrush, Photoshop
Client: Asmodée
J.S Rossbach, FRANCE
[top left]

Andrew Jones
I know this guy as "Living Rope". He is a "Living legend" around Massive Black. Not only are his concepts amazing but he is also one of the best graphic designers I have ever met.

ColdFear ExoShade
Painter, Photoshop
Client: Darkworks for Ubisoft
Aleksi Briclot, FRANCE
[above]

Andrew Jones
Not only is Aleksi's work amazing, he is one of the fastest concept artists I know. Watching his demonstrations at the ConceptArt.org workshops blows my mind every time.

The Vagabond
Photoshop, Bryce
Antonio Javier Caparó Salgado,
CANADA
[top right]

Andrew Jones
What a great design. Simple and elegant. I remember smiling when I first saw this work.

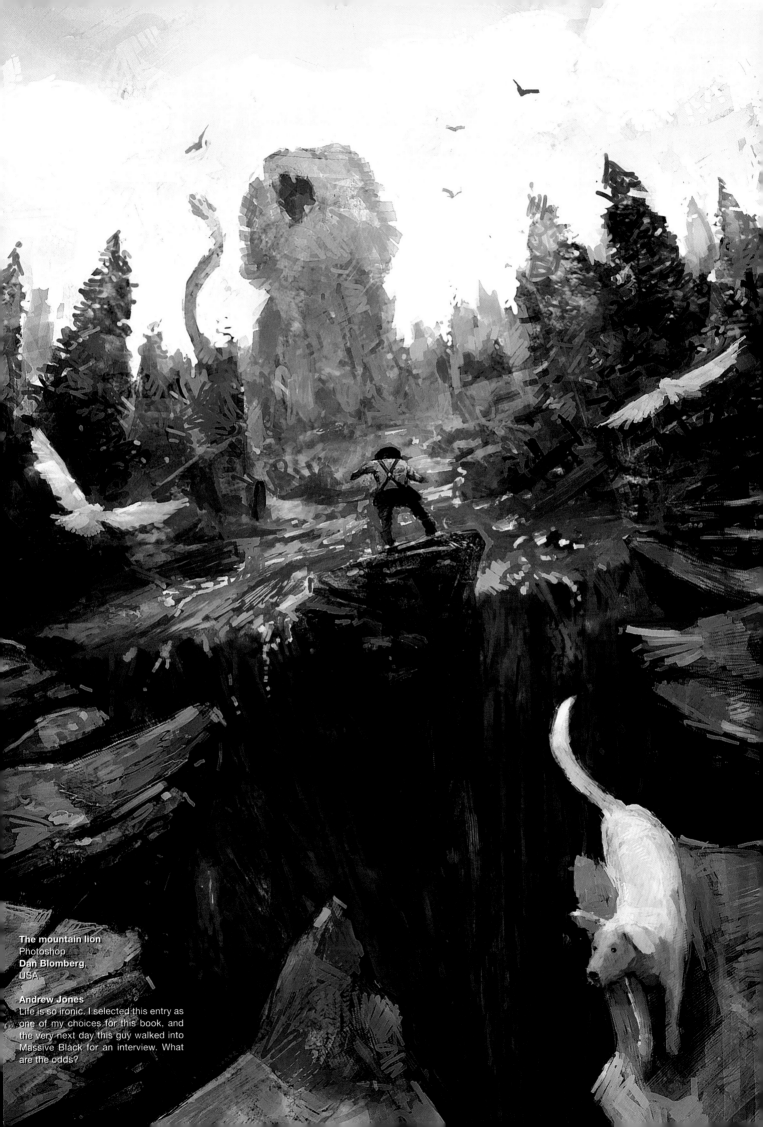

The mountain lion
Photoshop
Dan Blomberg,
USA

Andrew Jones
Life is so ironic. I selected this entry as
one of my choices for this book, and
the very next day this guy walked into
Massive Black for an interview. What
are the odds?

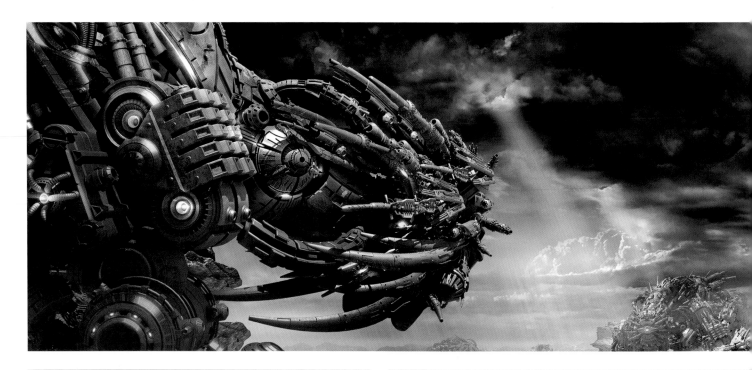

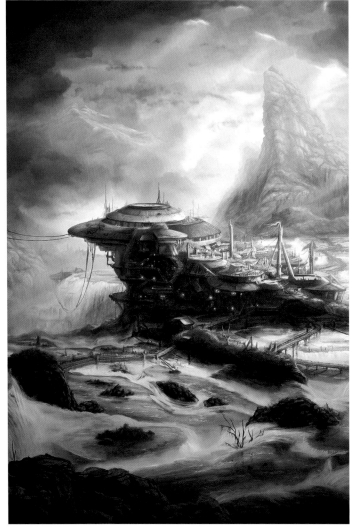

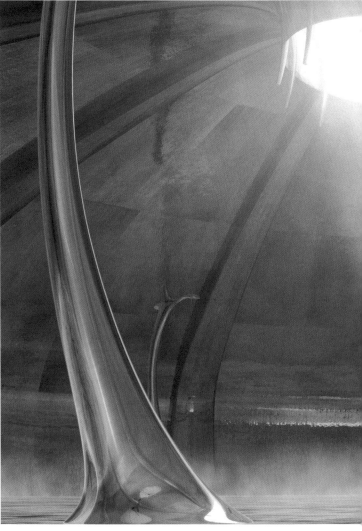

Water Village
Photoshop
Marcel Baumann,
SWITZERLAND
[above]

Andrew Jones
Cool design and mood. The composition
reminded me of an old Japanese print.

Unpredictable contact 2
3ds Max, Photoshop
Wei Ming,
CHINA
[top left]

Andrew Jones
The detail of this image really
overwhelmed me. I'm still not quite
sure what I'm looking, and that is what
keeps me looking at it.

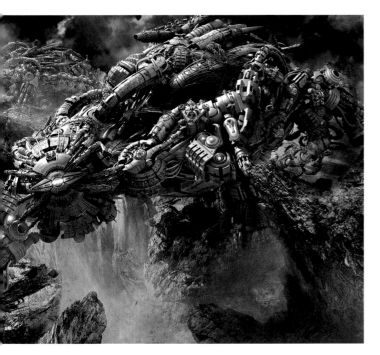

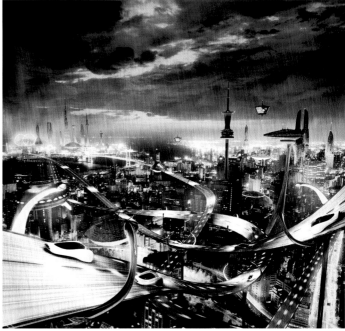

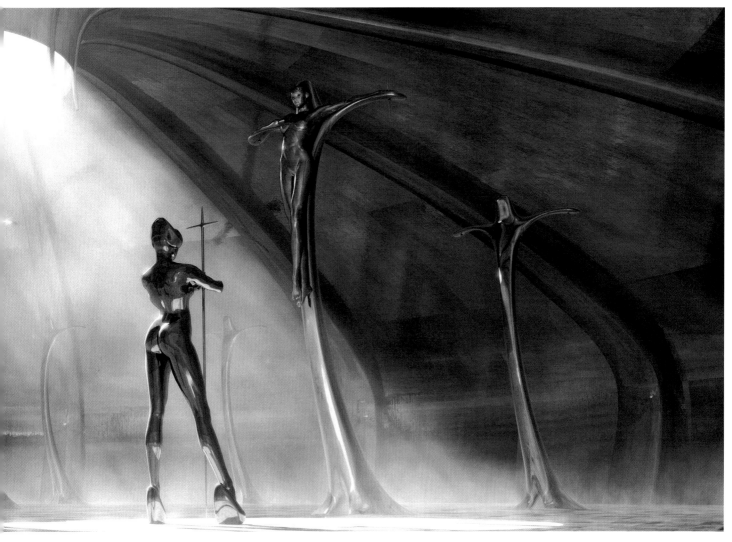

Cross
Poser, CINEMA 4D
Benedict Campbell,
GREAT BRITAIN
[above]

Andrew Jones
Reminds me of my time as an alter
boy in Catholic school...

Black rain
CINEMA 4D, Photoshop
Benedict Campbell,
GREAT BRITAIN
[top right]

Andrew Jones
I'm a sucker for these super complex
3D paintovers. If I can't understand it,
it makes it cooler.

Tresixxx
Photoshop
Coro Kaufman,
Massive Black Inc., USA
[top left]

Andrew Jones
My brother from another mother; the infamous El Coro. There are days where I just don't know where I would be in my life without this man. He is my rock.

Five cents
Photoshop
Coro Kaufman,
Massive Black Inc., USA
[above]

Andrew Jones
This is a painting of a woman who frequents the street Coro lives on. She asks for 5 cents all day long. We believe is part of her interdimensional mission to collect nickels.

Boo
Photoshop
Kemp Remilliard,
Massive Black Inc., USA
[top right]

Andrew Jones
This was done for the "Last man standing" competition on ConceptArt.org. It's riddled with inside jokes that you'll never get.

The Truth
Photoshop
Coro Kaufman,
Massive Black Inc., USA
[above]

Andrew Jones
No parking 12:01am to 6am Monday for street cleaning.

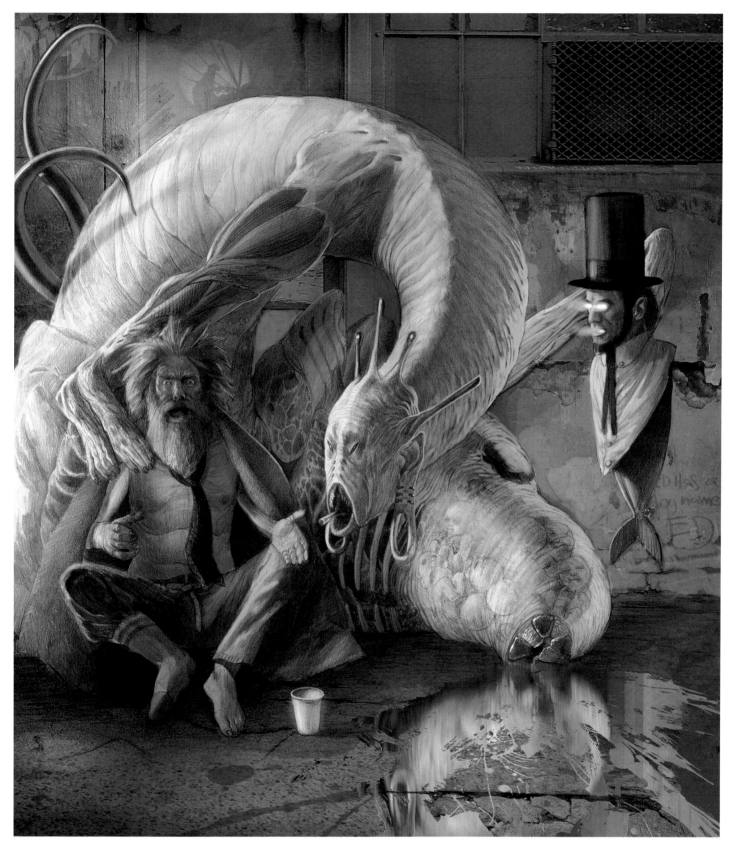

Essay Loko
Photoshop
Coro Kaufman,
Massive Black Inc., USA

Andrew Jones
The reflections in that puddle still give
me the chills. There are times when
I wonder how many years it will take
before my hallucinations overwhelm me,
and I become just another character in
Coro's universe.

NICOLAS BOUVIER

Nicolas "Sparth" Bouvier has been an active artistic director and concept designer in the gaming industry since 1996. Born in France, he now lives in Dallas, Texas, where he is working for the company id Software. He admits a fascination for technological discoveries, space, all sorts of flying objects, as well as for everything connected to the depiction of the future. One of his great passions is contemporary architecture, where he applies principles in his own art, with an experimental and original approach. He also harbors a fascination for modern skyscrapers, although he admits that he wouldn't be able to live too high above the ground himself.

le monde enfin
A book cover for a French novel, 'le monde enfin' written by Jean Pierre Andrevon. The book is all about desolation and hope in a ravaged world.

CONTENTS

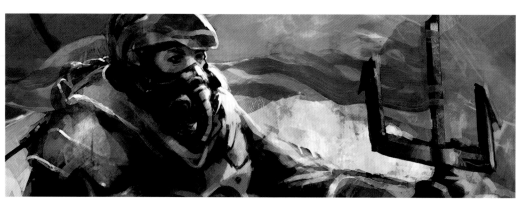

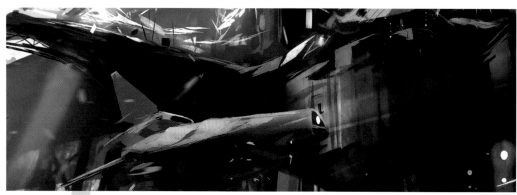

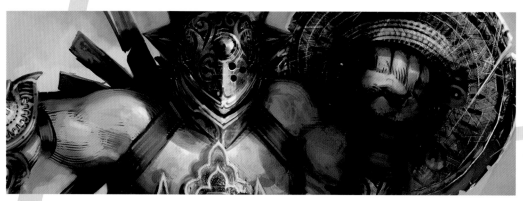

NICOLAS "SPARTH" BOUVIER: THE ARTIST

Background
I started drawing and painting at a very early age—probably around five years old. I imagined stories with talking animals who I put in humorous situations. I guess it was the only thing in which I felt differently, thought differently, and acted differently. Later on, my mother encouraged me to continue along the same path. For this reason, I logically felt there was really something going on when I created, and I've continued along this path ever since.

Education
At 15 years old my art teacher told me I was going to the "Art Deco" school in Paris—the best art-related school with the beaux arts at that time. My teacher was more convinced than I was that I would make it there! Four years later, I passed the exams for this school and succeeded in the first year. It was really a personal challenge at

the time, as the exams were tough. At that age, my philosophy was to rush forward and never look back, no matter the obstacles. At times when doubts crept in on whether or not I would make it, the philosophy gave me the confidence to continue.

Going digital
My first non-art related experience with a computer started while living in Singapore in 1983, when my father bought an IBM PC. It had no hard drive, just two floppy disk drives and a DOS boot disk! I spent endless hours playing Ultima 3 with my brother, which though not really creative, was a lot of fun and was my introduction to computers. I started creating on a computer much later in 1991. I had already spent a year in a preparatory school in order to acquire a more serious traditional background. When I arrived in the Decorative Art school, we started

having computer classes. They had several Macintosh systems, and teachers showed us how marvelous the digital world was. I must admit I followed the courses with little interest to begin with. I didn't do much more than play around, but did become acquainted with Photoshop and the use of a graphics tablet. I kept using traditional tools during my first years in the game industry. I did approximately 80% of my work for 'Alone in the Dark 4' (2001) with a regular graphite pencil and paper. Later on, my friend Benjamin Carre encouraged me to really discover how to paint with a computer. He was way ahead of me in this area and was already doing a lot of book covers digitally. I cannot believe how slow and reluctant I was to change my everyday habits and go digital. I think that success in this field can be reached with two formulas: the first is being able to team up with the right

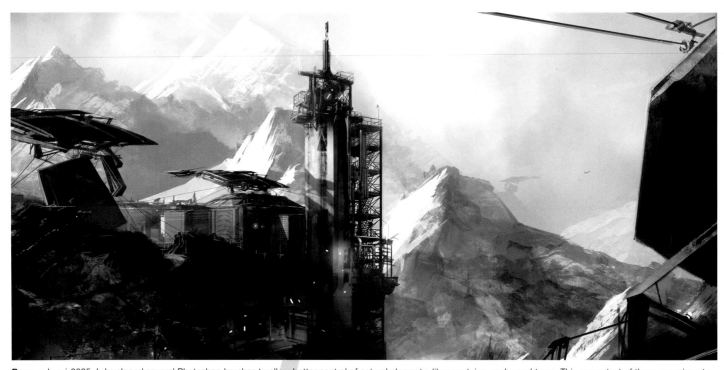

Bamon: In mi-2005, I developed several Photoshop brushes to allow better control of natural elements, like moutains, rocks and trees. This was a test of these experiments.

people at the right time; and the second is to be passionate. Passion isn't easy to describe or acquire when it is not there from the start, but there are many ways to train your tastes as well as find your specific fields of interest. Passion is vital as it is the real motivation behind any creative process.

Tools
To keep it simple, the only tool I commonly use is Photoshop. I have never been disappointed by the speed of response of the program, so I'm sticking with it for now. Painter is a great tool. I've tried it a few times, but that's the way it goes for artists—you stick with what works for you. Once an artist has mastered a program, it's hard to break them out of their regular routine and habits. I also have to admit that my

schedule has not allowed me to explore all the possibilities of Painter. The other downside is that it would be hard to switch tools in the middle of a game production. Photoshop is such a great tool, and I find that the possibilities of the brush editor are infinite, and I'm also particularly fond of the layering and blending techniques. I'm convinced that the mixing of 2D and 3D techniques will eventually become the norm for concept artists in the future. I think this will be a combination of 2D artists adopting more 3D tools and 3D artists adopting more 2D tools. The main challenge for current concept artists will be to keep up with the programs and once again escape from our regular habits. The world of creation is moving at a very fast pace so it will not be an easy task.

Technique
Apart from my traditional artistic background that has spanned approximately ten years, there are two key periods in my creative life where I feel my skills took big leaps forward. The first was around 2002 when, with my friends Benjamin Carre and Bengal, we created a lot of work for Darkworks Studio, a game studio based in Paris. The second important period was in 2005, when I learned and improved a lot of my Photoshop skills through my friends from the Ubisoft team in Montreal. To be more precise, we discovered techniques to improve our creations by using specific template brushes that would speed up the creative process and give a stronger feel to the illustrations. A great deal of the techniques you pick up along the way come from friends and colleagues.

Concept art for games
I started working for the video game industry around the end of 1996 in Paris. When I look back on that period compared to today's industry standards a lot of things have drastically changed. The concept design industry was just emerging in 1996. We all looked to famous artists like Syd Mead and Ralph McQuarrie for inspiration. There was also a great talent pool working in the comic book industry. But digital art was still an abstract concept to most, even though Craig Mullins had released many revolutionary images for the game 'Marathon' in 1995. In a way, these images flagged what changes were going to take place in the coming years. Concept design was already a mature discipline, but it was done in a very traditional way

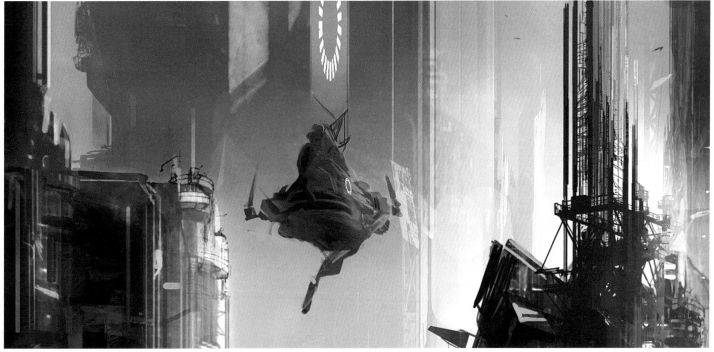

Dune: A preliminary sketch for a Dune book cover.

with pencils and drawing tables. Color pieces were rare, as it was difficult to include acrylic color concepts within the time limitations of a production. The time factor was not the only drawback. Once the image was done there was no way of modifying it—there was no "version 2" for acrylic paintings. It took ages for me to acquire the digital techniques to create good artwork—especially if you consider that I started messing around with my first Wacom tablet in 1995.

High-profile games
I worked on minor French projects and demos before really taking care of the art for a high-profile project with 'Alone in the Dark 4' in 1998. This was a long project, with little material to start with. The most satisfying project

I worked on was definitely 'Prince of Persia: Warrior Within' in 2004. The project lasted a year, and the heads of the production had a clear idea of the direction they wanted to take the project. It is a pleasure working under these conditions, where you know that 90% of the pieces you've been doing will end up in the game in one way or another. Productions vary a lot between companies. There are a huge number of parameters that can alter or improve a project: the amount of people; professionalism; the schedule; internal organization; and not least that every company has a different cultural approach to making games. The different approaches can feel a little chaotic, but they also make the adventure more interesting.

Breaking into the industry
There's a great deal of advice I could share with potential concept artists, but there are two that are more important than the rest. Firstly, don't make the move to digital without developing at least a basic traditional artistic background. If you're in a hurry, you should aim to learn both side-by-side. Within the huge population of today's artists the best are often those who started traditionally, and then slowly switched to digital later on by going through a smart process of their own. My second piece of advice would be to never forget about the world surrounding you. The more you learn about the intricacies of this world, its cultures, and global knowledge, the better you'll be able to express yourself with your art. Art is not about being a specialist in a narrow field of knowledge. On the contrary, art

is a process of retranslating the world and its visual principles on a larger scale. It takes a lot of time, observation, and analysis.

The future
I'm very happy in my role at id Software after moving jobs twice since 2003. I now have a young family to think of, and id Software has given me the opportunity to create things in a very open and exciting way. The company truly represents a small but amazingly creative family, and I feel privileged being a part of it. An entire life will not be enough in order to fully accomplish what I want in the artistic world, so there is no way I can think about doing anything else in the near future. The urge and passion to create has never left me, and while the engine is still running, there's no point in removing the keys.

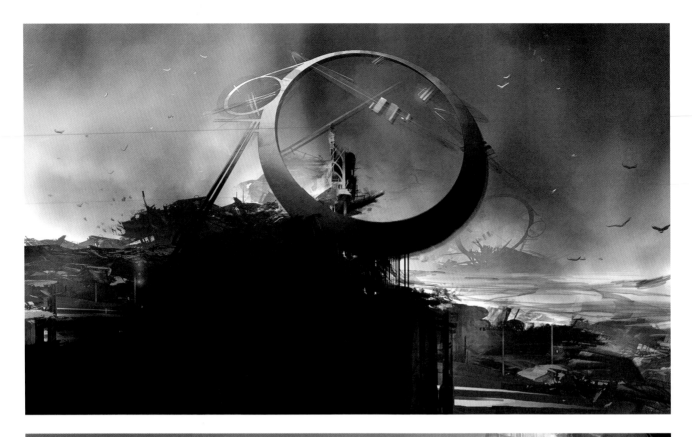

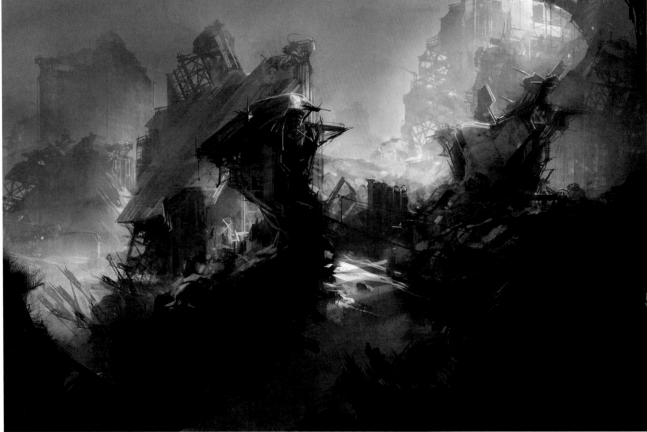

Dump poetry

I absolutely love to develop post-apocalyptic landscapes. I feel there's so much to imagine within this theme. This simple composition was put to the service of the main elliptical object. I often give priority to the initial concept instead of going further into every detail within the piece. [top]

Discontinuity

This was created in the same fashion as 'Dump poetry'. The composition is organized around a central path, dividing the piece into two equal parts. This comes from the fact that I had imagined this sketch as two parts of a wide horizontal book cover that would have spanned two different books. [above]

The alert

This artwork had been created for a Philip K. Dick book collecting many of his short stories. The theme was really developed around the concept of soldiers defending the Earth in a very typical space opera theme. [right]

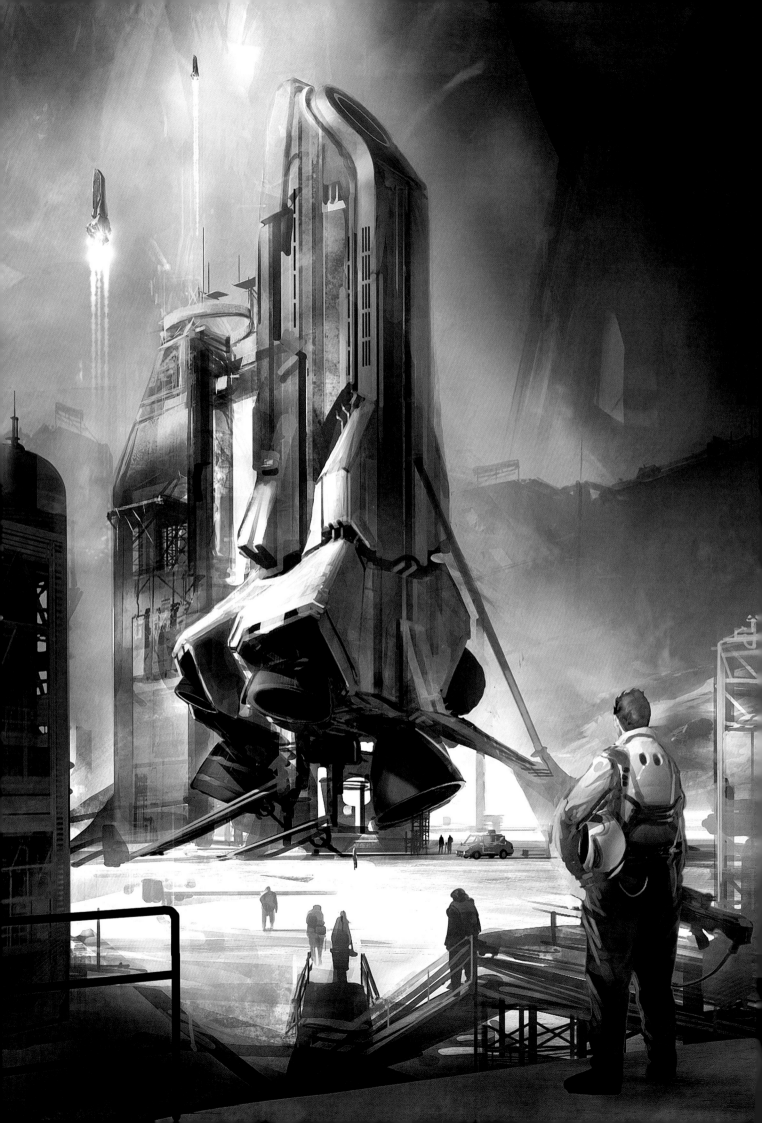

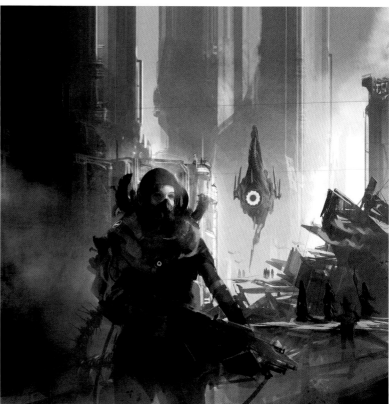

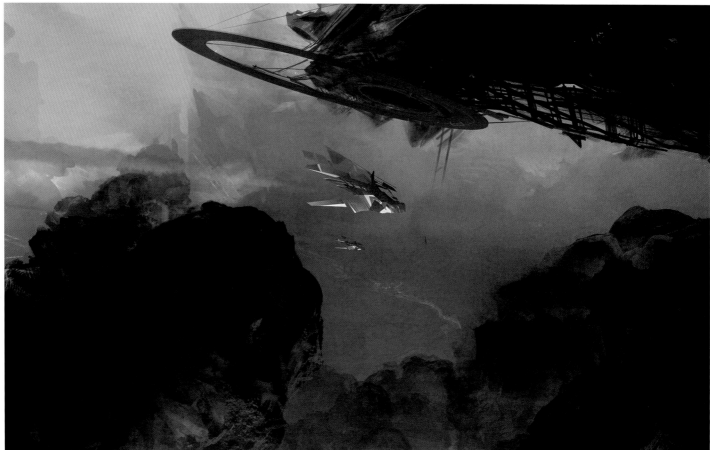

Paul Atreides riding the worm
I wanted a sense of pride and the epic for this illustration. The main character had to be standing to attention, as though on ceremony. Three characters sit in the background to show depth and add a feeling of vertigo. [top]

Vyle lava
An image created as a tribute to my friend David Levy aka "vyle". The rocks in the foreground have been done with a brush David invented. I am still using this brush a lot today. [above]

Chapterhouse Dune cover
This image shows the importance I sometimes give to graphic aspects of an image. Basic shapes are useful to describe objects or characters. No need to add all details—add the main ones and the viewer's brain will add the rest. [top]

Lapsang area
I often go back to the subject I appreciate the most: futuristic architecture. Lapsang area is one of these pieces where I'm trying to depict an original urban landscape. [right]

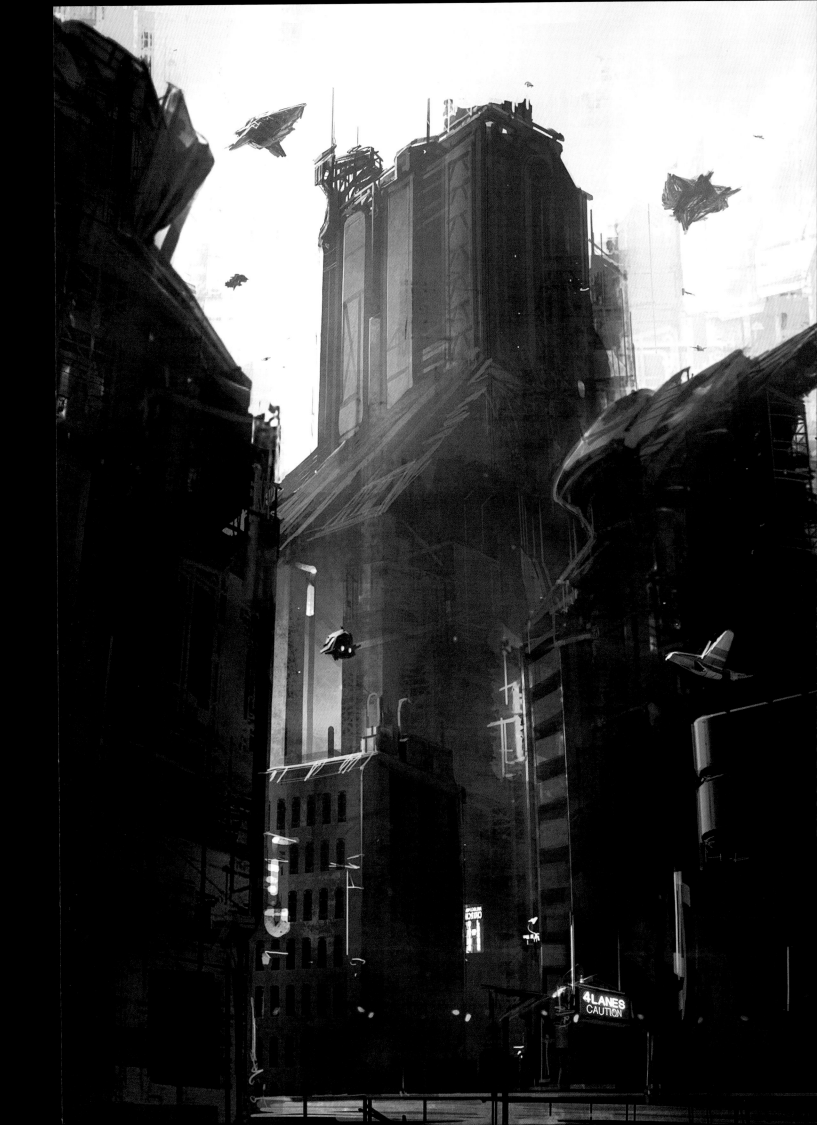

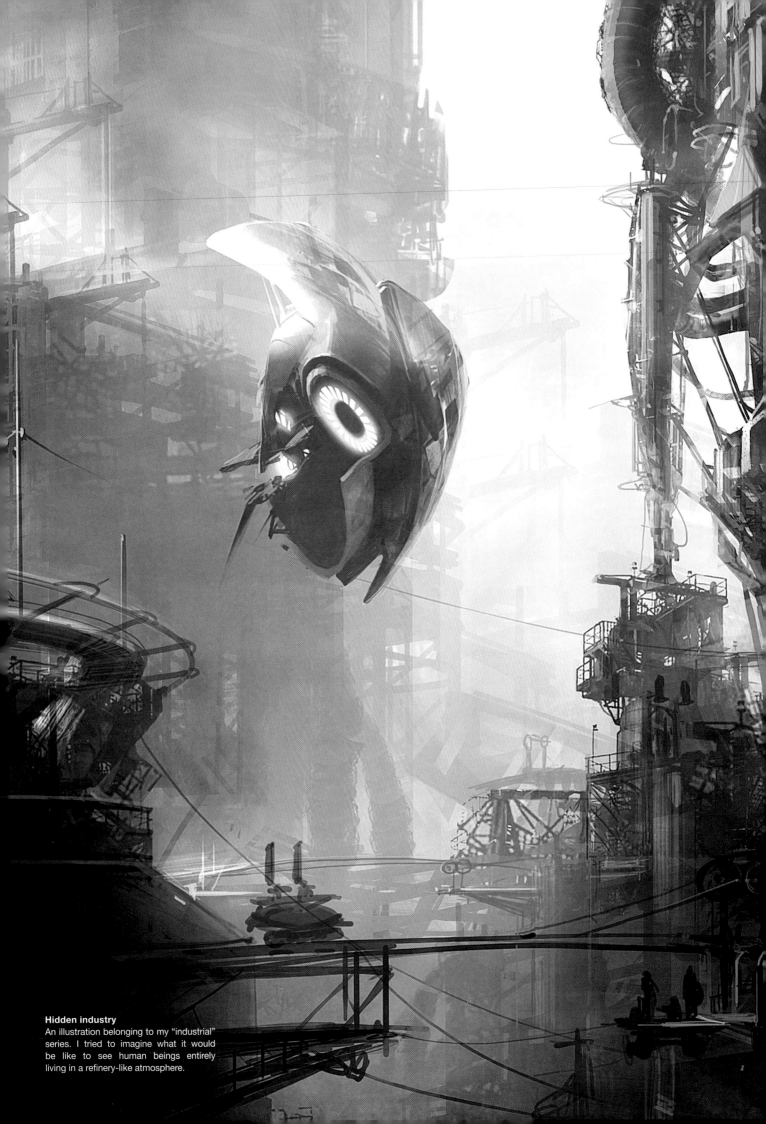

Hidden industry
An illustration belonging to my "industrial" series. I tried to imagine what it would be like to see human beings entirely living in a refinery-like atmosphere.

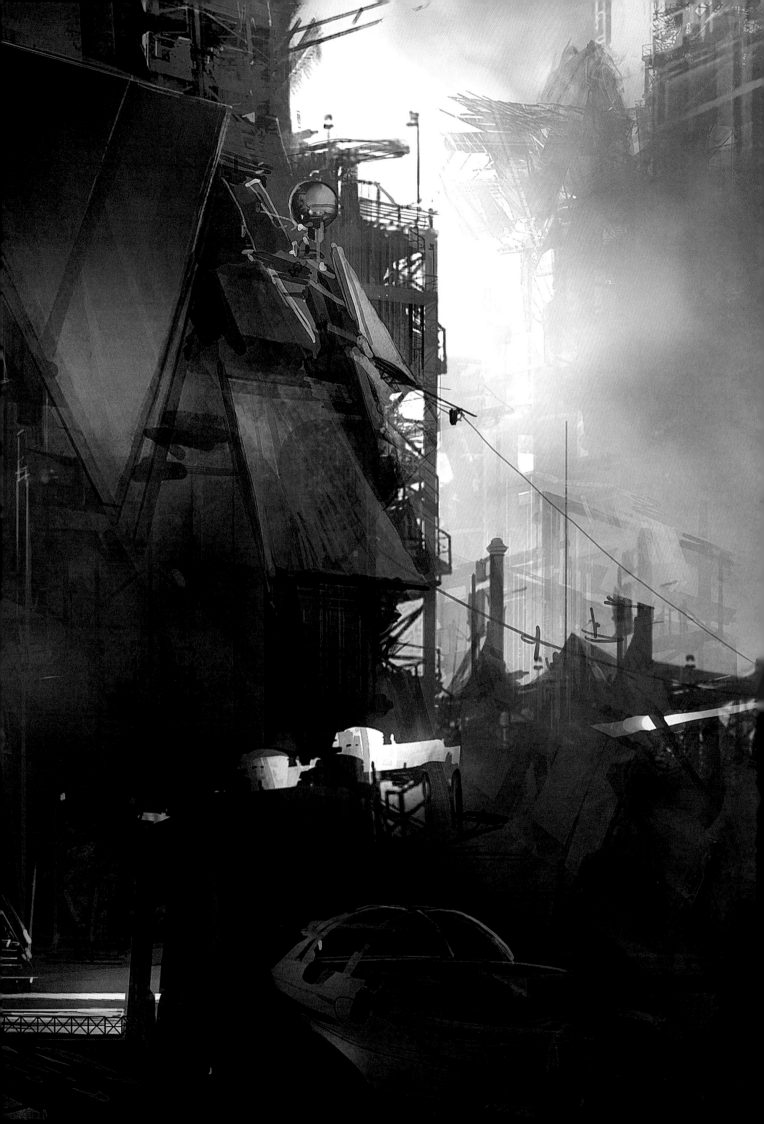

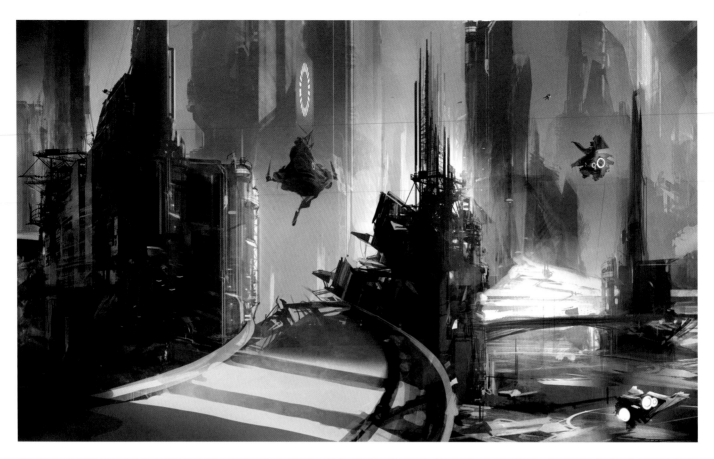

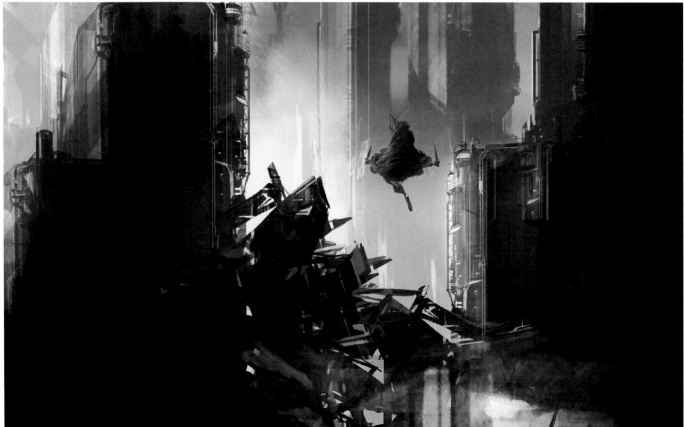

Maison des meres

I went through many sketches to reach the final result for the cover of 'Chapterhouse Dune'. These two works belong to this process. The composition of the first sketch is heavily focused on the large highway in the foreground. The second is aimed at determining the vertical architectures for the scene. Both sketches were extremely useful for the final version. [top, above]

Low larva

Low larva is a very vertical piece with multiple subjects. There's a lot to see, and apart from the main flying ship, the composition is pretty much exploded into several areas. On the lower area, you can observe these little bot devices grabbing materials out of the ground. [right]

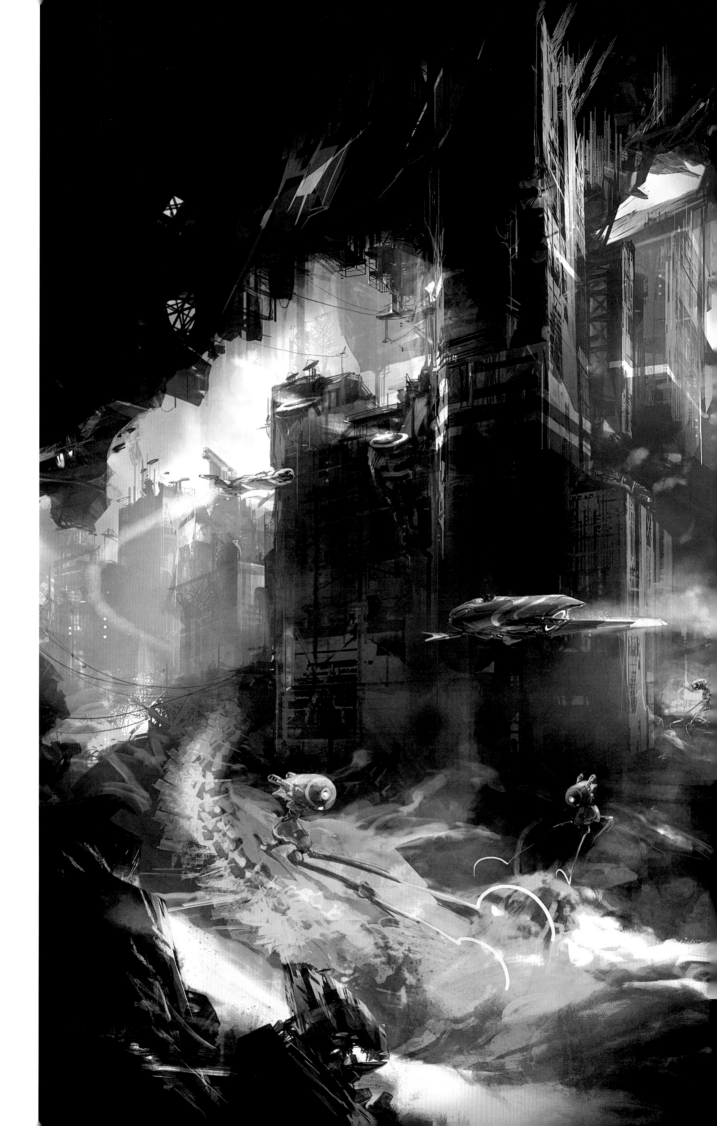

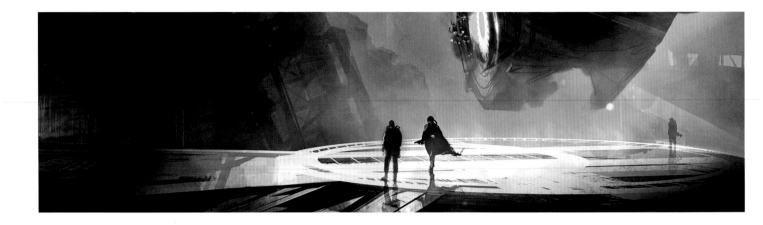

CONCEPT ART: ELLIPSOID COMPLEX

Inspiration and subject matter

This is definitely a personal piece, in the same spirit as the conceptual artwork I have created over the last two years. I've always been fascinated by space—largely due to the fact that I used to live in Florida and clearly remember how we would get out of our classes every time the space shuttle would take off from Cape Canaveral. My fascination with space probably comes from an initial frustration of not knowing what the future would look like. The best way to overcome this frustration was to imagine the future myself, and visually describe it as much as I could. It was a creative way to get around a roadblock, and it did help me to build my conceptual skills.

Technique

This image was created in Photoshop. The most important fact about the scene is that it was built mainly with custom brushes with the help of complex templates and portions previously created illustrations. In other words, the idea is to plan all of your forms from the start, eg walls, metal pieces, objects like spaceship engines, wings, metallic staircases, and even humans. You then transform all these objects into brushes, and use them afterwards as stamp tools, in the smartest way possible. It does take a great deal of practice to master these techniques, but it is definitely rewarding once they become second nature.

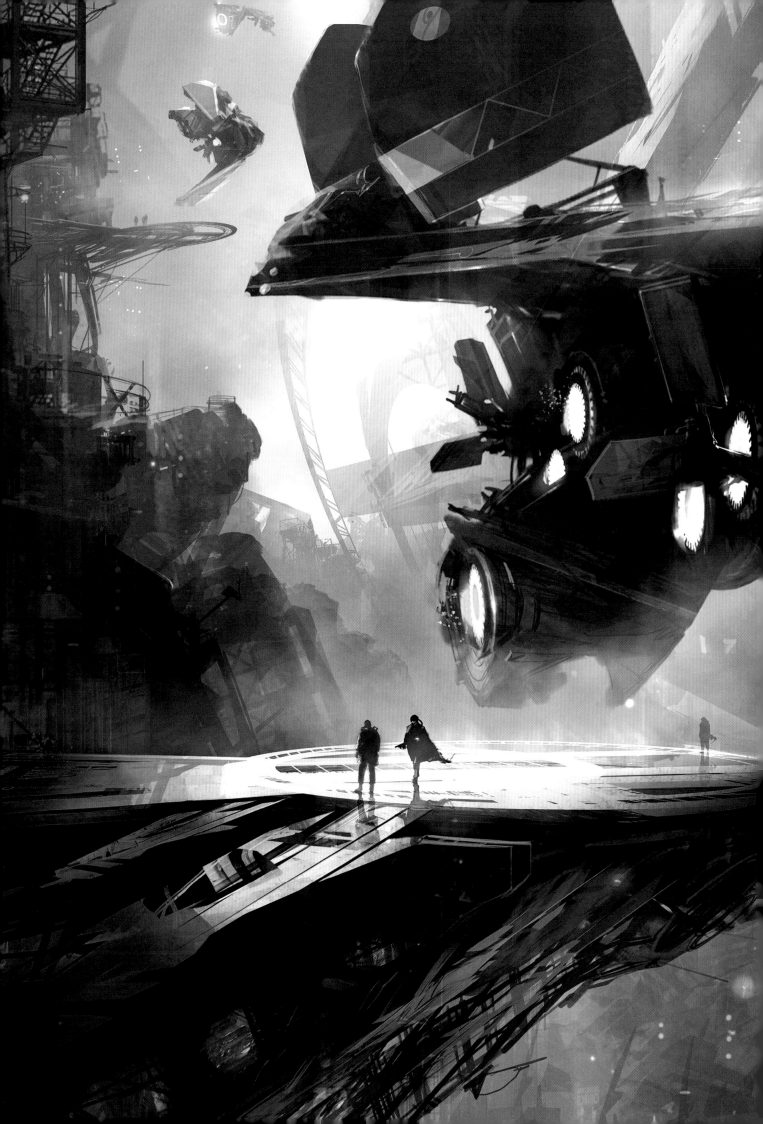

Background

I have several different ways of starting a painting, but here I decide to directly apply a colored background. Most of the time I start throwing in the basic forms in black and white only.

Mid-ground

The starting concept is a space theme, so the main details to start with are that it will be an outdoor scene and there will be a spacecraft central to the artwork. I have a large number of complex custom brushes in Photoshop using features such as dual brushes and textures. I tend to use these brushes at the beginning of the process.

Foreground

I start working on the foreground with a main landing platform for the spacecraft. I keep the lower right corner of the image free of any objects, as I really want to emphasize the feeling of height. To create the platform I used a complex custom brush, then distorted it by bending and flattening it to put it in the right perspective.

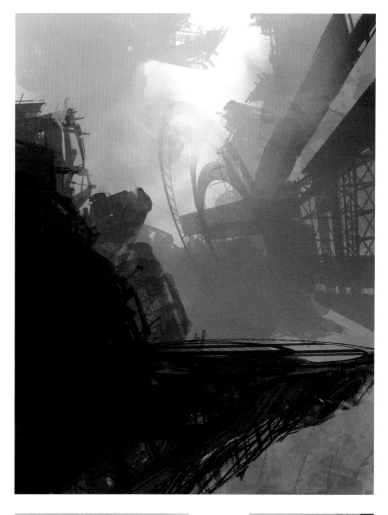

First highlights

I start to detail the platform a bit more to gain an idea of what the depth of the scene will look like. The brighter tones on the platform have been added by modifying the brush angle and roundness before applying strokes on the canvas.

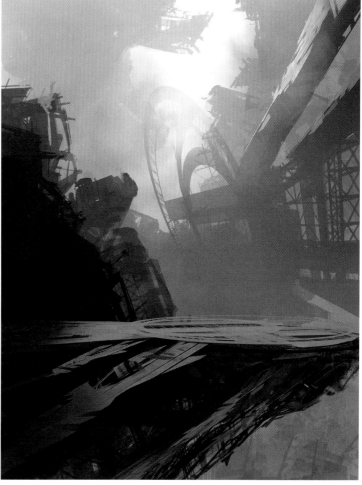

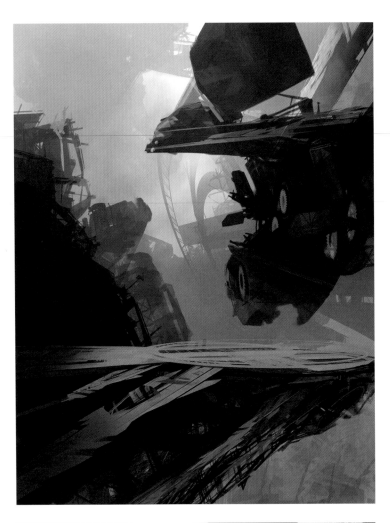

The spacecraft

The craft to the right of the scene is a 2D image which I create outside of the main illustration to add to this composition. Once placed, I refine the placed spacecraft's main outlines.

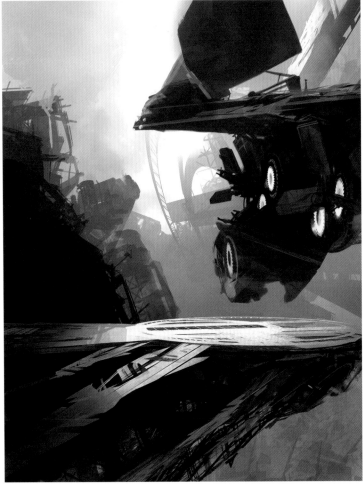

Light and composition

I add a dodge light for the spacecraft engines as well as in the background and foreground. The main intent here is to improve the composition by further dividing the dark and bright areas.

Color overlays

I add the first color details to the scene. This is done by adding several overlays, one on the top of another. I often use elements of previous illustrations in order to find these main color themes.

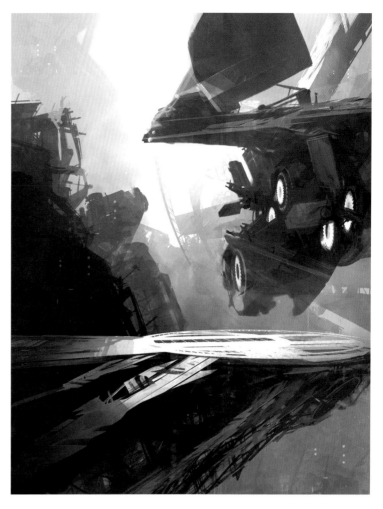

Improving details

This is a very important step. First of all, I decide to desaturate the whole scene. I then start a series of refinements to improve the overall image. I add more clouds to the sky, as well as luminosity to the lower right to create more vertical depth. I also spend time defining the buildings on the left and add a second smaller landing platform to create a nice background/foreground rhythm. Finally, as I find the foreground too grey, I decide to add more contrast as well as more shadows under the main heavy structure.

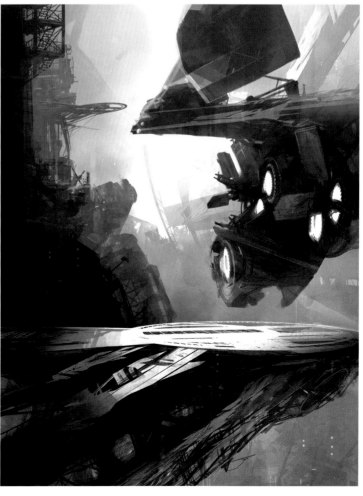

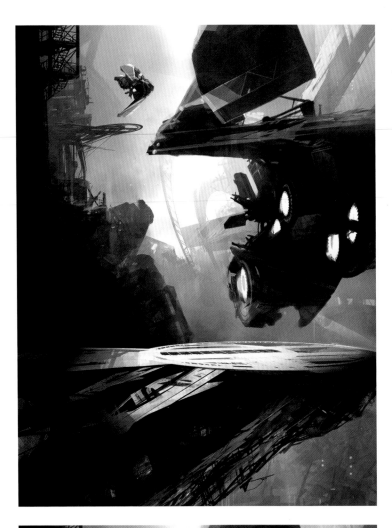

Go green

I changed the general hue to a much greener atmosphere. I often make these types of sudden changes during this process—it's all about letting the image speak for itself. An uninspired process where everything has been defined and planned from a to z will produce an uninspiring image. I'm convinced that leaving the door open to color changes right up until the end of this creative process helps a lot.

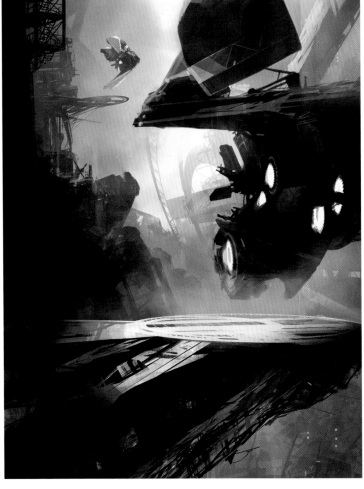

Atmosphere

I have to get a better grasp of the atmosphere. There is too much luminosity coming from the sky in the background planes. Reducing this luminosity will allow me to add more interest to the main large spacecraft. This is pretty logical, as the human eye is naturally attracted to the bright areas first. For more interest, I add smoke and particles around the ship's engines as well as in the upper section.

Lights

I decide to add detailed lights in several locations around the scene to increase the sense of realism. Smaller background lights contrast with the larger foreground lights to create a better sense of scale.

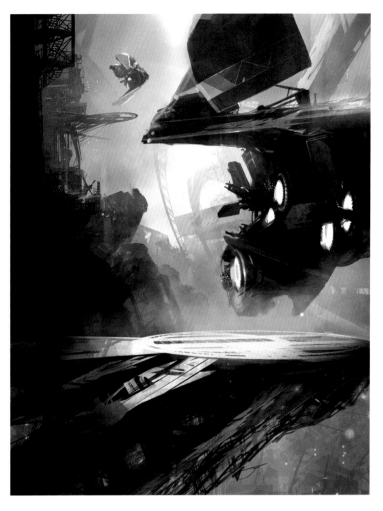

Refining the structure

I find the spacecraft's upper wings unbalanced and illogical. My solution is to add a second vertical wing just behind the first one which gives the craft a certain symmetry and adds to the realism.

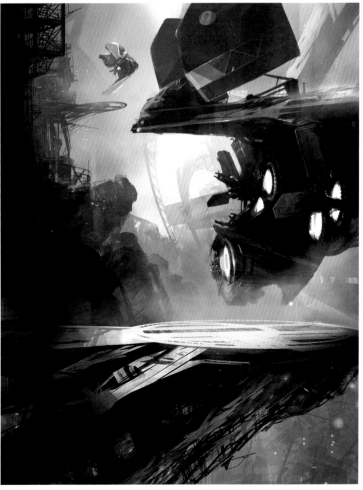

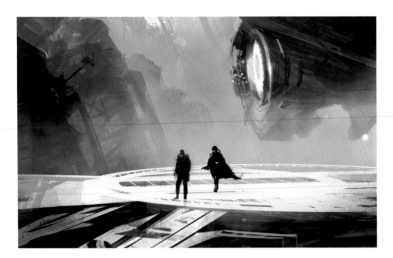

Hovering pilots

I add human silhouettes on the landing pad. They appear to be hovering above the surface, so I'll need to put them back on a solid surface.

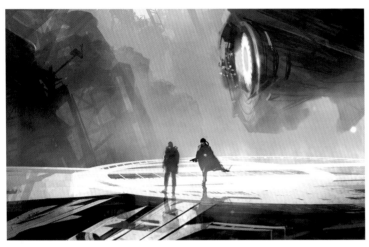

Grounded pilots

I add reflections to the characters on the platform. I also add dust flying around them to better place them into their environment. The platform is receiving light from the sky (especially from the viewer's angle), so I emphasize this reflection and add a stronger Dodge layer all around the characters.

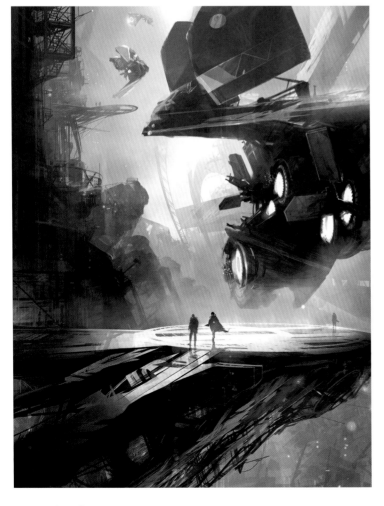

Final touches

Time to take care of the background. I start by adding very tiny people on the distant platform. The extra activity helps to tell some of the story of the scene where several vessels are landing and taking off at the same time. It helps to sell the idea of an epic environment as well as developing the concept of simultaneous events taking place in different areas. The most distant spacecraft in the background has been added for the same reason. The visual rhythm of the piece is now complete, and our eyes can establish a strong link between these three vessels, and therefore feel the depth coming up from the scene.

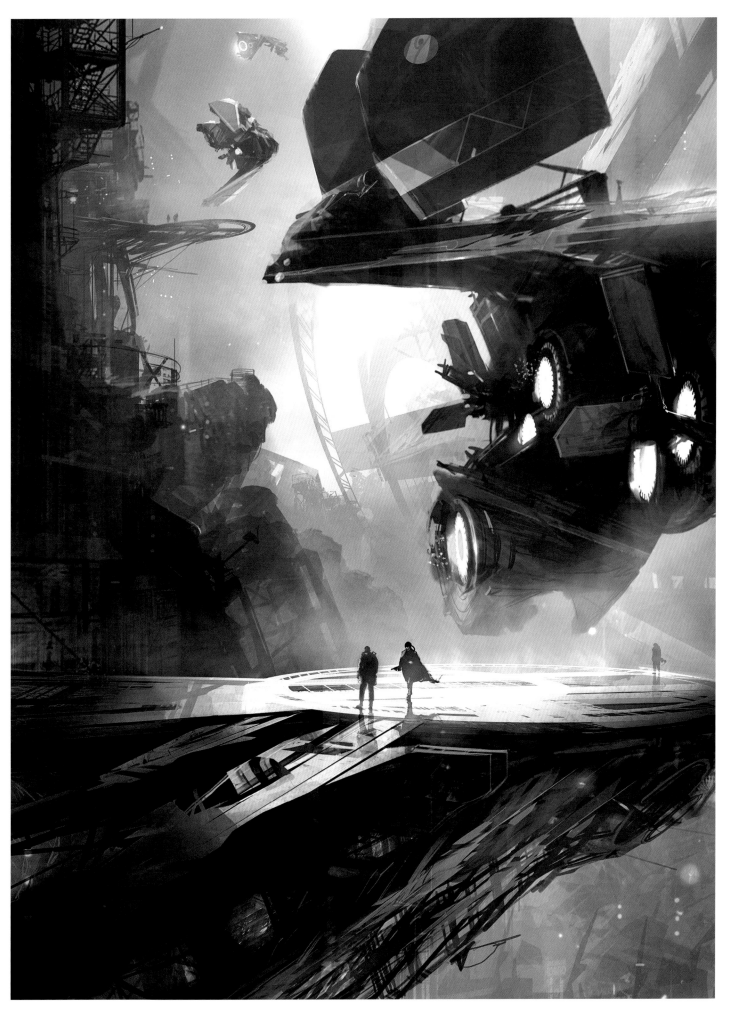

CONCEPT ART: FEAST OF DESTINY

Inspiration

For this work, I wanted to put in place a huge marketplace located on platforms in the air with bridges linking all the areas. I love creating images within the space opera genre, where spaceships will not be affected by any planet's gravity, and where the vertical aspect of cities play an important role in the everyday life of their inhabitants.

Technique

Unlike a few years ago, I now rarely use any pencils or paper to create the first concept sketches of my illustration. I now tend to go directly into Photoshop, open a white canvas, and go for it. This composition was created with a mix of regular brushes, as well as several more complex brushes used as stamp tools. The very first tool I used was a custom brush consisting of a flat line, with modified Shape Dynamics, and the Angle Jitter set to "Initial Direction". It takes some effort to grasp this brush, as each stroke has to be started in the proper direction. I chose this piece as the basis of a tutorial because it underwent multiple steps and changes before finding a result that satisfied me. At several stages I could have decided to keep a particular state and polish it, but I didn't. I continued moving forward, sometimes by erasing unwelcome elements. There is one detail that I won't show in this tutorial for visual reasons, but rather I'll explain it. From the very first moment I lay the stylus on the tablet, to the very last steps of the polishing, there is one action that I use every minute or so—the Horizontal Flip tool. Why? Because when you work on an image for a certain length of time, your eye tends to get used to the composition as well as any errors that might be present in the illustration. Flipping the image often allows you to see all the details with a new eye. It helps spotting and fixing perspective errors, and really helps to improve composition and movement.

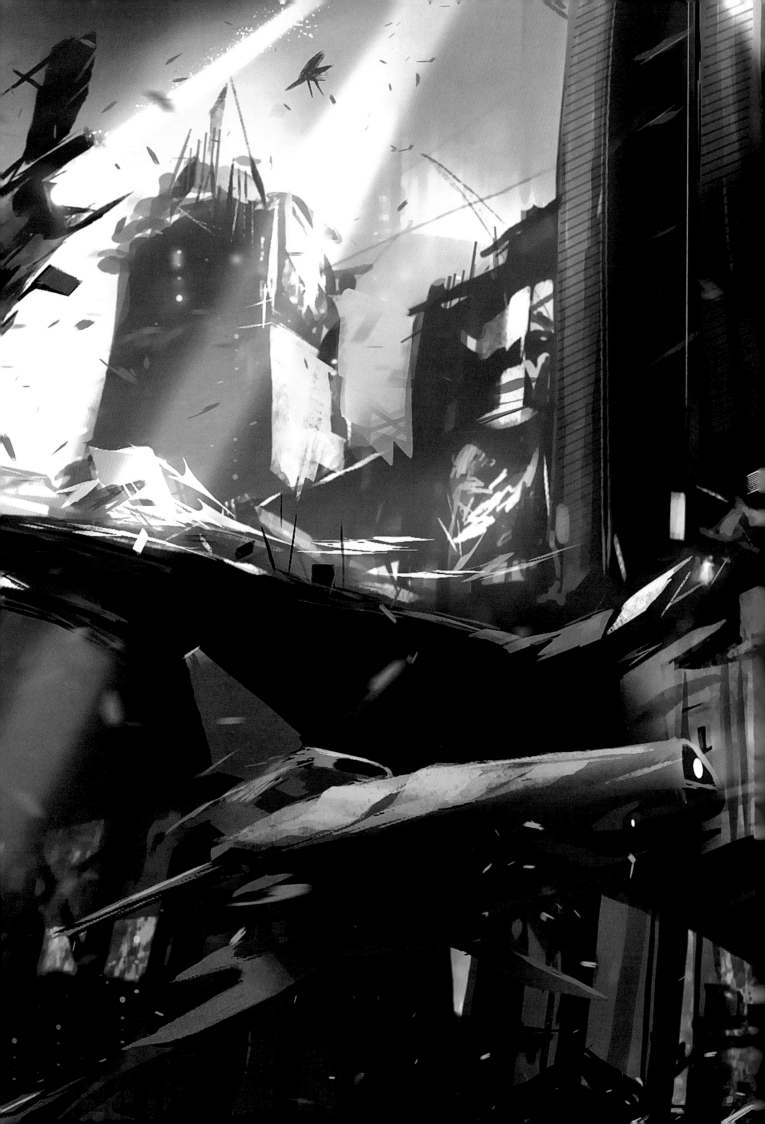

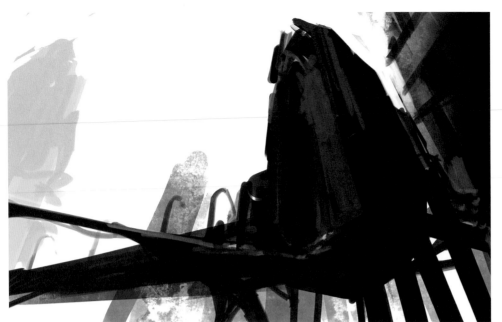

First buildings

My first important step is to take care of the large temple-like architectural structures. You can already observe that the composition has been built on a central vertical line dividing the image into two equal parts.

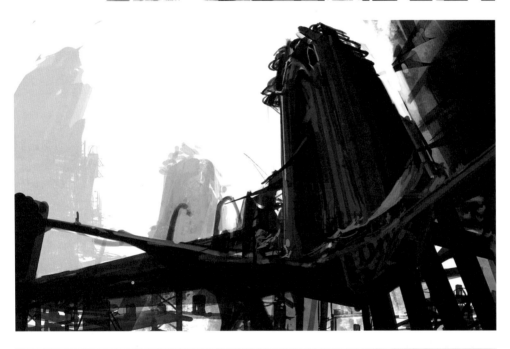

Polishing the composition

The early forms which didn't have any meaning at first are now more defined. We can now see the bridges going from one building to another.

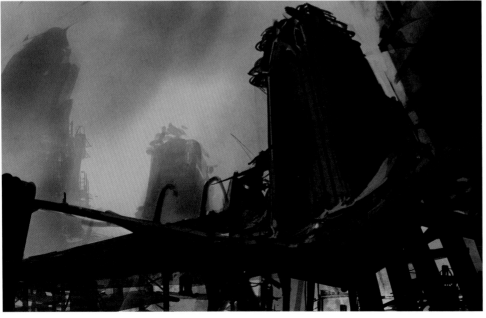

Atmosphere

I start by painting over the white background. I also add depth to the skyscrapers by putting darker tones here and there, in a foggy way. I need to figure out my color palette fast in order to know which direction to move. To do so, I start to add ochres and browns on a new layer with a Multiply blend mode. My main aim at this point is to block out the unrealistic whites in the background.

Darkness

At this stage, I add a layer with a blend mode Overlay consisting of several warm tones going from yellow to orange. I take an abstract approach within this layer to create the tiny details in the scene. I often proceed in the same way, adding color layers in Multiply or Overlay blend modes. This allows me to tweak details within the layers, and take advantage of working in layers.

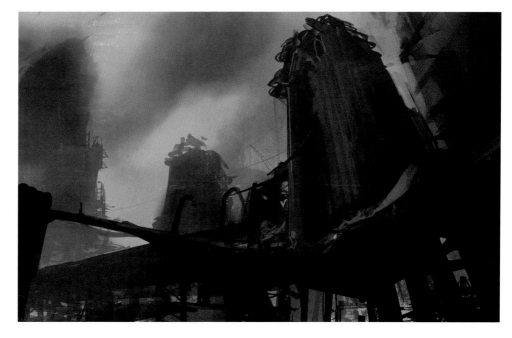

Brightness

I decide to radically change the hue of the image. This is another strategy I choose often, as it helps me to observe my image with a new eye. I also further define the central tower in the background.

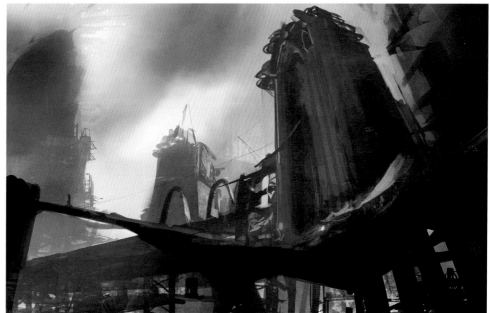

Main spacecraft

I add a spacecraft which will play an important role in the composition. It will remain secondary, as I already know there will be an even larger central subject in the foreground. I also define the left area, dividing the planes to add more depth. The lower left bridge now receives blue light from an outside source. This helps me to put more distance between foreground and background.

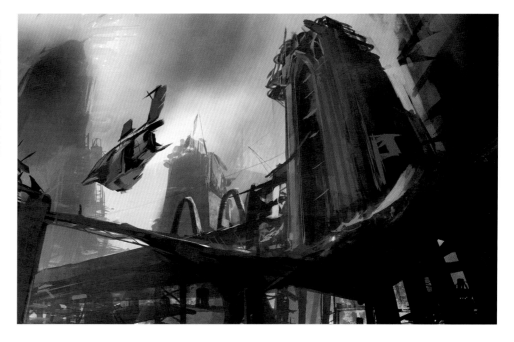

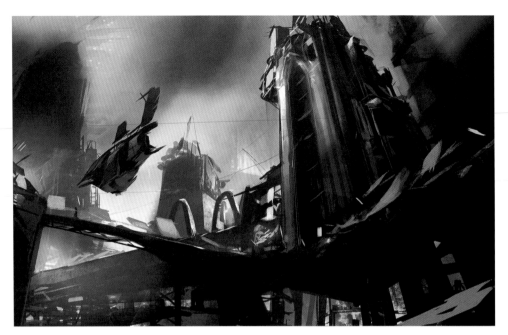

Lifeforms

It's now time for me to think about the city's inhabitants. In a very graphic way, I add tents here and there, as well as green squares which I see as TV screens. I choose very colorful tones for the tents to create a dynamic visual rhythm. I then add a general fog over the whole image giving particular attention to the left part of the scene to bring forward the bridge structure. I also fully define the cathedral.

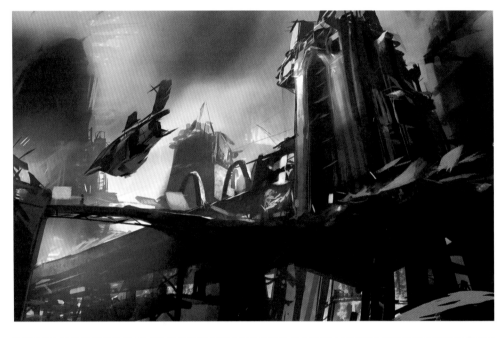

Warp phase one

The Warp tool allows me to drastically modify the perspective to add dynamism to the scene. Even though the buildings are a bit distorted, I decide to keep it this way.

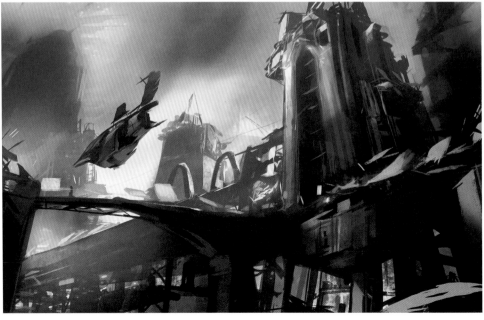

Going green

I decide to modify the hue and color balance again, as well as fix the image contrast with Levels. I lost a lot of orange areas intentionally, and the image has gained a green shade. I find the foreground too black, and start defining the bridge as well as all the structures supporting it.

Warp phase two

After a lot of observation, I find that the composition is definitely not to my taste. I establish a new focus on the central bridge using the Warp tool.

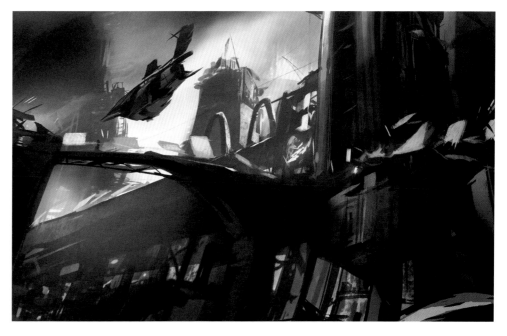

Warp polishing

Some warped areas need to be fixed as I've lost the vertical orientation of my buildings. I start warping areas again, but this time very slightly, doing minor warps, especially in the lower parts of the structures. Now that I know the main architectural structures are in place, I spend time defining the tents and bridge. I find the yellow in the sky disturbing and too distracting so I switch to a blue tone by using a Color blend mode applied only to the sky.

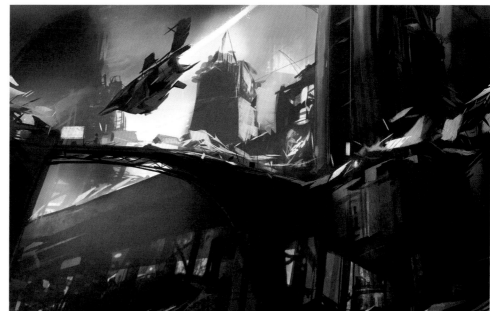

Hue change

The green tones so far have helped me to create the atmosphere I've been aiming for. I still feel there's room to move to give make the environment more striking. After several attempts, I settle on a blue atmosphere that I decide to keep for good. It's now time to refine the city. I add lights with realistic halos, and put more shadows under the tents. In order to not lose details from previous layers, I use a Multiply blend mode on the layer (I tend to use the Multiply blend mode for all cast shadows on objects). I then add a Smart Blur to the whole scene to remove unnecessary details.

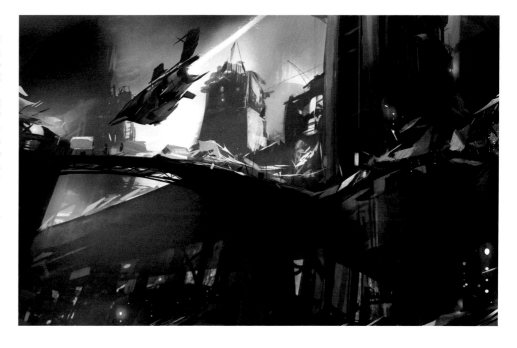

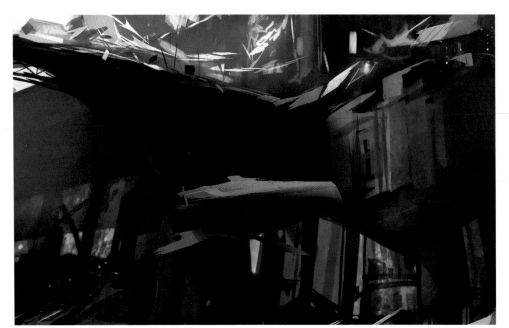

Painting atmosphere

This orange ship is very important for the scene. It is actually the main subject or main event within this futuristic street or passage. I choose an orange color in order to have a high level of contrast between the object and its surroundings. Orange acts as a complementary color when it is put into such a blue environment.

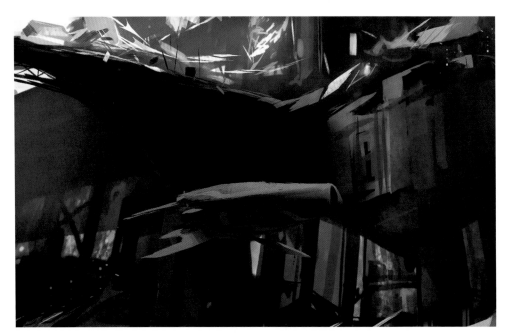

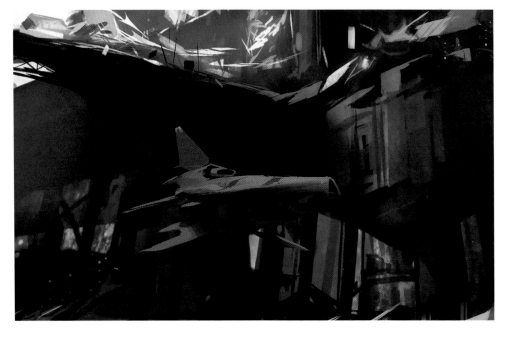

Upsizing

Eventually I realize that the ship is too small, so I resize it to give it more impact. The top of the ship is also too dark, so I add brightness using a few layers with Dodge blend mode.

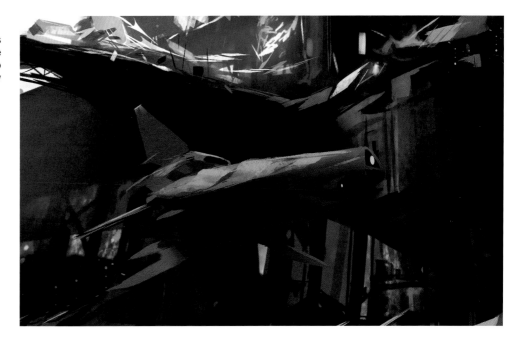

Light beams

The light beams have been added in order to give a more cheerful look to the city. We can now feel that there is an atmosphere of feast or celebration going on. I still find the lower left area too empty for now, and add two small vessels in the correct perspective.

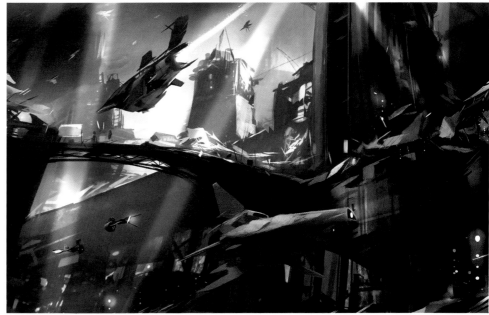

Air particles

I add particles in the air by painting small stick like forms all around, and applying a Motion Blur on them. Whether these are confetti, leaves or pieces of debris is not really important. These air particles are mostly important for their graphic value. They also add a lot of movement and will give the final touch to this "living futuristic city" concept.

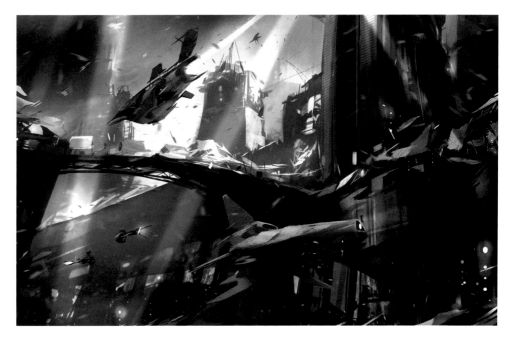

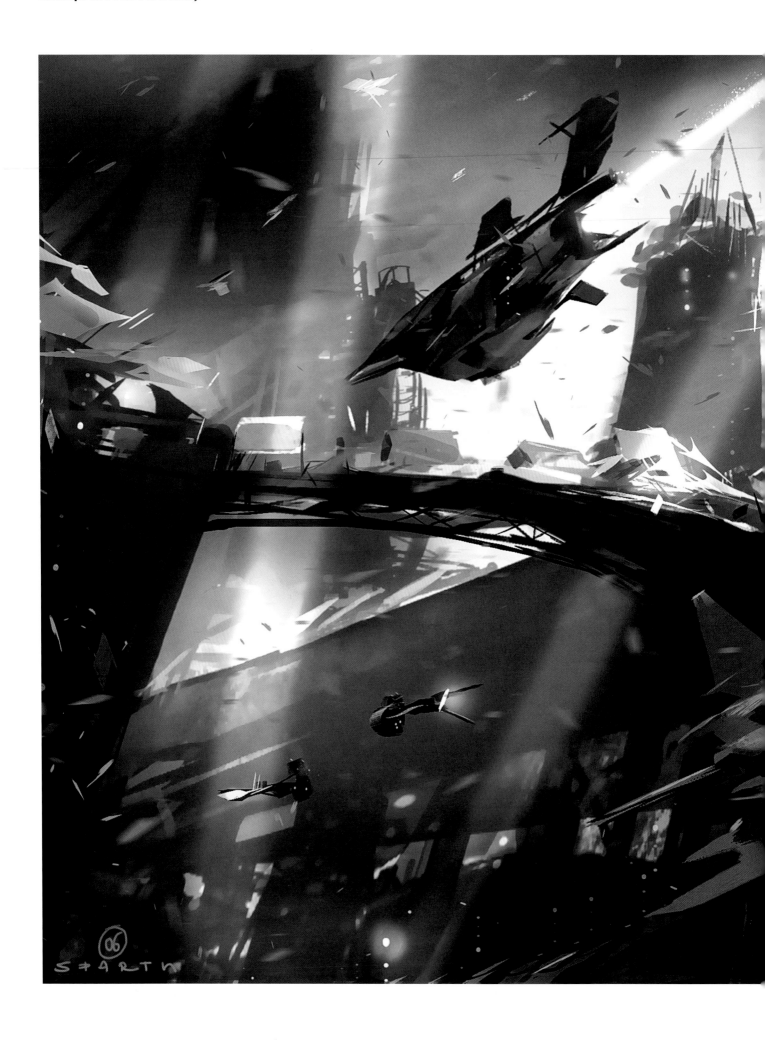

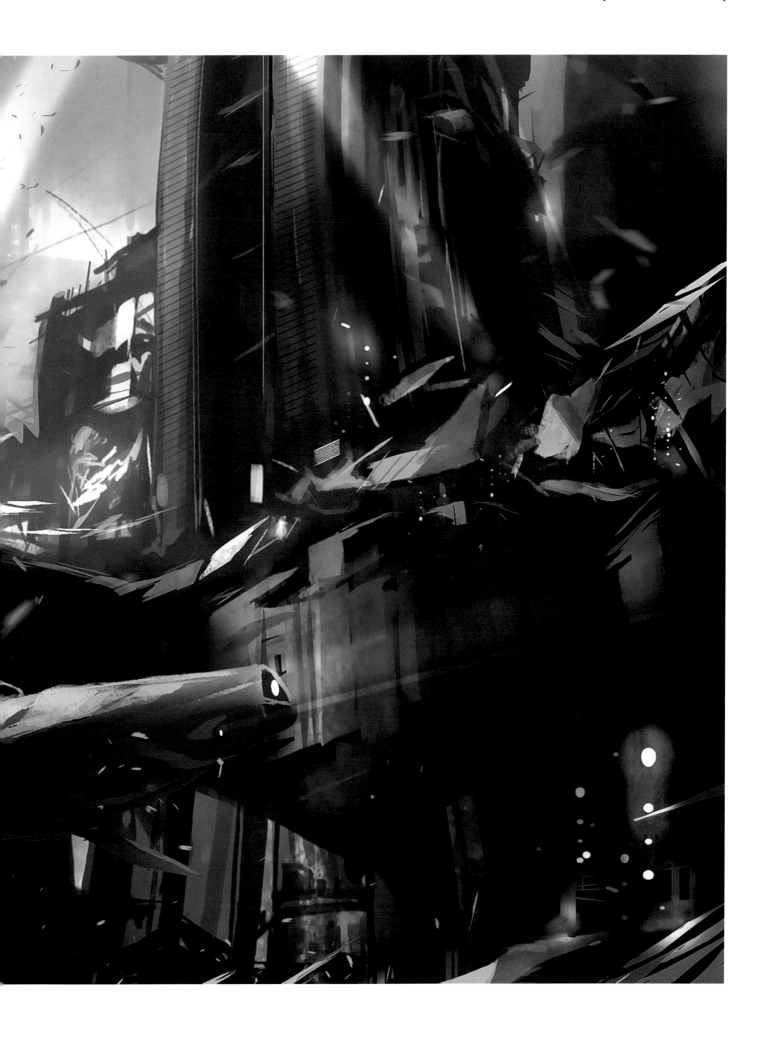

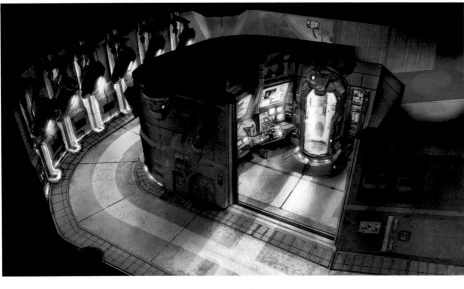

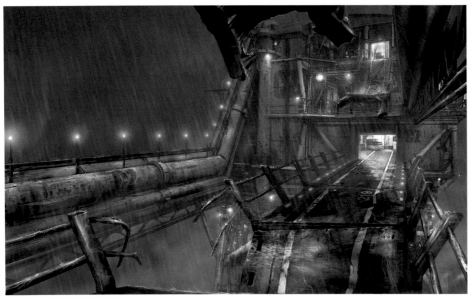

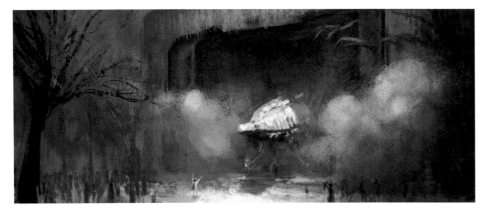

ColdFear: The Experimentation Room
Photoshop, Painter
Client: Darkworks for Ubisoft
Aleksi Briclot, FRANCE
[top]

Nicolas Bouvier
A very defined piece with a predominantly green atmosphere. The hi-tech architecture is spot-on. The strong surrounding dark areas add to the spookiness of the scene.

ColdFear: Heliport Access
Photoshop
Client: Darkworks for Ubisoft
Aleksi Briclot, FRANCE
[above center]

Nicolas Bouvier
Aleksi is a master when it comes to describing scenes where attention is drawn to bright interior atmospheres. Proper texturing also provides impressive results. The rain adds to the sense of foreboding and sells the scariness and danger of the scene.

Unveiling
Photoshop
Ben Mauro, USA
[above left]

Nicolas Bouvier
"Unveiling" shows that a lot of details are sometimes unnecessary to add magic to a digital painting. Details are present only where the viewer would linger: under the ship; or the tiny human figure guiding the vehicle. A strong piece that gets straight to the point.

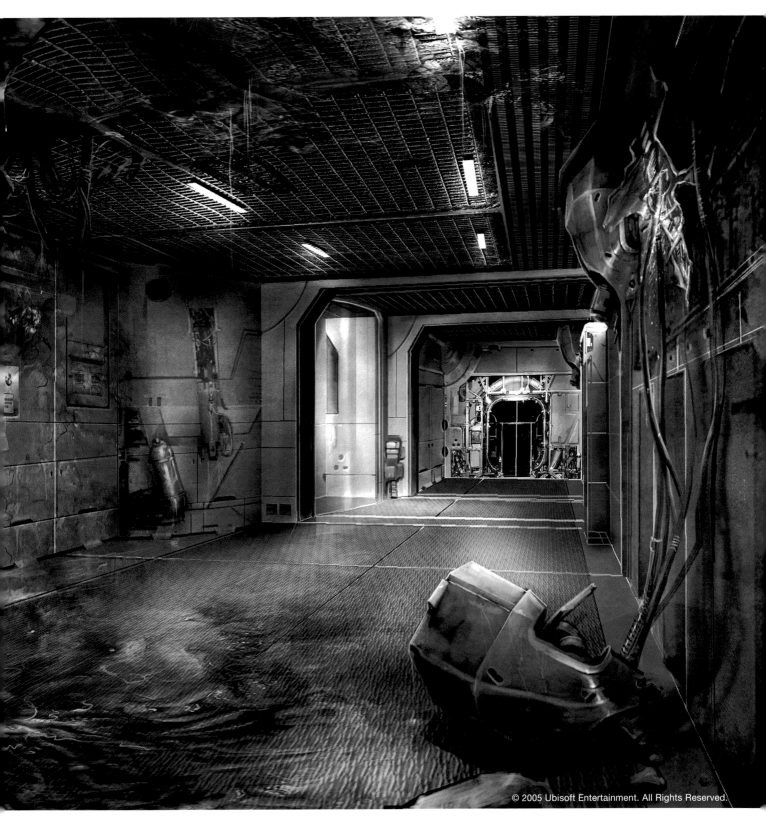

ColdFear Main Corridor
Photoshop
Client: Darkworks for Ubisoft
Aleksi Briclot, FRANCE
[above]

Nicolas Bouvier
A formidable piece of work—especially with
the depiction of the organic details. There
is a very strong contrast between the flesh
areas and the technological architecture.

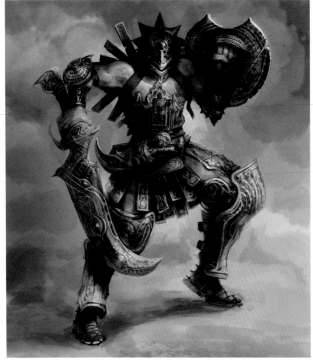

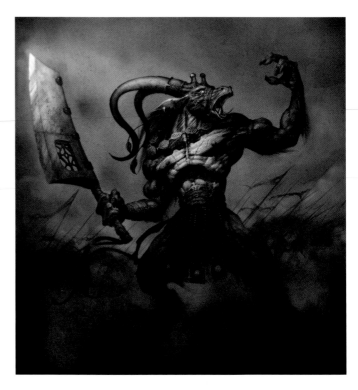

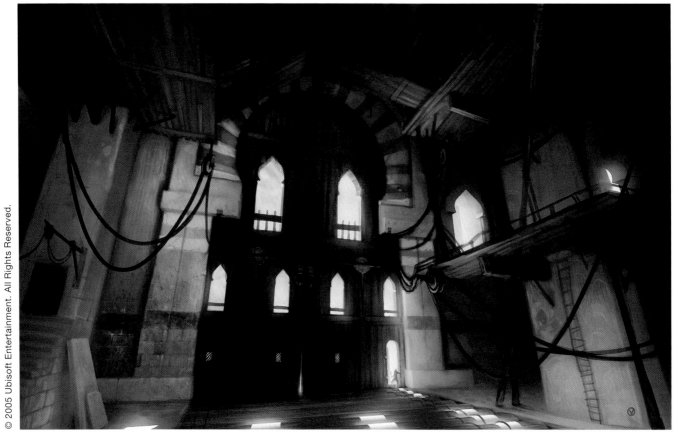

Arena soldier
Photoshop, Painter
David Levy, Ubisoft, CANADA
[top left]

Nicolas Bouvier
David has done an amazing job in describing the decorative ornaments of these gladiator outfits. I was lucky enough to be able to see all the characters of the series in 2005, and the amount of work David did for this project was phenomenal.

King's workshop
3ds Max, Photoshop
David Levy, Ubisoft, CANADA
[above]

Nicolas Bouvier
A very nice design done for 'Prince of Persia: The Two Thrones'. The gigantic sense of scale is provided by the tiny human figure near the round door.

Mad Minotaur
Photoshop
Eric Ryan, USA
[top right]

Nicolas Bouvier
Careful attention has been given to the torso of this creature and the translucent ear directs the viewer's attention to the head. Subtle elements help define the foreground while the background remains sketchy. Swirling dust cleverly hints at a raging battle.

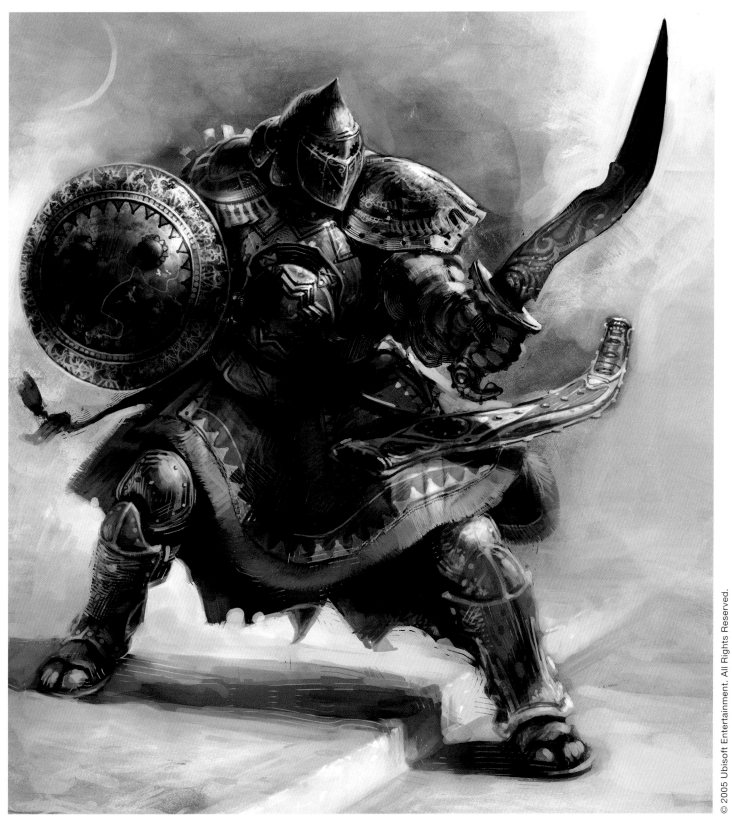

Babylonian soldier
Photoshop, Painter
David Levy, Ubisoft, CANADA

Nicolas Bouvier
The bulky aspect of this armor is really the biggest feature of this image. A very unusual design compared to regular oriental fantasy illustrations.

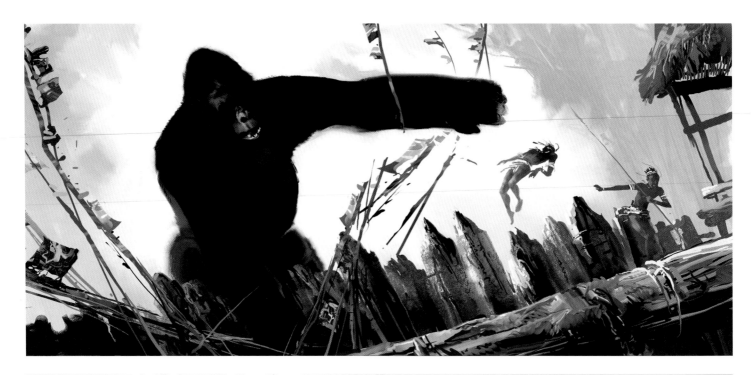

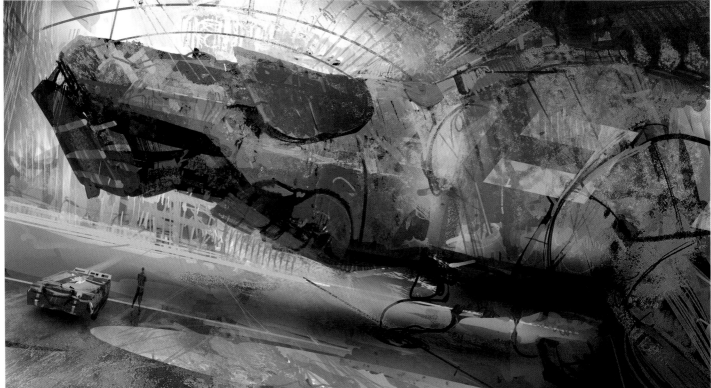

Kong comes
Photoshop, Painter
Neil Campbell Ross, GREAT BRITAIN
[top]

Nicolas Bouvier
This image is one of my personal favorites from Neil. Everything in this scene has been smartly put in place, in a very graphic way. Composition is absolutely perfect—Kong's outline strongly determines the main planes and volumes.

First arrival
Photoshop
Patrick Desgreniers, CANADA
[above]

Nicolas Bouvier
On the brink of abstraction, this illustration best describes Patrick's style and technique. A very intelligent balance of large plain brushes, mixed with personal textures added where needed. I remain amazed by Patrick's ability to create smart designs in just a few brush strokes. No matter how much time he spends, the result is always visible in the first few minutes.

Sidekicks
Photoshop
Jennifer Bricking, USA
[right]

Nicolas Bouvier
These two humorous creatures look like survivors from an apocalyptic world. The textures of the background represent a very nice addition, giving the piece the splendor of a traditional framed painting.

AN601G
Photoshop, Painter, ZBrush
Tomasz Jedruszek, POLAND

Nicolas Bouvier
I've always loved spaceships! No matter the design or size, there are infinite ways to imagine these vehicles. This organic vehicle is technically impressive. The logos and typographic elements play a large role in the ship's design too.

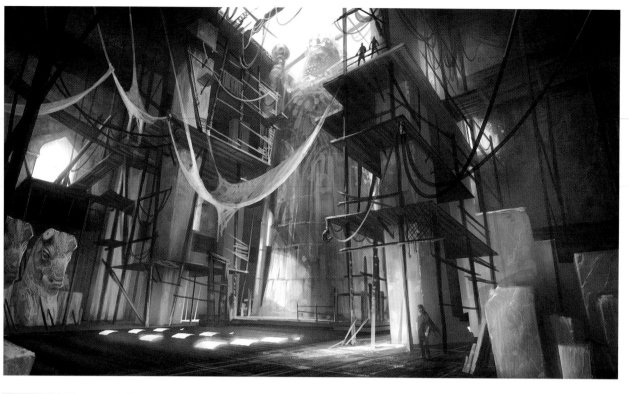

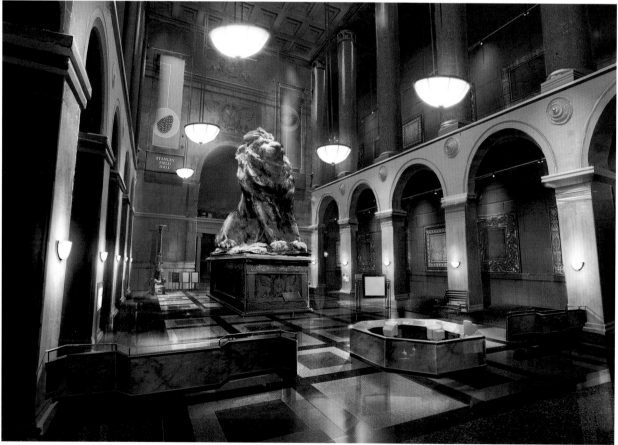

Sculptor's workshop
3ds Max, Photoshop
David Levy, Ubisoft, CANADA
[top]

Nicolas Bouvier
Another great image by David. The thing
that strikes me the most in this scene
are the rhythms created by the wood
structures all around. The visual puzzle
is striking.

Museum lion lobby: Stranglehold
Photoshop
Tae Young Choi, Midway Games, USA
[above]

Nicolas Bouvier
An intense piece where light and reflections
give this image a remarkably realistic look.
Careful attention has been given to the
furniture. Without a description, the image
clearly shows that we're in a museum.

Dragon room: Stranglehold
Photoshop
Tae Young Choi, Midway Games, USA
[right]

Nicolas Bouvier
A good concept design is one that can be
easily realized by a 3D artist. Here, we've got
it all, from the turning stairs to the detailed
roofs—no section has been forgotten by the
artist. A true pleasure to look at.

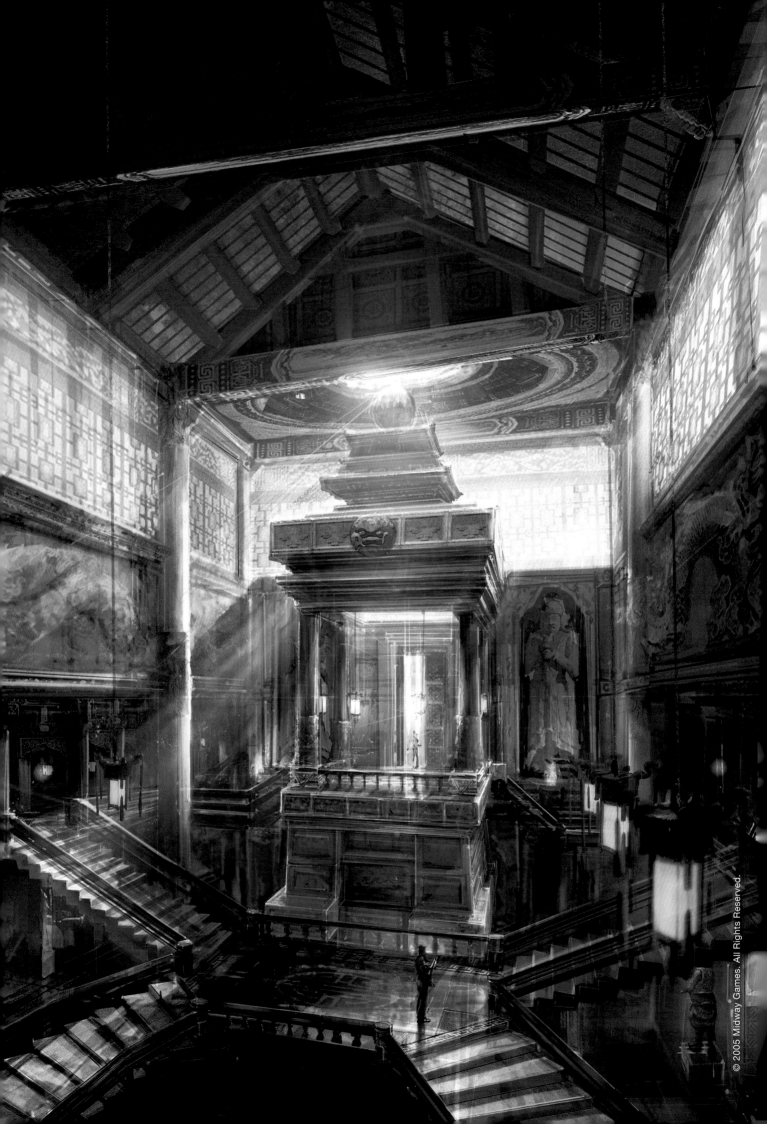

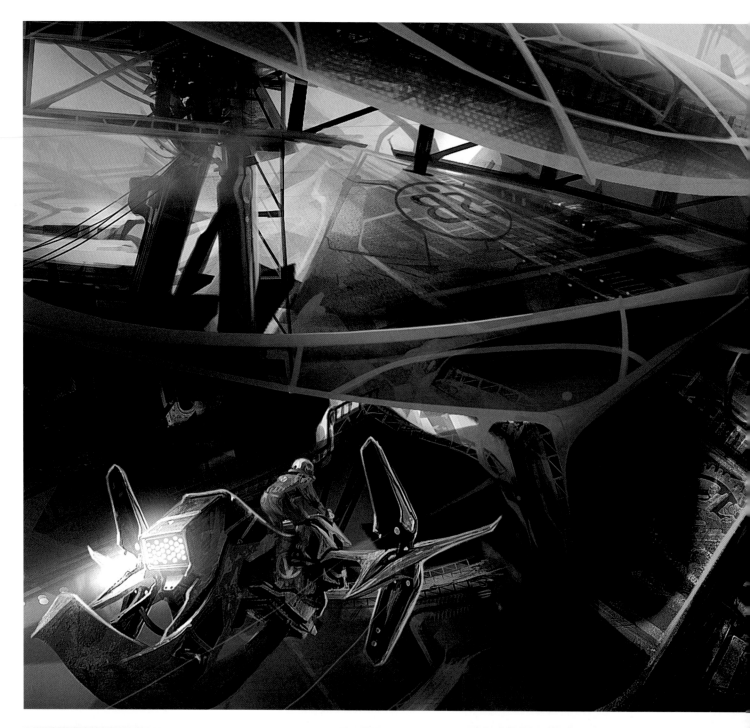

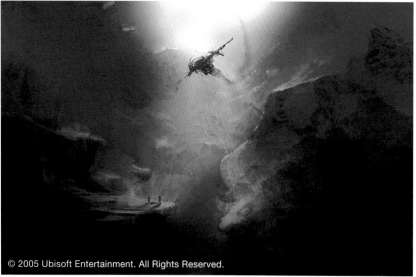

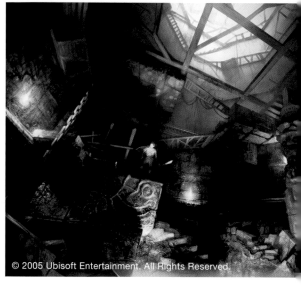

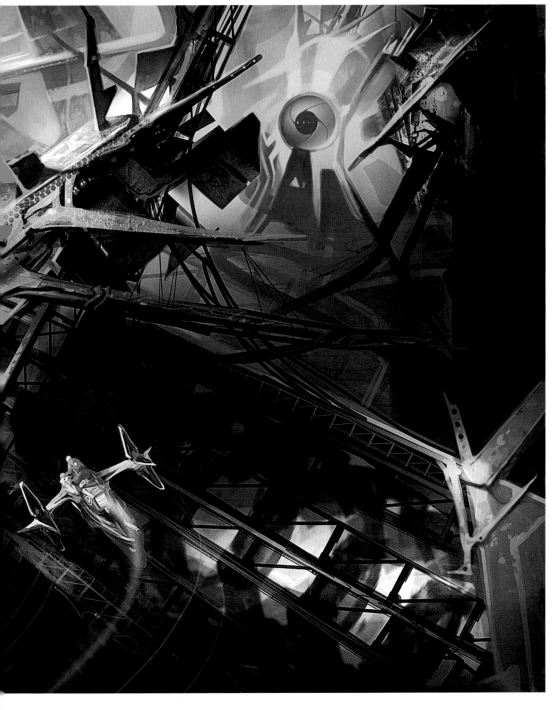

Ship wreckage
Photoshop
David Levy, CANADA
[left]

Nicolas Bouvier
David is a master when it comes to creating artwork with the very strong custom brush techniques that he has developed. The curved structures act as visual guidelines for the viewers moving around the picture.

Into the cave
Photoshop
Nicolas Ferrand, Ubisoft, CANADA
[far left]

Nicolas Bouvier
Nicolas has created a very mystical piece here—simple and atmospheric. The smoke trail behind the ship gives valuable information to the viewer who can picture the scene of an emergency rescue from a snowy cave. The minimalism of the piece leaves plenty of room for our imagination to finish the story.

Prince of Persia environment
3ds Max, Photoshop
David Levy, Ubisoft, CANADA
[center left]

Nicolas Bouvier
An image describing the interior sections of an oriental castle. The little figure standing on the left carved rock helps us determine the height of the room. The contrast between the warm yellow areas and the blue cold tones is absolutely beautiful.

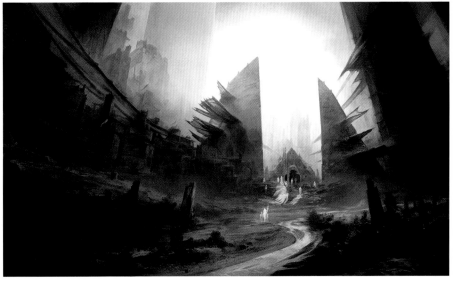

The Gate
Photoshop
Bruno Gentile, CANADA
[left]

Nicolas Bouvier
This painting is absolutely fantastic. I rarely find images that can please me on multiple levels, and this is one of them. From the draped floating figures to the ochre wings attached to the ruins, everything in there belongs to an amazing dreamy and mysterious world.

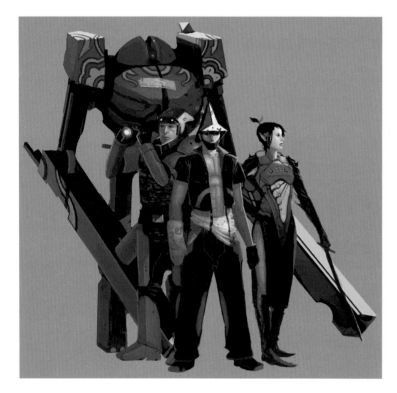

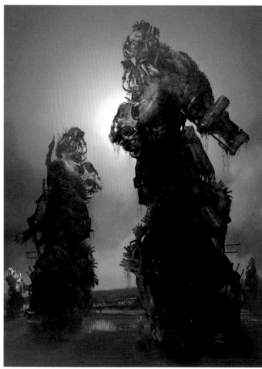

The Guard
Painter
Client: Creoteam,
Collapse: Devastated World
Roman Gunyavy, UKRAINE
[top]

Nicolas Bouvier
This massive beast is not only scary
because of its size, but also because
it has no eyes. The plain black
background is a very nice touch.

Red Swirl Gang
Photoshop
Robin Chyo,
USA
[above]

Nicolas Bouvier
The artist has been painting with
basic triangles and shapes in a very
smart way. Strong design, strong
composition, and subtle color tones
make it a great image.

Decayed Hern
Photoshop
Paul Gerrard,
GREAT BRITAIN
[above]

Nicolas Bouvier
The nearly invisible white figure on the
ground gives a hint of the proportions
of these two similar structures. I feel
myself immersed when looking at
this scene. I can literally imagine the
sounds of this environment.

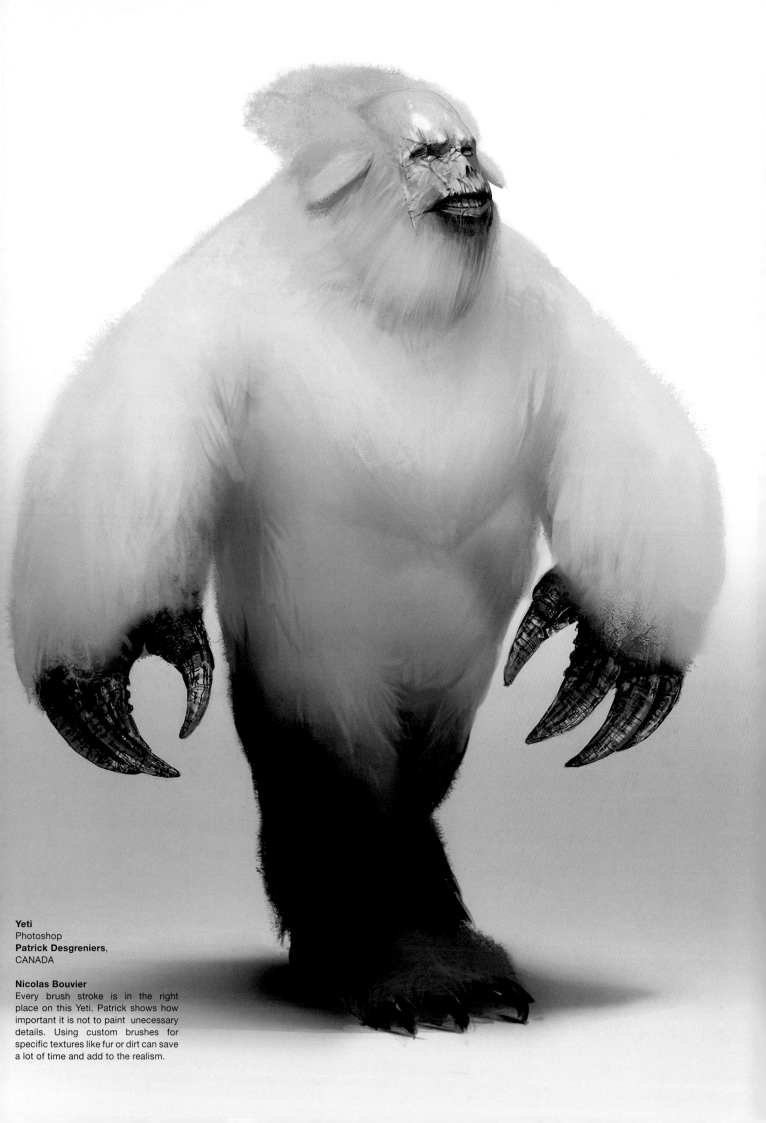

Yeti
Photoshop
Patrick Desgreniers,
CANADA

Nicolas Bouvier
Every brush stroke is in the right place on this Yeti. Patrick shows how important it is not to paint unecessary details. Using custom brushes for specific textures like fur or dirt can save a lot of time and add to the realism.

VIKTOR ANTONOV

Viktor Antonov art-directed and did concept design for Valve's acclaimed 'Half-Life 2'. He holds a transportation design degree from Art Center College of Design, and has over 10 years of experience in the entertainment industry as a matte painter, conceptual designer, art director and production manager. He was a designer for the animation feature film 'Renaissance', a futuristic thriller which opened in March 2006, and did matte paining for the sci-fi series 'Skyland'. Viktor recently founded the entertainment design studio The Building, in Paris France. He is currently working on an illustrated novel, 'The Colony', and is a visiting design instructor at the Baden-Wüerttemberg Film Academy.

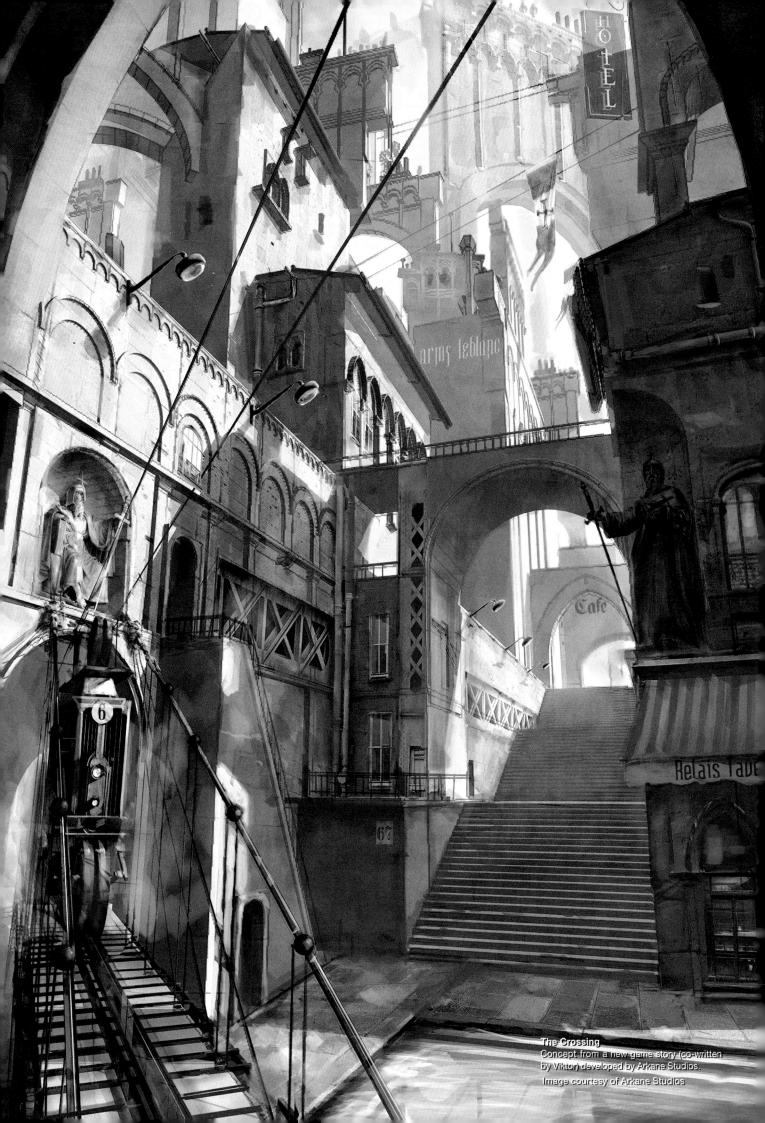

The Crossing
Concept from a new game story (co-written by Viktor) developed by Arkane Studios.
Image courtesy of Arkane Studios

CONTENTS

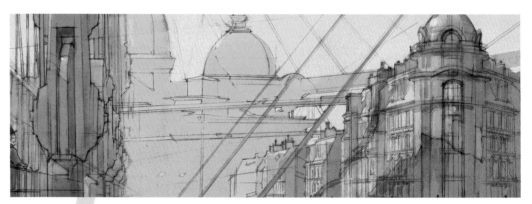

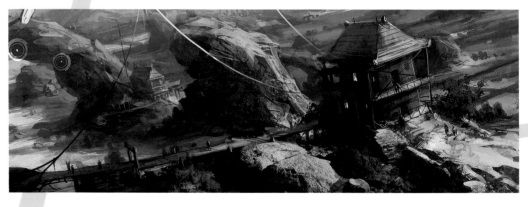

Early beginnings

I've been drawing since I was 3 years old. When I was a kid, I would usually spend most of the day with crayons and markers instead of playing outside. My mother was a painter and my father an illustrator.

Educating Viktor

I studied Industrial (Transportation) Design at Art Center College of Design in Pasadena. The school made a clear distinction between design and "Art". That's also where I learned that design was somewhat of an industrial craft which requires a lot of discipline and skill, while the word "art" in the entertainment industry is often open to too many interpretations. One of the differences between industrial design and illustration is that alongside drawing/illustration skills, industrial designers learn production materials and methods, aerodynamics and ergonomics.

Digital art

During my education, computers were too slow and there were no Wacom tablets. I'm from the first generation of digital artists and markers were still the industry standard in 95/96. My very first digital art assignment was to paint textures for a game level with a mouse. This was also the first time I really used a computer. Back then game textures were mini-illustrations with the lighting and even props painted in. "Painting" with pixels was a great exercise, sort of like doing mosaic murals.

Tools

I've always used Photoshop. I try not to get distracted by every new package. I tend to use Photoshop as a traditional 2D painting and compositing tool, and I always stick to a minimum of tools: the Brush tool and the Eraser with pressure sensitivity. For 3D, I use either Maya or XSI, depending on the team I work with.

Influences

My main artistic references have been the naturalist, realist and orientalist painters from the late 19th century. They had achieved technical perfection and had mastered composition, color and lighting. The stories they told in their paintings were more important than the medium or flashy brushwork (introduced by the impressionists who followed them). Classic photographers like Alfred Stieglitz, Lewis Hine, and Robert Frank are important influences because in a successful photo the stuff you leave out of the picture is just as important as the things in the frame. Showing the minimum of important information is a rule that applies very well in concept design. Another important source of inspiration to me are the great cinematographers like Jack Cardiff and Sven Nikvist.

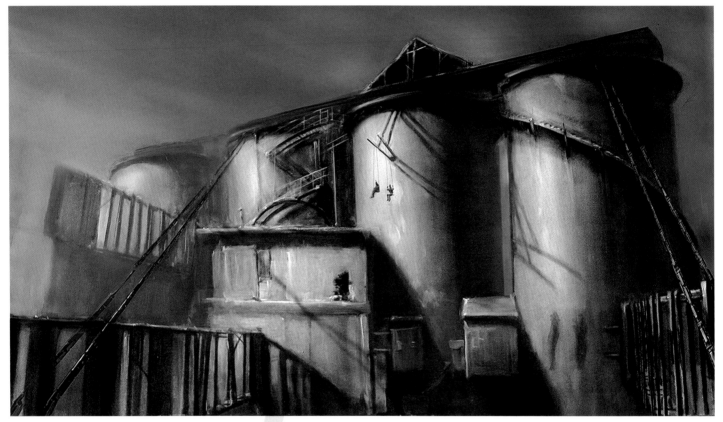

Merrel plant: A painting from the "Vulkan Bros. Industrial Heritage Pleasureworks" series.

They created some of greatest 20th century images using only framing, light and color. In terms of illustration techniques, I picked up the most from Art Center instructors Gary Meyer and Bob Kato.

Switching to games

I switched from industrial design to games after I realized the amazing creative possibilities and freedom games allowed. I've always loved designing realistic yet fantastical places. 3D game engines allowed new levels of immersion. The main challenge was using a primitive medium to get a sophisticated message through. Game-making tools are finally getting more predictable and stable, allowing the designer

to spend more time on content. The process for concept art in games is definitely different for each project. Games are a collective effort—the process is very organic, mainly depending on the individuals making up the team and the company culture.

Half-Life 2

'Half-Life 2' was one of the most ambitious and difficult projects I've worked on. This was because the Valve team was briefed by Gabe Newell to create "the best game ever" which included: ground-breaking gameplay, revolutionary storytelling, the best visuals ever, and the most powerful game engine. In the beginning, one of my responsibilities on

the project was to define what "best visuals" meant at the time. Part of my strategy of course was to attack "graphics": reach a level of detail unseen before in the industry; define a lighting style, an atmosphere that would become the "HL2 look"; and create a new generation of surfaces and textures. For me all of the above covered the technical side of visuals, but my dream was to design an original game universe; a realistic, yet mysterious world not seen before in games or film. I wanted to take HL out the claustrophobic underground bases. Most sci-fi fictional locations are Gotham-like New York, Los Angeles, an alien planet or Earth in the far future. I started by eliminating

most of these choices, which was considered a risky decision from a marketing point of view. My goal was to take the player to a place that felt vaguely familiar, but exotic at the same time—a place with depth and history. The result was City 17, a fictional Eastern European metropolis. Eastern Europe offered plenty of visual and cultural contrasts—between modern and past, between east and west, between all the different regimes, and invasions that left their mark. Last but not least, was the Combine technology and architecture, and all the challenges that came with establishing a fresh looking sci-fi look of an alien civilization. The stark, monochromatic Combine aesthetics were designed

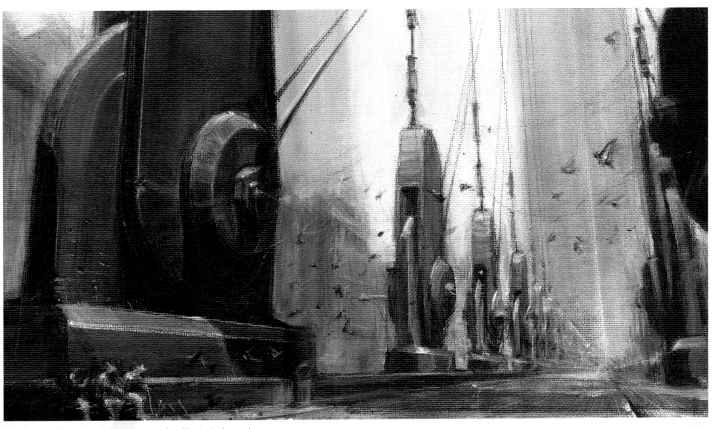

The Colony: A painting from an upcoming illustrated novel.

to contrast the soft, pastel human architecture and create a sense of intrusion. A five-year production cycle followed, developing tools and content in parallel. It was a very long, difficult wait for the whole team before the 2004 "happy ending". Finally, engineers, artists and game designers found out that they had taken the right risks and choices in their relative fields.

Breaking into the industry
I would point out three pieces of advice to artists interested in joining the concept art discipline. First of all, take the time to learn traditional drawing and painting. Secondly, look at the market and try to do something different rather than following trends. There are multitudes of artists who follow the trends, so you need to give yourself an advantage by differentiating from them. Thirdly, constantly refresh your reference sources. There's much more than film and games to learn from. Painting, sculpture, photography, architecture, and even literature are great sources of inspiration.

The future of VFX
I believe the "next-gen" VFX will become more subtle, complex and will become a function of story. Then concept artists could focus on volumes, proportions and style rather than level of detail, shiny surfaces and explosions. Historical examples of the medium taking over the content are many: when silent movies transitioned to talkies, musicals became one of the most important film genres. The birth of Technicolor affected the studios so much that most movie sets became over-saturated matte paintings like those found in 'Spartacus'.

Moving forward
There have already been some significant changes in the way I work. I recently co-wrote 'The Crossing', a new game story and IP (intellectual property) developed by Arkane Studios. I'm also writing a couple of stories that will be published as illustrated novels, after which I'll consider developing them into video games or animated features. For me "designing" by writing became as important as drawing. A strong world design depends on a solid back-story, a history, and an established culture of the place. The plot and the dramatic context of any story are closely linked to the visual choices for any game or movie. My current major venture has been the founding of The Building Studios, a design company for which I've assembled a team of world-class story boarders, character, environment, and concept artists. The studio handles entire pre-productions, and some of us provide consulting and art direction through the whole production cycle.

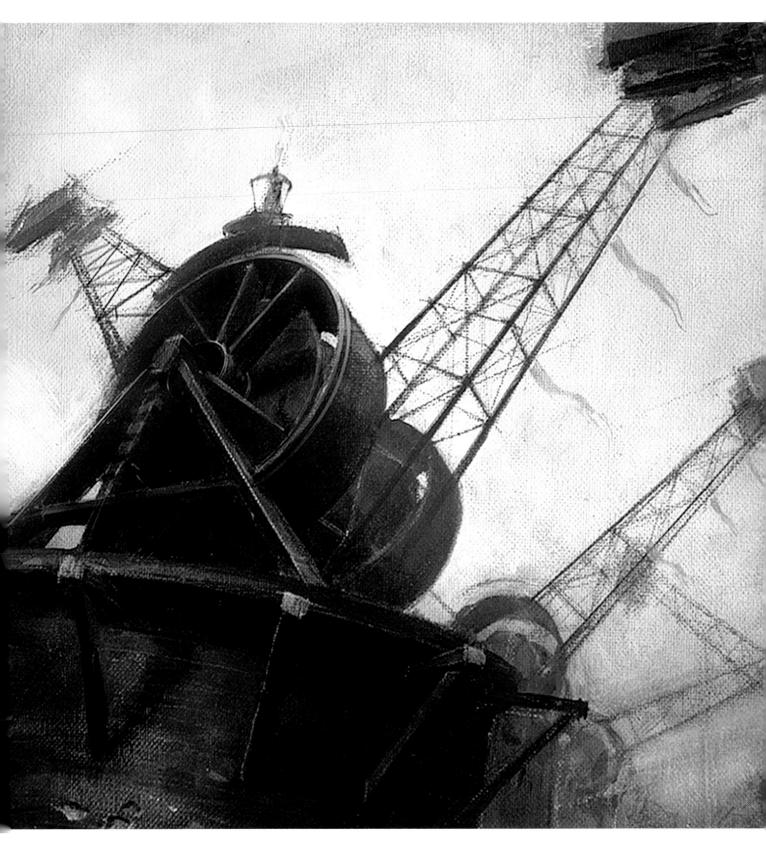

The pendulum
An oil painting from the series "Vulkan Bros. Industrial Heritage Pleasureworks". Each painting is an advertisement for a fictional ghostly amusement park ride. The illustration style is close to early world fair illustrations. With this series, I'm taking industrial architecture out of its regular context, and presenting each one of the structures like a piece of character design. *[above]*

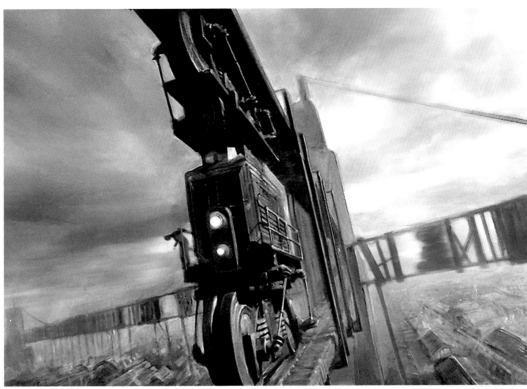

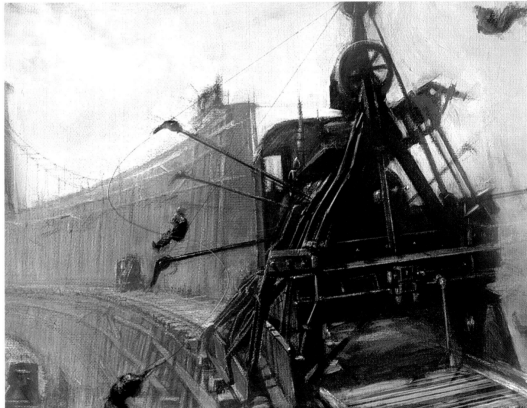

Flanking rail transport
I used this project as an opportunity to do some unusual vehicle designs which were mechanically believable, yet fantastic. I rendered the strange trains in specially-designed environments.
[top]

Steam spreader
Another one of the infernal rides—a train-like vehicle with some bungee-jumping devices attached to its arms.
[above]

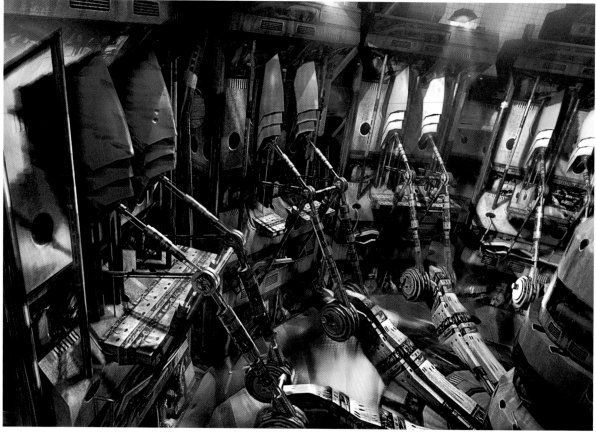

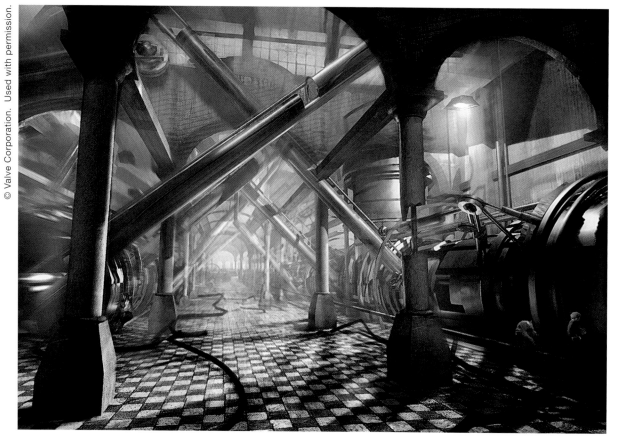

Half-Life 2: Core engine
A digital concept illustration of Combine technology for 'Half-Life 2'. The pistons were designed to allow spectacular physics animations.
[top]

Half-Life 2: The children factory
This concept was done at an early stage of the project, and was never used in the game because the story changed. In this scenario the invading aliens had been on Earth for 50-60 years, and their technology (the large pistons) had been deeply integrated into human infrastructures.
[above]

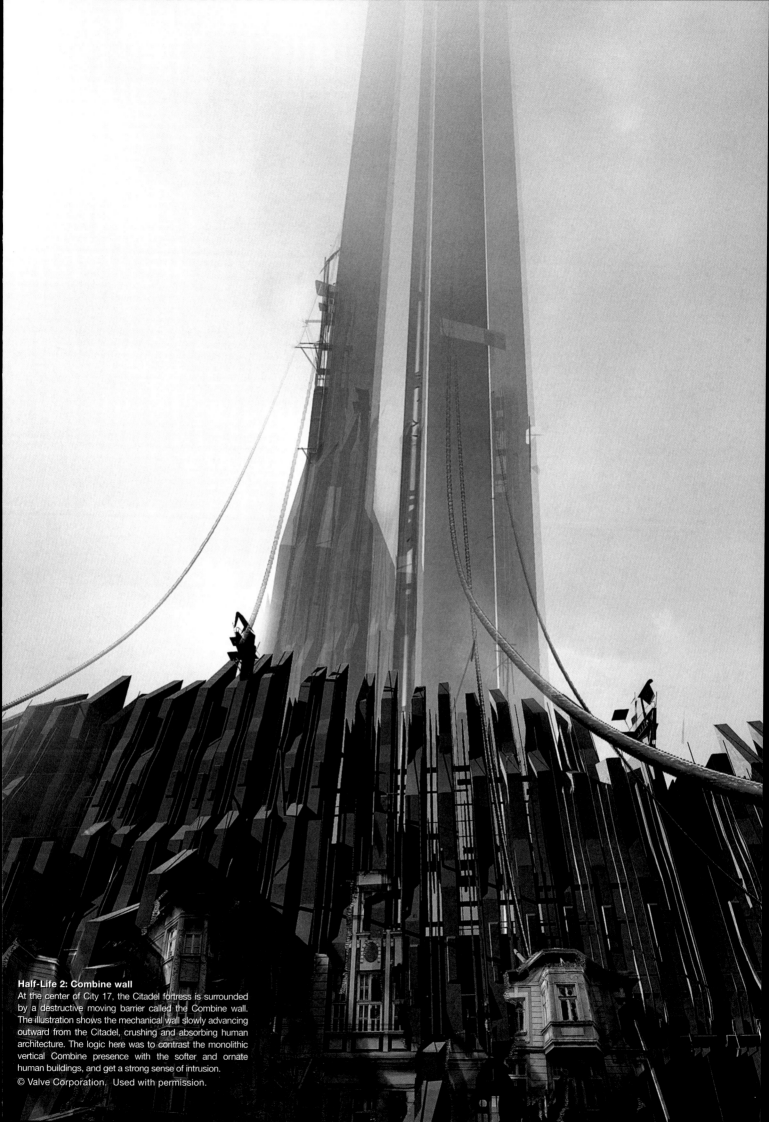

Half-Life 2: Combine wall
At the center of City 17, the Citadel fortress is surrounded
by a destructive moving barrier called the Combine wall.
The illustration shows the mechanical wall slowly advancing
outward from the Citadel, crushing and absorbing human
architecture. The logic here was to contrast the monolithic
vertical Combine presence with the softer and ornate
human buildings, and get a strong sense of intrusion.

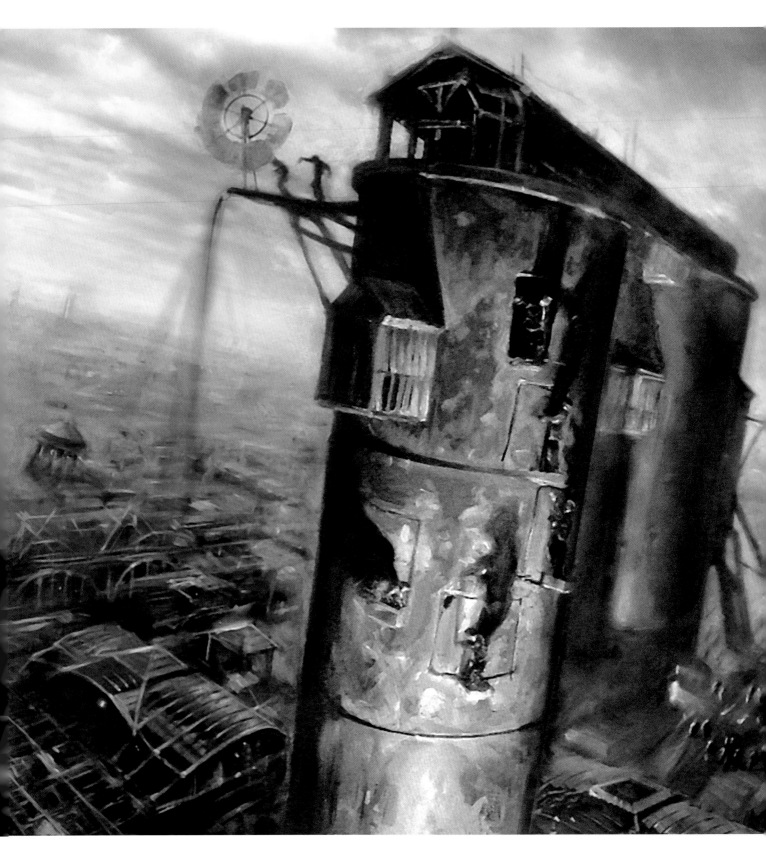

Clutha steel tower
Another one of the "Vulkan Bros"
rides. A large, panoramic oil painting.
Here, I've used somewhat unusual
lighting without revealing the light
source to establish a mystical feel.
[above]

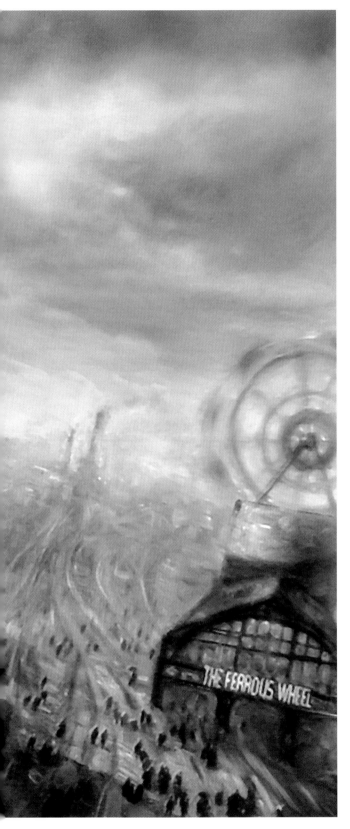

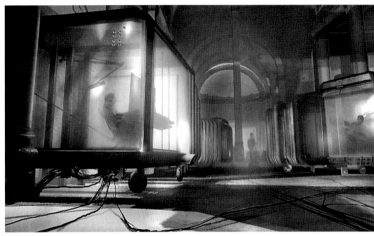

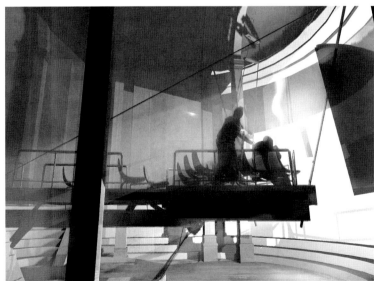

Renaissance

Concept designs for the movie 'Renaissance'. The story is a dark futuristic thriller or "film noir" set in Paris in the year 2054. The three concepts are designs of the main character Karas' home and his workplace—the police headquarters.

The design themes used here are a mixture of traditional Parisian architecture, very evolved metal architecture, and some reminders of 1970s urban planning.
[above: series]

Half-Life 2: The Lost Coast
The Monastery is a Photoshop/ pencil drawing of an aerial shot of an Orthodox monastery. I wanted to avoid a high-tech, digital look for this piece, and inspire the modelers to capture the almost organic feel of old churches in the south-eastern part of Europe. *[top]*

Half-Life 2: The Lost Coast
Another shot of the monastery. The rock shapes are simplified, with little detail in order to emphasize their faceted, angular silhouettes. *[above]*

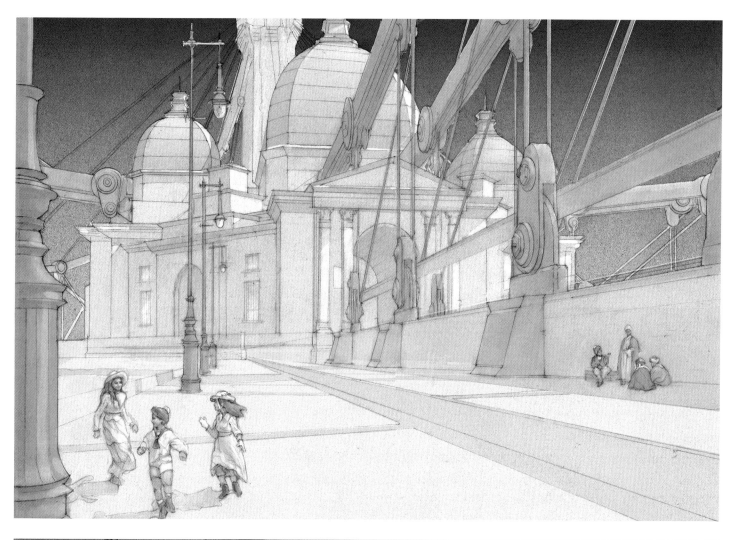

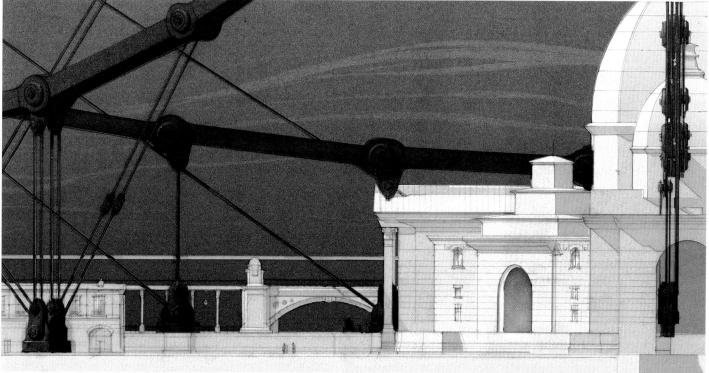

The Colony
A detail from 'The Colony', an illustrated novel I'm currently working on. The drawing style resembles late 19th century architectural illustrations. [top]

This is a utopian architectural project of a European-style city suspended on cables over an oriental colony. [top]

The Colony
An orthographic side-view projection of the same utopian city. Again, the style is "ink wash" over a line drawing, because it represents a drawing by one of the story characters, a 19th century architect. [above]

THE CROSSING: ROOFTOPS

Inspiration

This concept piece for a city is part of a very exciting process I've undertaken for the first time to design an original IP (intellectual property) and establish the world design logic. The project is 'The Crossing', a game title developed by Arkane Studios in collaboration with my design company, The Building Studios. The fiction here is a parallel reality with the following premise: "What if the crusader Templar knights were not exterminated in 1307, but became France's rulers? How would this affect the course of history, and what would Paris look like in 2022?" In order to have a convincing design I tend to go 50-100 years back into the history of the place.

Technique

The effect I'm looking for in this concept is fairly realistic, yet somewhat painterly. I start with a two-point perspective, painting in masses. To maintain the correct parallax and crispness, I bring in modeled building elements from Maya. To finish up the concept, I bring in photo textures to enhance the realism of the building surfaces and then add atmospheric effects like haze and smoke.

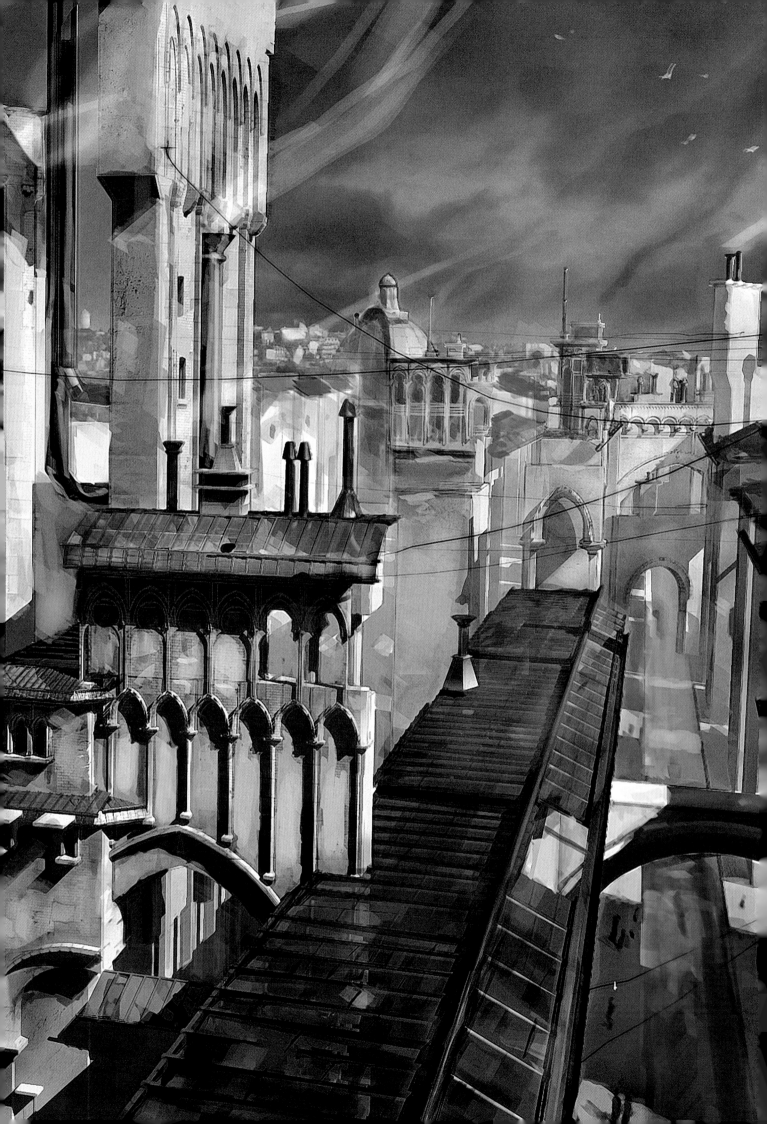

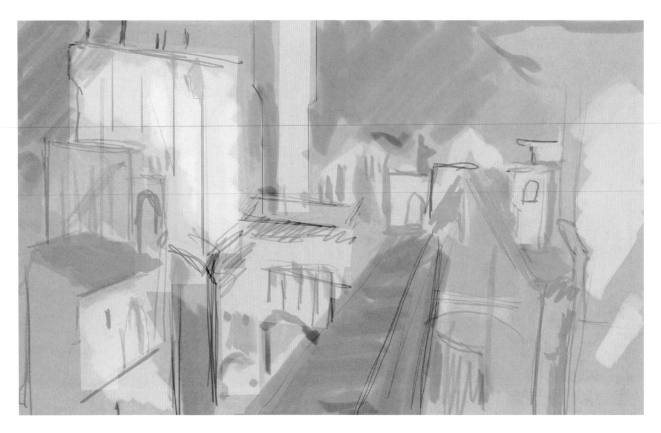

Note to self

Before starting this illustration, some architectural studies for the project have been done by concept artist Laurent Gapaillard and myself.

This is my Photoshop rough thumbnail—it's a visual note to myself more than anything else. The important information here is the vertical, monumental aspect of the buildings, and the building materials (bright limestone) contrasting against a darker sky.

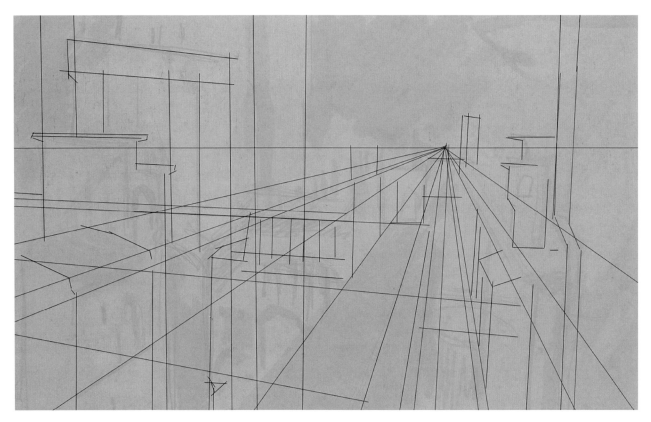

Perspective

Defining the perspective is crucial for a good illustration. It establishes the spatial relationship between the object and the "viewer"—where am I relative to the subject I'm looking at? The first step to this is locating the horizon line. In this case, it is in the upper part of the page. Next comes the location of the vanishing points. One of them is far off the canvas and the other sits in the right half of the scene.

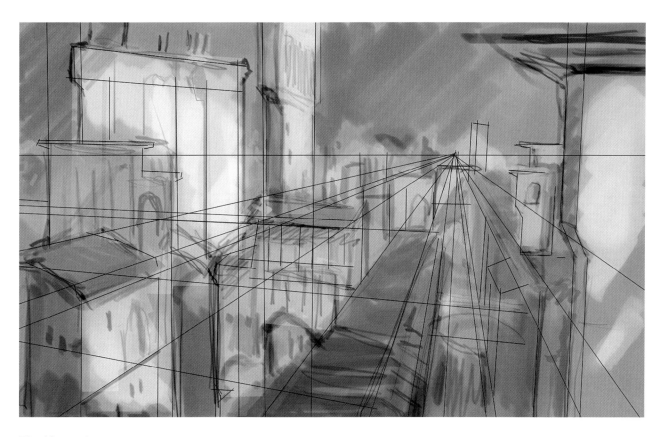

Blocking out

Large, blocky smokestacks are the main visual theme of this concept. Using my two-point perspective I block them out as big, rectangular masses with the Brush tool. Parallel to this, I'm thinking about the value composition and making sure the lighting in the image provides enough contrast. This is achieved by placing the imaginary light source behind the viewer, and having the bright walls stand out from a dark sky.

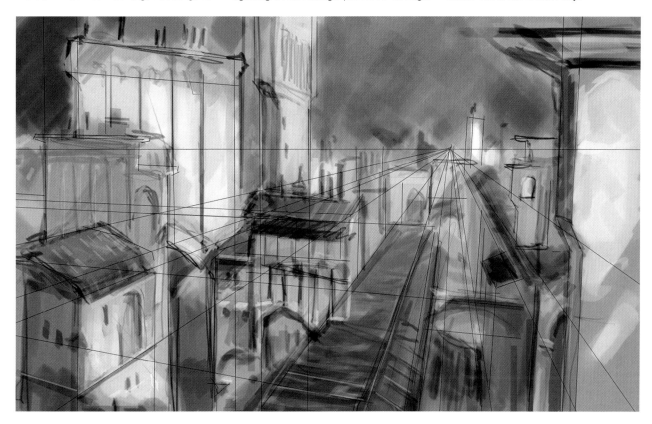

Architectural details

I'm starting to add some rough architectural details such as arches and gothic ornaments. This city is a parallel version of Paris, with the following premise: "What if the French capital had evolved as a gothic metropolis instead of a neoclassical renaissance capital?" Most details still look like scribbles, but this allows me to change things easily and see shapes which I like in the patterns.

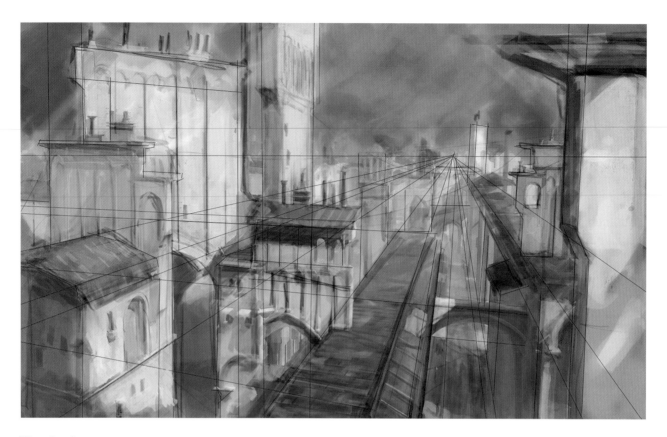

Visual noise

Here, I add more detail to determine the visual noise level. Some material indications are starting to emerge. I am still keeping it black and white in order to maintain the value composition. Generally, if an image functions well in grayscale, it is certain that it'll work in color. The opposite is not always true.

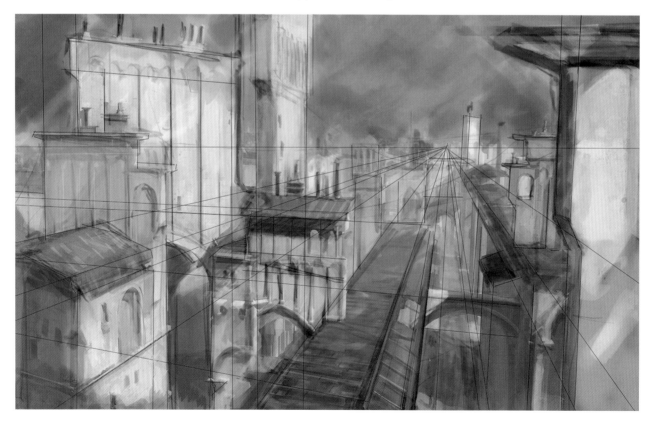

Color palette

This a palette test-painted on a color layer over the grayscale image. Different hues of the limestone beige stand out against the cool sky and shadow areas. Touches of higher saturation detail would add life to the image.

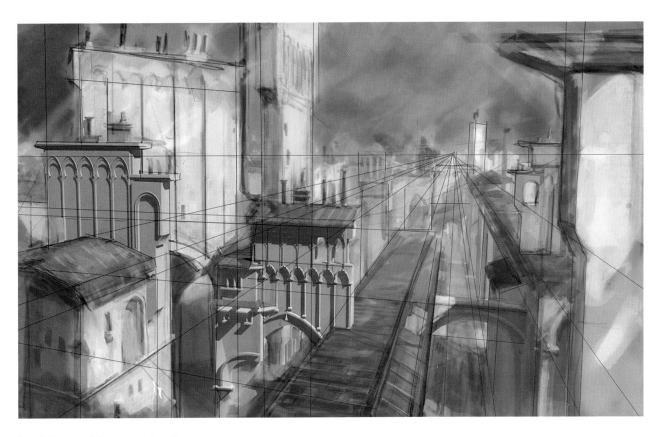

Modeling architectural details

I turn the color layer off for the moment, so I can focus only on detail and textures. The composition is ready, so it's time to go to a higher level of realism. This is where I start "texturing" the piece and add some crisp detailing. Instead of just overlaying photos, I model some architectural details and patterns in Maya and composite them into the illustration. I do this for highly complex or repetitive architecture in order to achieve the correct parallax and crispness.

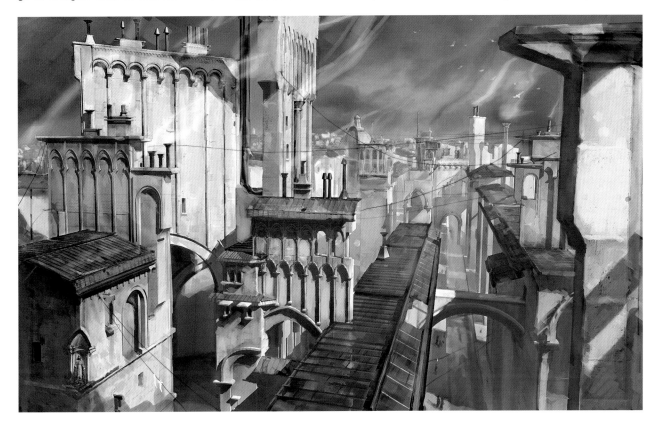

Painting atmosphere

Here is the finished result. The texturing was completed when some material noise was overlaid on some of the surfaces. In the last 10 percent of the process, all the elements are tuned and adjusted together, and atmospheric effects like haze and smoke are added. The effect I was looking for in this concept was fairly realistic and familiar, yet somewhat painterly.

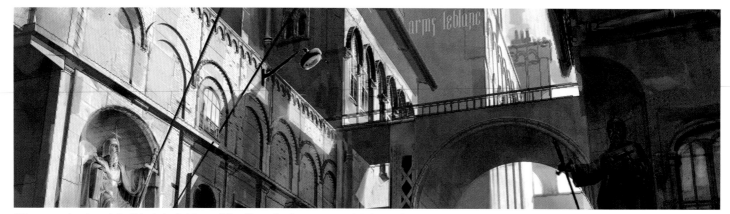

THE CROSSING: STREET-LEVEL

Inspiration

This street-level concept is part of the process to design an original intellectual property called 'The Crossing'. The game is being developed by Arkane Studios in collaboration with my design company, The Building Studios. The premise for the game is: "What if the crusader Templar knights were not exterminated in 1307, but became France's rulers? How would this affect the course of history, and what would Paris look like in 2022?" In order to have a convincing design

I tend to go 50-100 years back into the history of the place. In 'The Crossing' we'll be changing the course of history for the last 600 years and assume that Paris has evolved as a gothic metropolis instead of a neoclassical city. The Renaissance never took place, but the city is still Paris.

Technique

This street-level concept is another view of the environment created for the

Rooftops concept. Being the same environment, I'll use the same color palette for the street level with variations in lighting and shadows. I start the concept with a simple three-point perspective, before laying in masses and refining the details. I then add details which give the city a personality such as arches and statues. Finally, I use photo textures to texture the surfaces, and then add the final details.

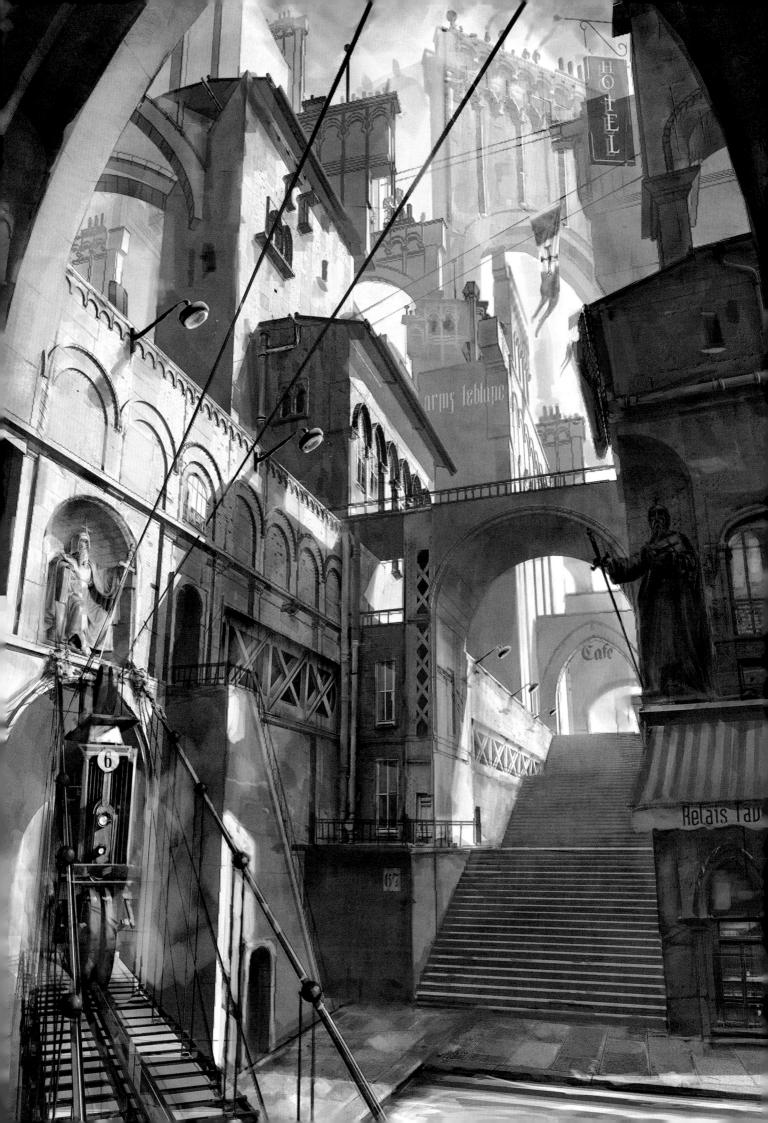

Street-level theme

This time I'll take the rooftop theme and try to imagine what the street level of the same "Parallel Paris" would look like. For this purpose, I've constructed a 3-point perspective with the 3rd vanishing point high in the sky. I've placed the horizon line on the lower part of the page.

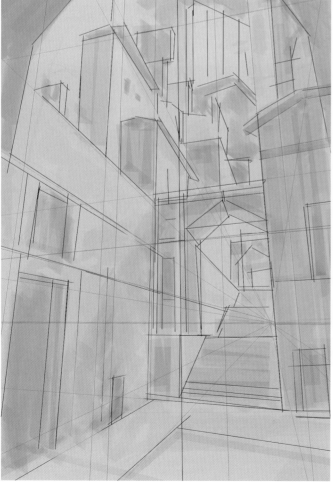

Vertical masses

This town would have a definite vertical/canyon feel about it. So with the Photoshop Line tool and the Brush tool, I start laying out some vertical masses following my perspective lines. The design theme here would be lots of gothic arches. The floor is lower than the viewer's position. I'd like the spaces to be truly three-dimensional.

Menacing masses

Here, I've darkened all of the surfaces facing me, suggesting that the street is backlit. This will help silhouette some masses and give them a somewhat menacing presence. I'm also sketching out some doors and windows to establish a sense of scale.

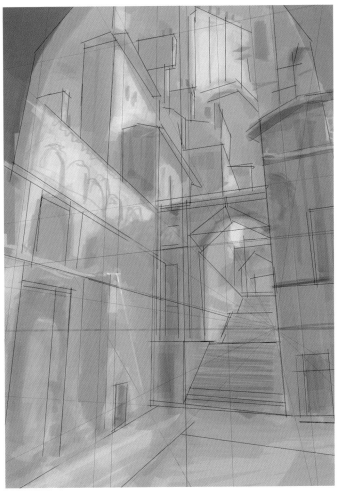

Adding detail

I'm adding more detail and increasing the contrast levels. I've also added a bridge with a train silhouette to justify the viewer's position and create a foreground with a new interest point.

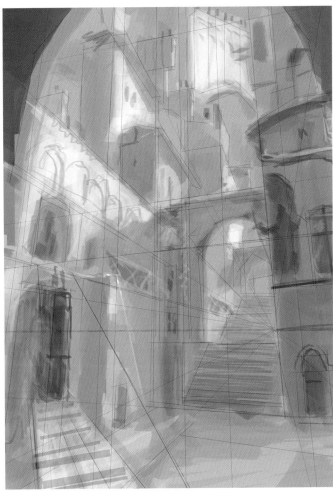

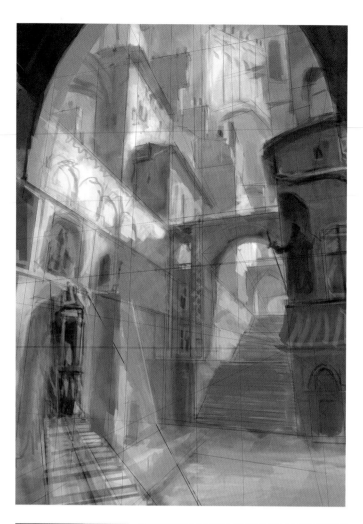

Adding personality

I add more detail, and indications for some recognizable city elements like a café shade, gutter, pipes, some gothic ornaments and Templar knight statues. These are the things that make a city specific and give it a personality. In our "Parallel Paris" story the technology has not evolved to a 20th century level because France is still governed by crusading warriors.

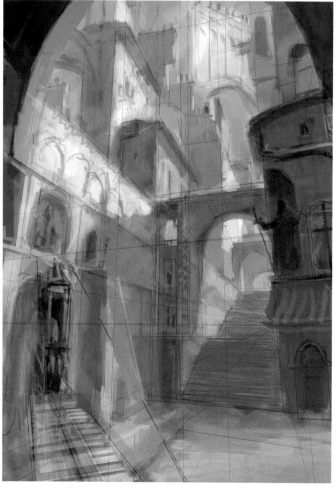

Color palette

The color palette for the concept has already been established with the Rooftops concept. I lay down color following the same rooftops color scheme.

Textures

This is the stage where I texture parts of the concept with the three textures I've modeled for the concept. I then apply some noise from photo textures.

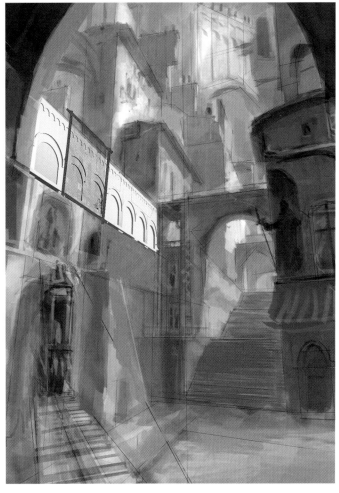

The final concept

Finishing an illustration is probably the most tedious part of the process. To get to the final stage, I use the Line tool for edge clean-up. Textures, vehicles, small industrial details and lettering are all added to the scene to bring it to completion.

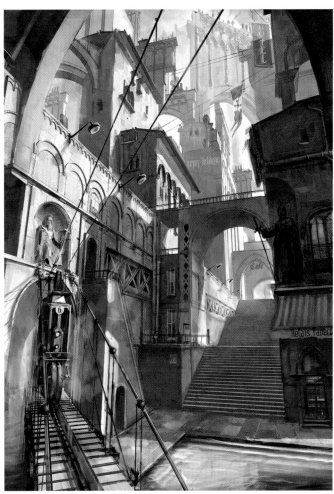

CONCEPT ART: 19TH CENTURY CITY

Inspiration

'The Colony' is an illustrated novel I'm working on in collaboration with Julien Renoult (one of my invited gallery artists). Julien is a French graphic novel artist and was the character designer for the movie 'Renaissance'. 'The Colony' is a historical fantasy taking place in 1885. The nineteenth century in modern fiction is mostly associated with Victorian London, Steam Tech and Jack the Ripper stories. This novel is an adventure story about other aspects of the period: the Industrial Revolution; the birth of metal architecture; and the new surge of colonization. It's a tribute to big ventures like the Suez canal, the Brooklyn bridge, or other architectural utopias that were never built. The protagonist is a structural engineer on a quest of an impossible project: the perfect Colonial capital—a utopian town suspended on cables above the colonized territory.

Technique

The technique fits the style of the story's period: ink washes and oil paintings, modernized by contemporary compositions, Photoshop "washes" and digital "oil" paintings. The tutorial image is a traditional style pencil/Photoshop illustration because it's a period piece "drawn" by one of the story characters, the city's architect. Most of the other illustrations for the illustrated novel will be highly detailed color paintings.

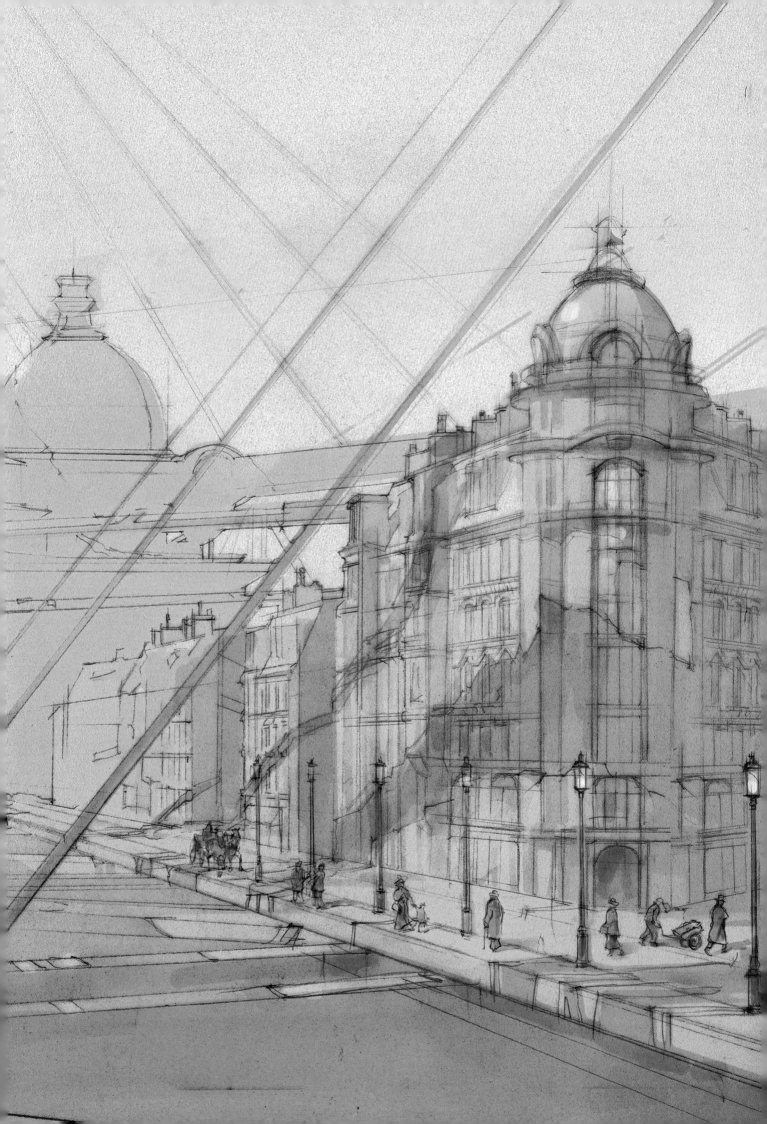

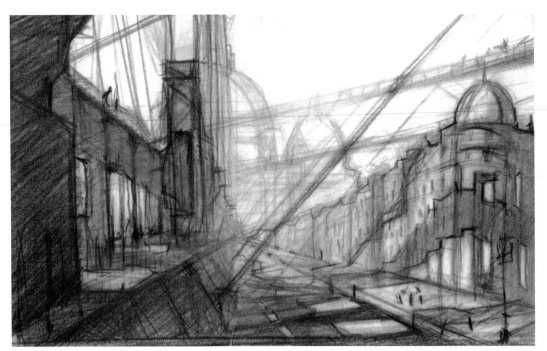

Starting

I usually start with very rough thumbnail sketches, trying to establish the first, faraway read. The purpose of the thumbnail is to assure a good value (darks and lights) composition. At this point, it's OK to be sloppy and free—details do not matter, only masses, silhouette and negative shapes are important. The intention here is to achieve an asymmetrical balance between the left and the right side of the page.

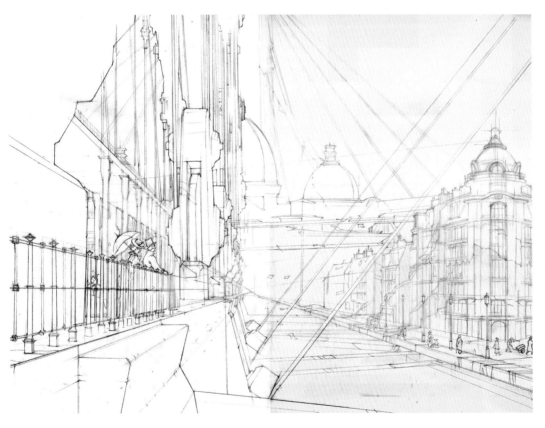

Perspective

For this illustration, I did a pretty tight pencil drawing using a ruler in some areas because I needed a particular rendering style related to the story. After the thumbnail stage the perspective was reconstructed and a precise horizon line and vanishing point were re-established.

Ink wash

The finished image should look like a pencil/watercolor turn-of-the-century architectural drawing. After scanning the drawing, I do a Photoshop "ink wash" over the linework, to try to establish the hue.

Adding value

I'm starting to add some value to the wash, detaching foreground from background elements and suggesting depth. The hard part here is to preserve the value composition from the thumbnail sketch while adding a lot of precision and detail.

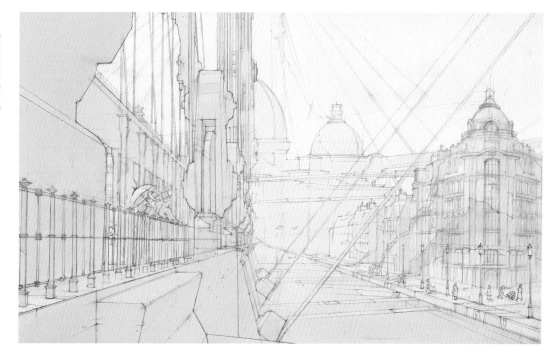

Adding value

This is what the layer under the line drawing looks like. It's the "watercolor wash". I'm gradually darkening elements important for my composition. This layer is done with the Brush tool set on Pressure Sensitivity. It is OK to keep things loose and liquid looking because the line drawing will hold everything together.

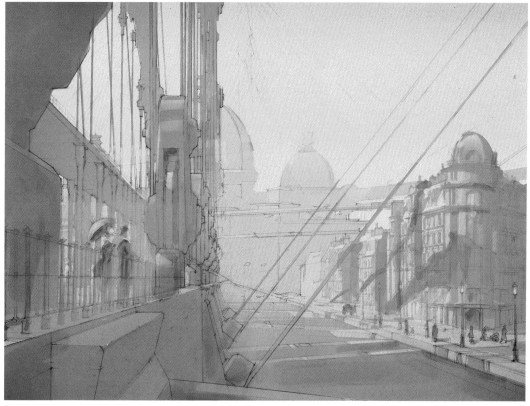

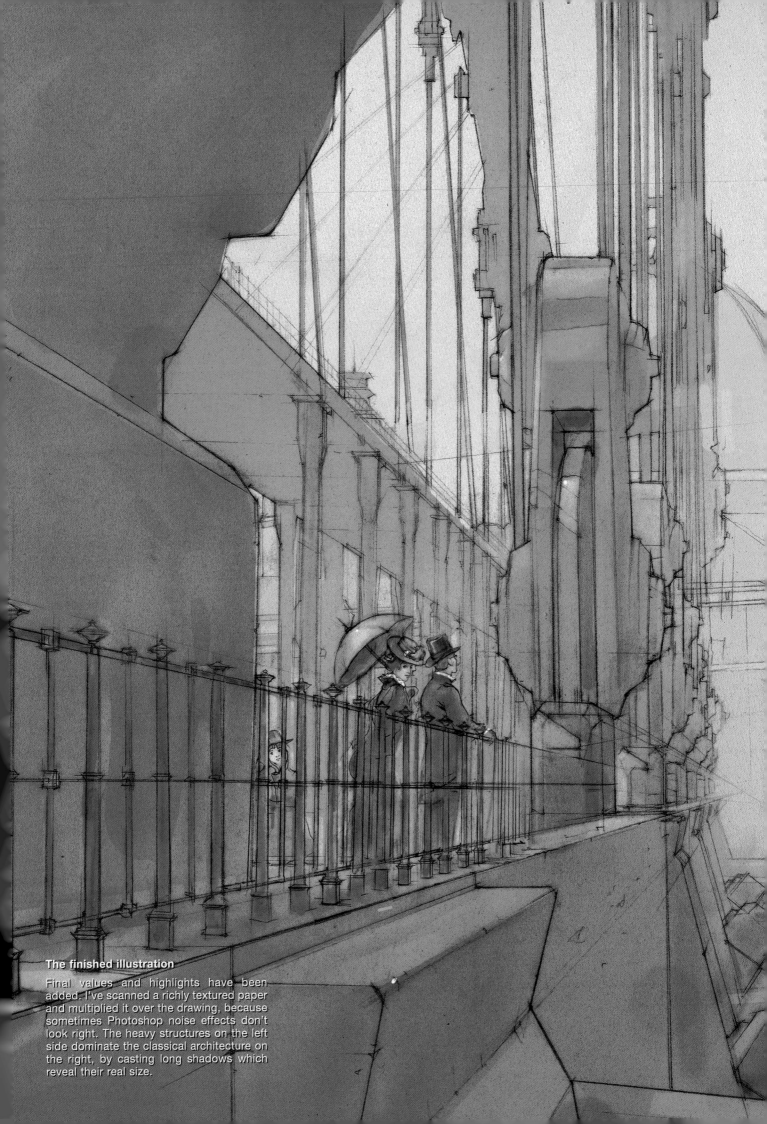

The finished illustration

Final values and highlights have been added. I've scanned a richly textured paper and multiplied it over the drawing, because sometimes Photoshop noise effects don't look right. The heavy structures on the left side dominate the classical architecture on the right, by casting long shadows which reveal their real size.

Stalker
Pencil, Photoshop
Timur Mutsaev, UKRAINE
[left]

Viktor Antonov
I chose these pieces because of the beautiful, fluent pencil-work, strong character and costume design.

Stalker
Pencil, Photoshop
Timur Mutsaev, UKRAINE
[right]

Viktor Antonov
A realistic and original character. Managing large amounts of detail (costume) and keeping a good silhouette read is difficult, but Timur has done a fantastic job.

Stalker
Pencil, Photoshop
Timur Mutsaev, UKRAINE
[right]

Viktor Antonov
Timur has succeeded in combining a rough, industrial looking outfit and a lot of femininity and grace. A very strong face.

AERA: Eisenmann
Pencil, Photoshop
Tobias Mannewitz, GERMANY
[far right]

Viktor Antonov
A nice realistic design of the materials and tools—a strong character.

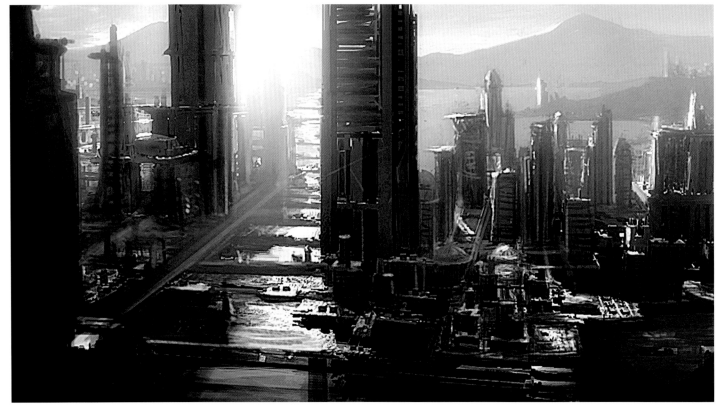

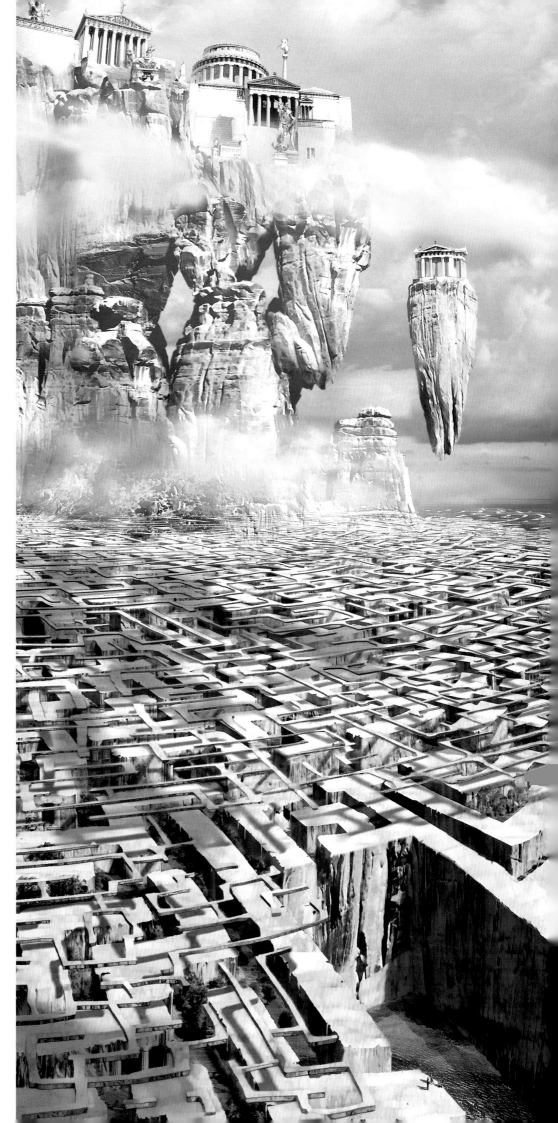

Sail sleigh
Photoshop
Client: Guild Wars Factions
Daniel Dociu, Arenanet, USA
[far left]

Viktor Antonov
Strong transportation design. It looks familiar and strange at the same time. Great sail layout.

Sewers II
Photoshop
Client: Guild Wars Factions
Daniel Dociu, Arenanet, USA
[left]

Viktor Antonov
From this concept we get a great feeling of mass and scale from the heavy volumes. Surprising and unusual shapes.

Olympus
Photoshop
Dave Seeley, USA
[right]

Viktor Antonov
A good sense of scale and depth, I love the clouds casting shadows on the ground surface.

Cityscape3
Photoshop
Emmanuel Shiu, USA
[left]

Viktor Antonov
I chose this piece because of its efficient and simple lighting—grouping objects in large masses and silhouetting them is a great device.

Renaissance characters
Photoshop
Julien Renoult, Onyx Films, FRANCE

Viktor Antonov
'Renaissance' was an immensely ambitious project—a fully 3D animated feature film, all shot in black and white. It was recently released in France with a lot of critical acclaim. Julien did most of the character designs for it. This selection shows his ability to combine stylized aesthetics with lots personality and attitude. Great renderings and cool costume design.

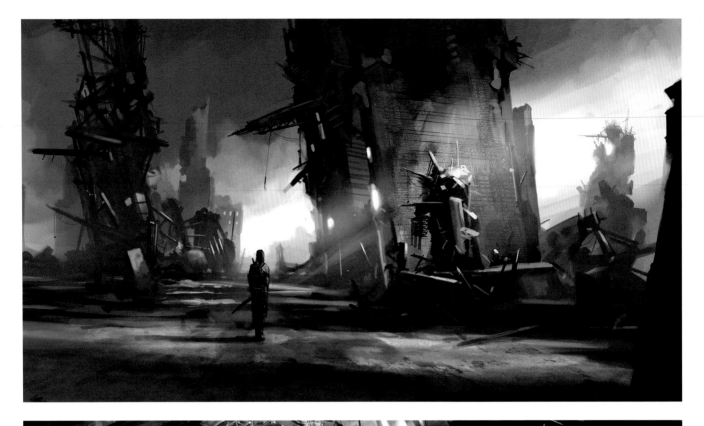

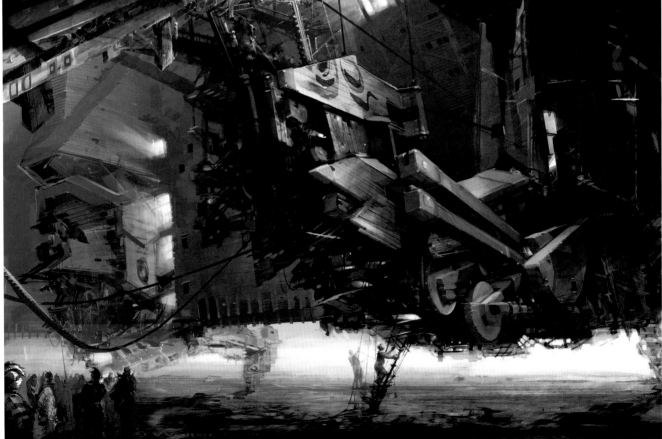

Nanotecture
Photoshop
Francis Tsai,
USA
[top]

Viktor Antonov
A concept with a strong mood and atmosphere—great silhouette shapes.

Walker Interior
Photoshop
Client: Guild Wars Factions
Daniel Dociu, Arenanet, USA
[above]

Viktor Antonov
The shapes in this piece have a good balance between chaos and order. Nice and subtle lighting.

Fish Fort
Photoshop
Client: Guild Wars Factions
Daniel Dociu, Arenanet, USA
[right]

Viktor Antonov
A very strong design. The illustration suggests a very complex interior mechanism, but little is revealed.

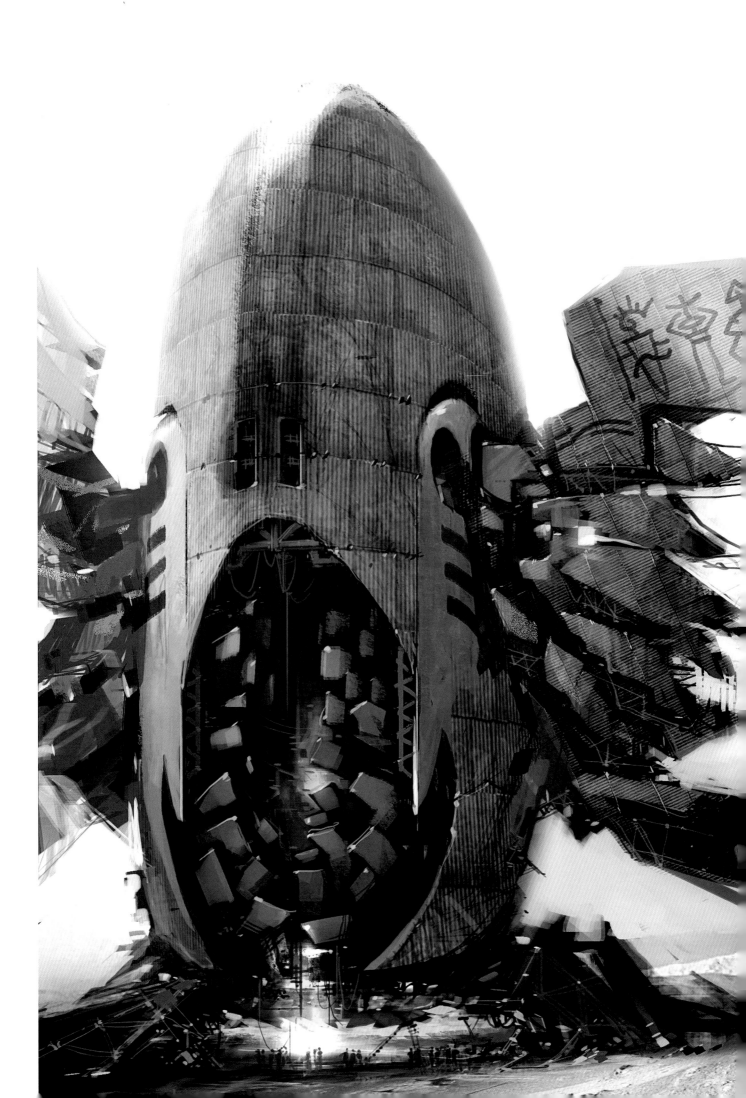

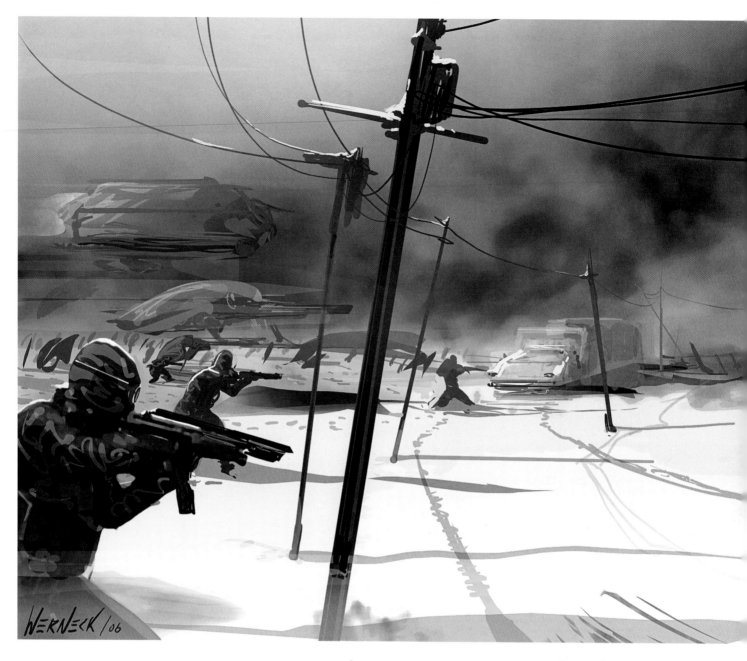

Counter-Attack
Photoshop
Bruno Werneck, USA
[above]

Viktor Antonov
I like the simplicity of the piece, and the great value/spatial composition. Leaving empty spaces in the foreground is daring and rarely done by concept artists.

Catamaran
Photoshop
Martin Deschambault, CANADA
[left]

Viktor Antonov
Elegant and minimal illustration. Very stylish industrial design.

Airforce Interceptor
Photoshop
Kevin Cunningham, USA
[above]

Viktor Antonov
A very nicely rendered, mean, bad-ass machine.

Pigoons
Photoshop
Jason Courtney,
USA
[top]

Viktor Antonov
A beautifully rendered illustration.
Cool creature design and a great
space composition.

Thai Flight
Photoshop
Thierry Doizon, Steambot Studios,
CANADA
[above]

Viktor Antonov
Great palette and a very nice
dynamic composition.

Planet Fan
Photoshop
Shinjiro Nobayashi,
JAPAN
[right]

Viktor Antonov
I chose this illustration because of
the amazing sense of scale. The fans
are some of the biggest things I've
seen rendered.

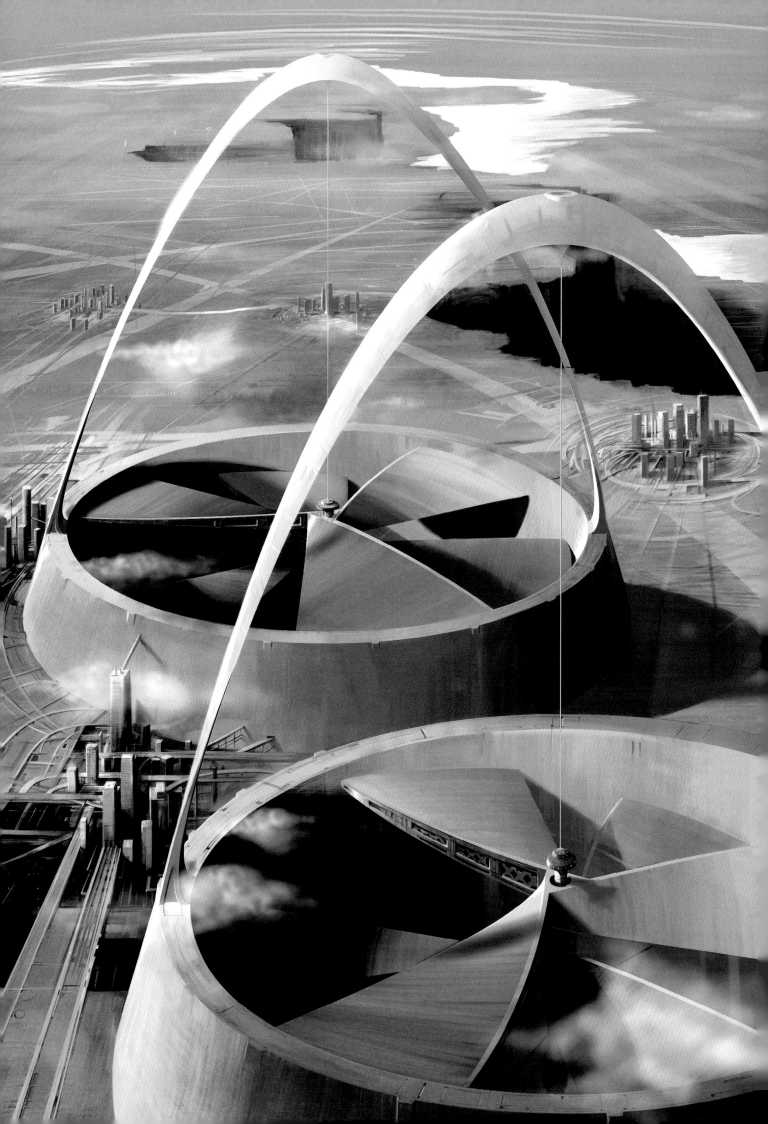

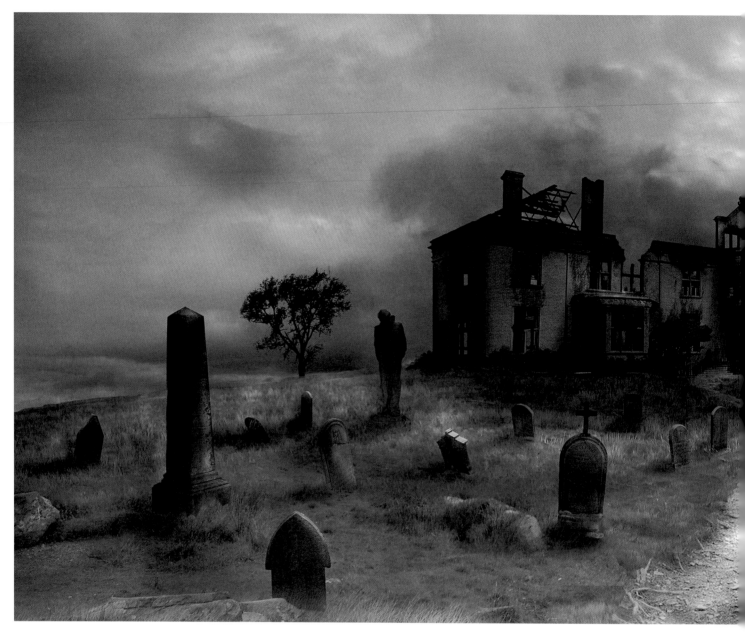

The Borley Rectory
Photoshop
Daniel Rutter, USA
[above]

Viktor Antonov
A beautiful atmospheric piece with a lot
of depth. The concept is very detailed,
yet the detail is well managed and the
overall read is good. It's particularly
difficult to make a low contrast/
diffused light illustration, and avoid a
flat and dull look.

Keras station
Photoshop
Yi Xiao, CHINA
[right]

Viktor Antonov
Good spatial composition, nice rendering
and a sense of movement.

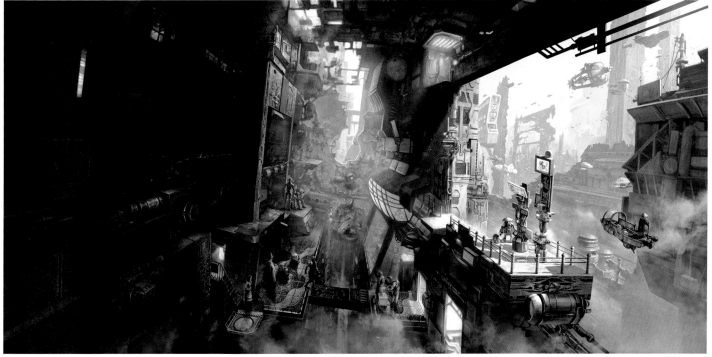

Index

SOFTWARE INDEX
Products credited by popular name in this book are listed alphabetically here by company.

Adobe	Photoshop	www.adobe.com
Autodesk	3ds Max	www.autodesk.com
Corel	Painter	www.corel.com
DAZ Productions	Bryce	www.daz3d.com
MAXON	CINEMA 4D	www.maxoncomputer.com
Mentalimages	mental ray	www.mentalimages.com
Pixologic	ZBrush	www.pixologic.com
Smith Micro	Poser	www.smithmicro.com

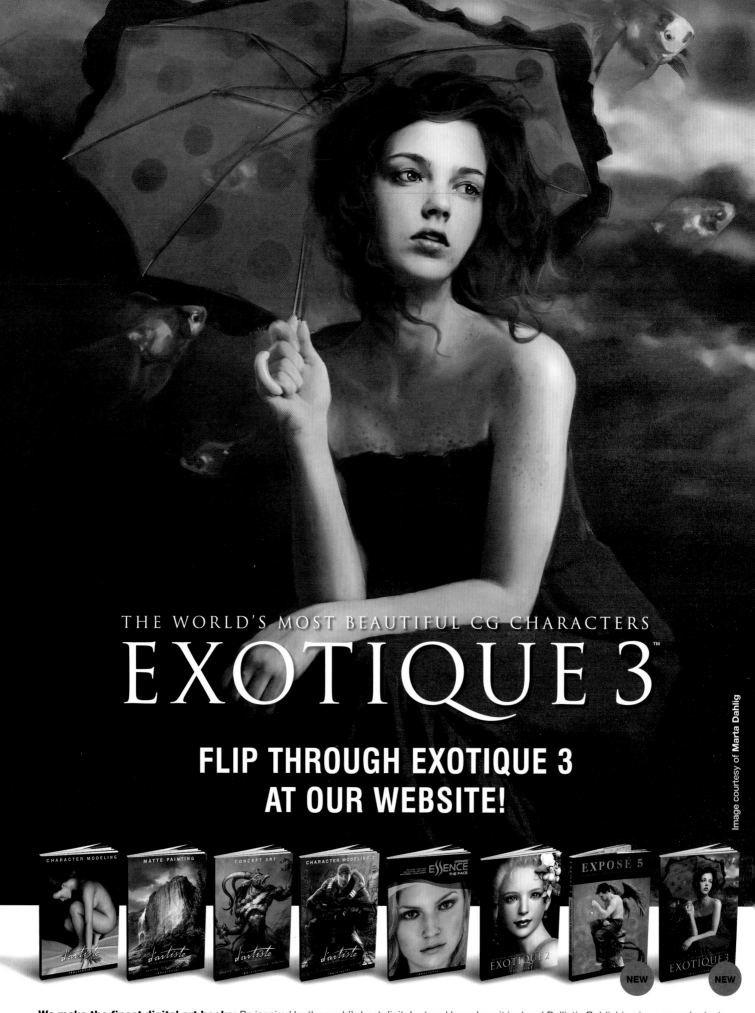

THE WORLD'S MOST BEAUTIFUL CG CHARACTERS
EXOTIQUE 3™

FLIP THROUGH EXOTIQUE 3 AT OUR WEBSITE!

Image courtesy of **Marta Dahlig**